Put any picture you want on any state book cover. Makes a great gift. Go to www.america24-7.com/customcover

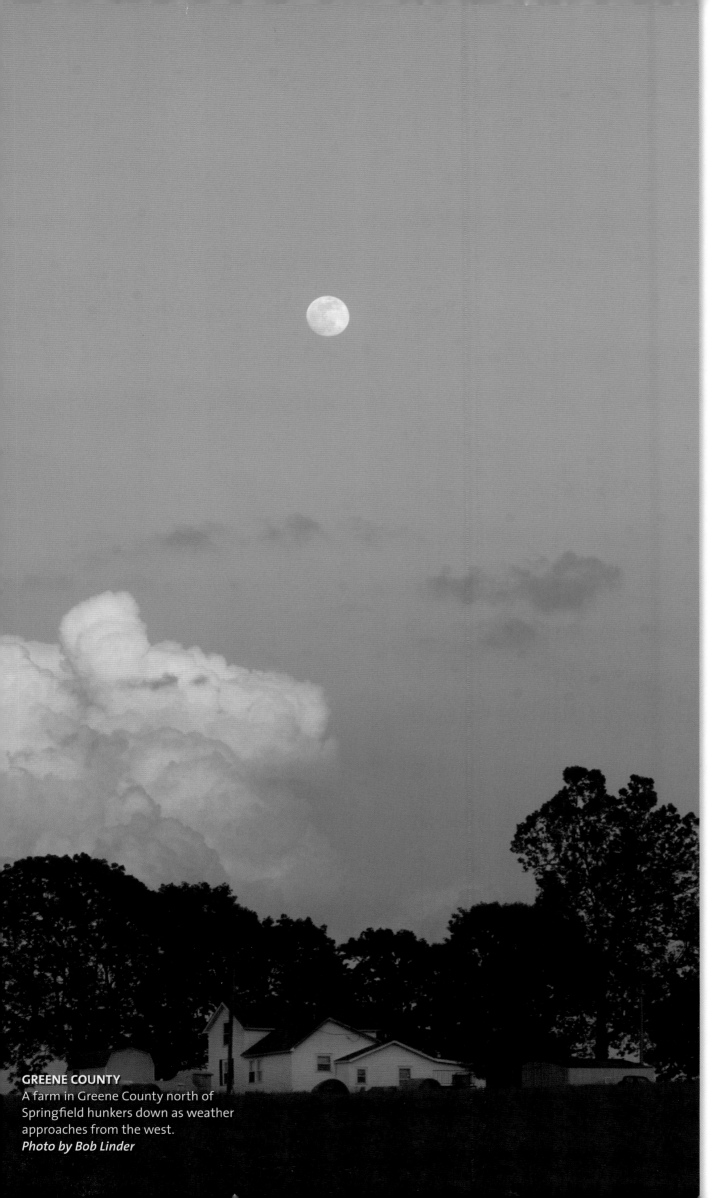

GREENE COUNTY
A farm in Greene County north of Springfield hunkers down as weather approaches from the west.
Photo by Bob Linder

Missouri 24/7 is the sequel to *The New York Times* bestseller *America 24/7* shot by tens of thousands of digital photographers across America over the course of a single week. We would like to thank the following sponsors, the wonderful people of Missouri, and the talented photojournalists who made this book possible.

LONDON, NEW YORK, MUNICH, MELBOURNE, and DELHI

Created by Rick Smolan and David Elliot Cohen

24/7 Media, LLC
PO Box 1189
Sausalito, CA 94966-1189
www.america24-7.com

First Edition, 2004
04 05 06 07 08 10 9 8 7 6 5 4 3 2 1

Published in the United States by
DK Publishing, Inc.
375 Hudson Street
New York, NY 10014

DK Publishing, Inc. offers special discounts for bulk purchases for sales promo-
tions or premiums. Specific, large-quantity needs can be met with special
editions, personalized covers, excerpts of existing guides, and corporate
imprints. For more information, contact:

Special Markets Department
DK Publishing, Inc.
375 Hudson Street
New York, NY 10014
Fax: 212-689-5254

Cataloging-in-Publication data is available
from the Library of Congress
ISBN 0-7566-0065-0

Printed in the UK by Butler & Tanner Limited

First printing, October 2004

ST. LOUIS
Shoot the moon: An airplane on its way to
Lambert-St. Louis International Airport
traces the curve of the Jefferson National
Expansion Memorial Gateway Arch.
Photo by Robert Cohen,
St. Louis Post-Dispatch

MISSOURI 24/7

24 Hours. 7 Days.
Extraordinary Images of
One Week in Missouri.

Created by Rick Smolan and David Elliot Cohen

DK Publishing

About the America 24/7 Project

A hundred years hence, historians may pose questions such as: What was America like at the beginning of the third millennium? How did life change after 9/11 and the ensuing war on terrorism? How was America affected by its corporate scandals and the high-tech boom and bust? Could Americans still express themselves freely?

To address these questions, we created *America 24/7*, the largest collaborative photography event in history. We invited Americans to tell their stories with digital pictures. We asked them to shoot a visual memoir of their lives, families, and communities.

During one week in May 2003, more than 25,000 professionals and amateurs shot more than a million pictures. These images, sent to us via the Internet, compose a panoramic yet highly intimate view of Americans in celebration and sadness; in action and contemplation; at work, home, and school. The best of these photographs, more than 6,000, are collected in 51 volumes that make up the *America 24/7* series: the landmark national volume *America 24/7*, published to critical acclaim in 2003, and the 50 state books published in 2004.

Our decision to make *America 24/7* an all-digital project was prompted by the fact that in 2003 digital camera sales overtook film camera sales. This technological evolution allowed us to extend the project to a huge pool of photographers. We were thrilled by the response to our challenge and moved by the insight offered into American life. Sometimes, the amateurs outshot the pros—even the Pulitzer Prize winners.

The exuberant democracy of images visible throughout these books is a revelation. The message that emerges is that now, more than ever, America is a supersized idea. A dreamspace, where individuals and families from around the world are free to govern themselves, worship, read, and speak as they wish. Within its wide margins, the polyglot American nation manages to encompass an inexplicably complex yet workable whole. The pictures in this book are dedicated to that idea.

—*Rick Smolan and David Elliot Cohen*

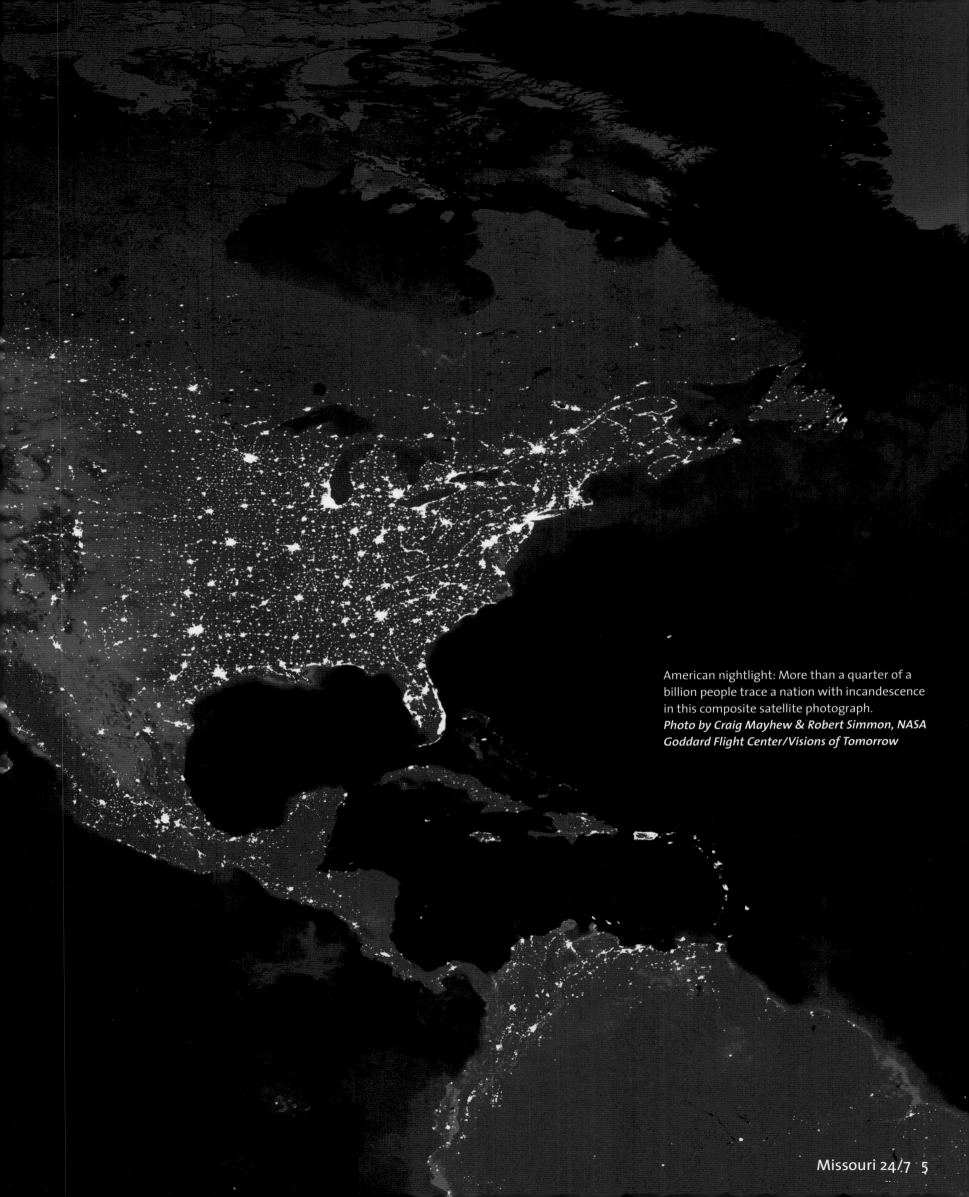

American nightlight: More than a quarter of a billion people trace a nation with incandescence in this composite satellite photograph.
Photo by Craig Mayhew & Robert Simmon, NASA Goddard Flight Center/Visions of Tomorrow

Either Way, It's Missouri

By Sylvester Brown, Jr.

Ask about the slogan "The Show Me State" and you'll get conflicting answers. Missourians are staunch skeptics, some say. Others admit to needing direction now and then. Both sides are supported by legend.

The truth is probably somewhere in the middle.

Call it Missour-uh or Missour-ee. It's recognized either way. Mark Twain, Laura Ingalls Wilder, Harry Truman, George Washington Carver—even Sheryl Crow and Nelly—made sure of it.

This is Missouri—tamed by the Sioux, snatched by Spain, given to France, and sold to Jefferson. This was the country's compromise—a slave state, but only in part. Slavery made its way north by way of steamboats, saddlebags, and old southern habits.

Missouri smiled at the union and winked at the south—even mixed a horse and a donkey and dubbed it the "Missouri mule."

This is Missouri, baby, the middle state, something in between.

Missouri represents America's adventurous teenage years—a time when Lewis and Clark stretched the wobbly legs of democracy westward, along the path of the mighty Missouri River. This was the muddy middle passage to golden dreams and fat, fertile land.

Ours is the jambalaya on America's 50-course buffet. Creole-style villages of French settlers are preserved in St. Genevieve and in St. Charles. The heart of German immigration oompahs with gusto in Hermann, while the ragtime memories of Scott Joplin are celebrated midstate, in Sedalia, every year.

St. Louis was the state's first big city. The "City of Kansas" soon followed. Businessmen with Yankee alliances cultivated their St. Louis fortunes

ROCHEPORT
An early morning barge eases its way east on the mighty Missouri River toward the I-70 bridge. Then it's on to St. Louis and the Mississippi.
Photo by Chris Stanfield

while Kansas City got rich off countless cattle from the Wild West. Both are economic engines of the state, though the rural folk prefer it another way.

The outlaw Jesse James reflects the spirit of a young Kansas City. The thief and murderer who carried the bitter banner of secession today is romanticized in his hometown of Kearney.

Neither Republican nor Democrat, Missouri swings with both parties. Still, KC's "Boss" Pendergast built a machine that helped elect two presidents and inspire a "New Deal."

Republicans get their way, too. In a strange twist of fate and metal Republican John Ashcroft lost his Senate seat. It really didn't matter. Longtime politician Jim Talent got it back. And Aschroft? He got a spot in the nation's cabinet.

Missouri's new division is really old division. Sprawl—urban, suburban and now, rural. Sprawl fuels rifts as power shifts. No one's wearing blue or gray but guns, abortion, education, stadiums, and tiffs divide us anyway.

This book gets up close and personal with a complex state. Missouri. The middle state. United and divided, strengthened and weakened by diversity and invisible borders.

Missouri is tree-covered hills, fish-filled lakes, timeless caverns, and the Santa Fe Trail. It's factories and farms, faiths and factions. It's barbecue, Branson, and Budweiser. It's bluegrass and country, Bootheel gospel, Kansas City jazz, St. Louie blues, and rock and roll —Chuck Berry–style.

It's a mix, you see...

This is Missouri, baby, the middle state, something in between.

Born and raised in St. Louis, SYLVESTER BROWN, JR. *is a metro columnist for the* St. Louis Post-Dispatch. *He lives with wife Victoria and their two daughters in the Skinker DeBaliviere neighborhood of St. Louis.*

LEXINGTON

Main Street, a witness to history. The Battle of Lexington during the Civil War left a cannonball lodged in the courthouse. Later, Jesse James robbed the bank and got away with $2,000. He also made off with a watch that he returned when he noticed its inscription to a little girl.

Photo by Robert Cohen,
St. Louis Post-Dispatch

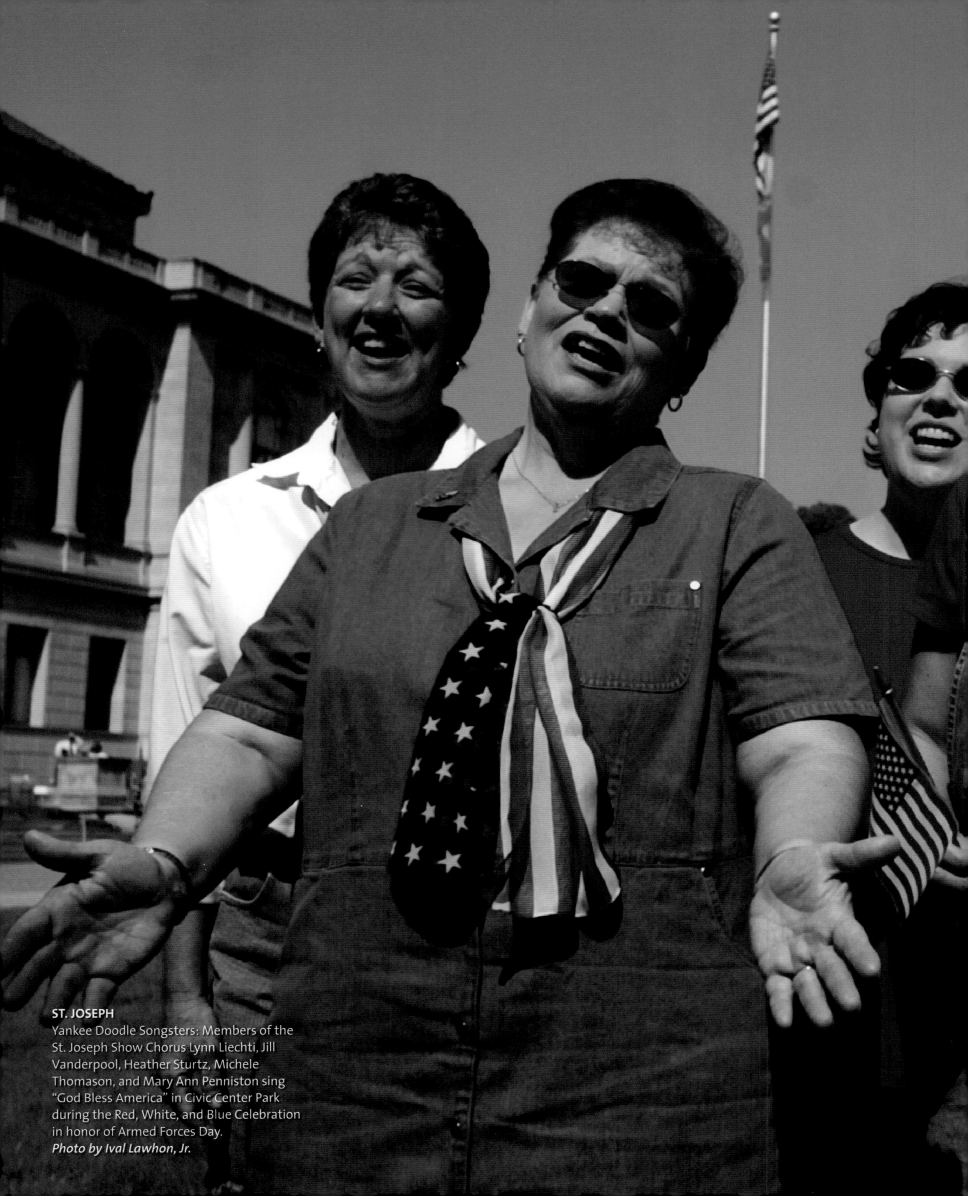

ST. JOSEPH
Yankee Doodle Songsters: Members of the
St. Joseph Show Chorus Lynn Liechti, Jill
Vanderpool, Heather Sturtz, Michele
Thomason, and Mary Ann Penniston sing
"God Bless America" in Civic Center Park
during the Red, White, and Blue Celebration
in honor of Armed Forces Day.
Photo by Ival Lawhon, Jr.

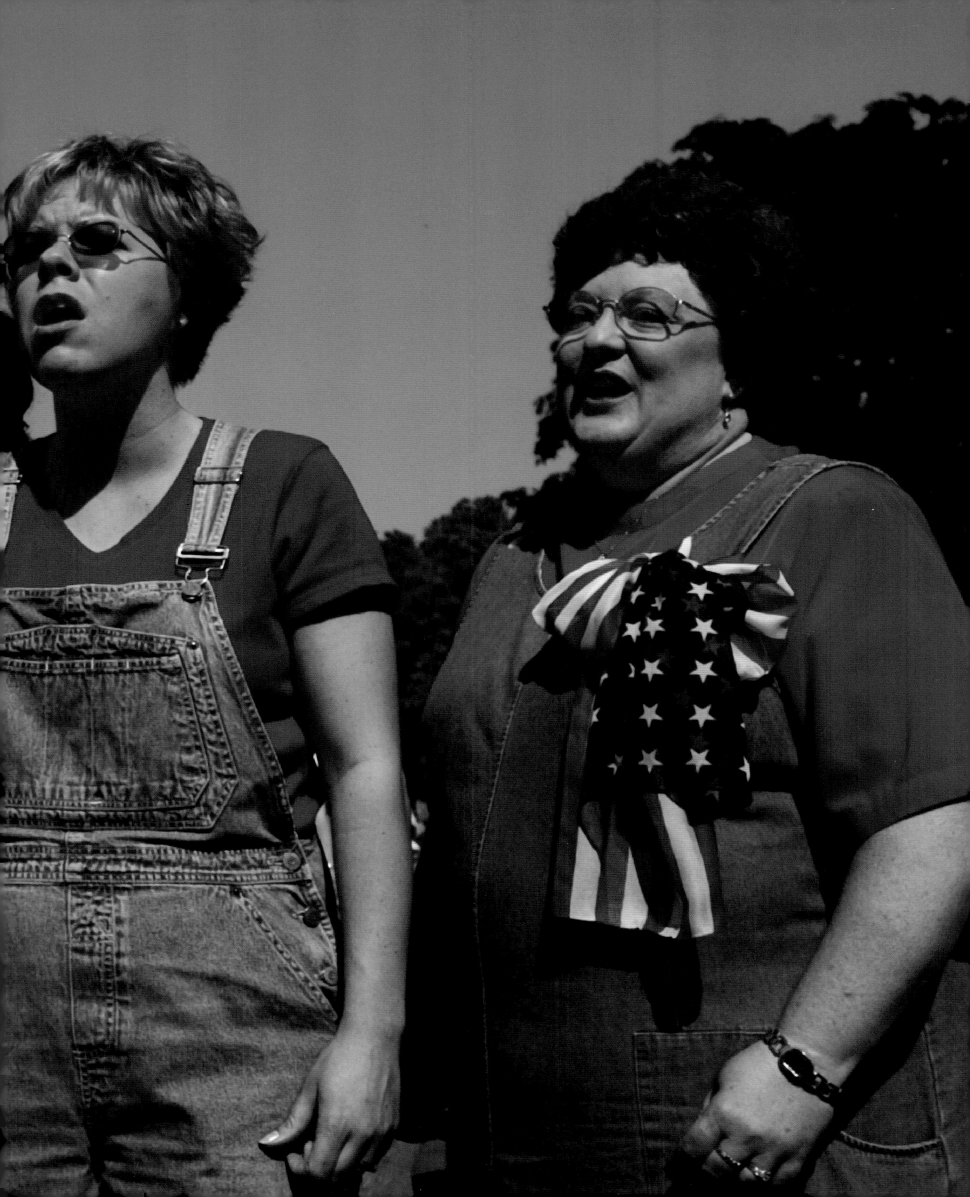

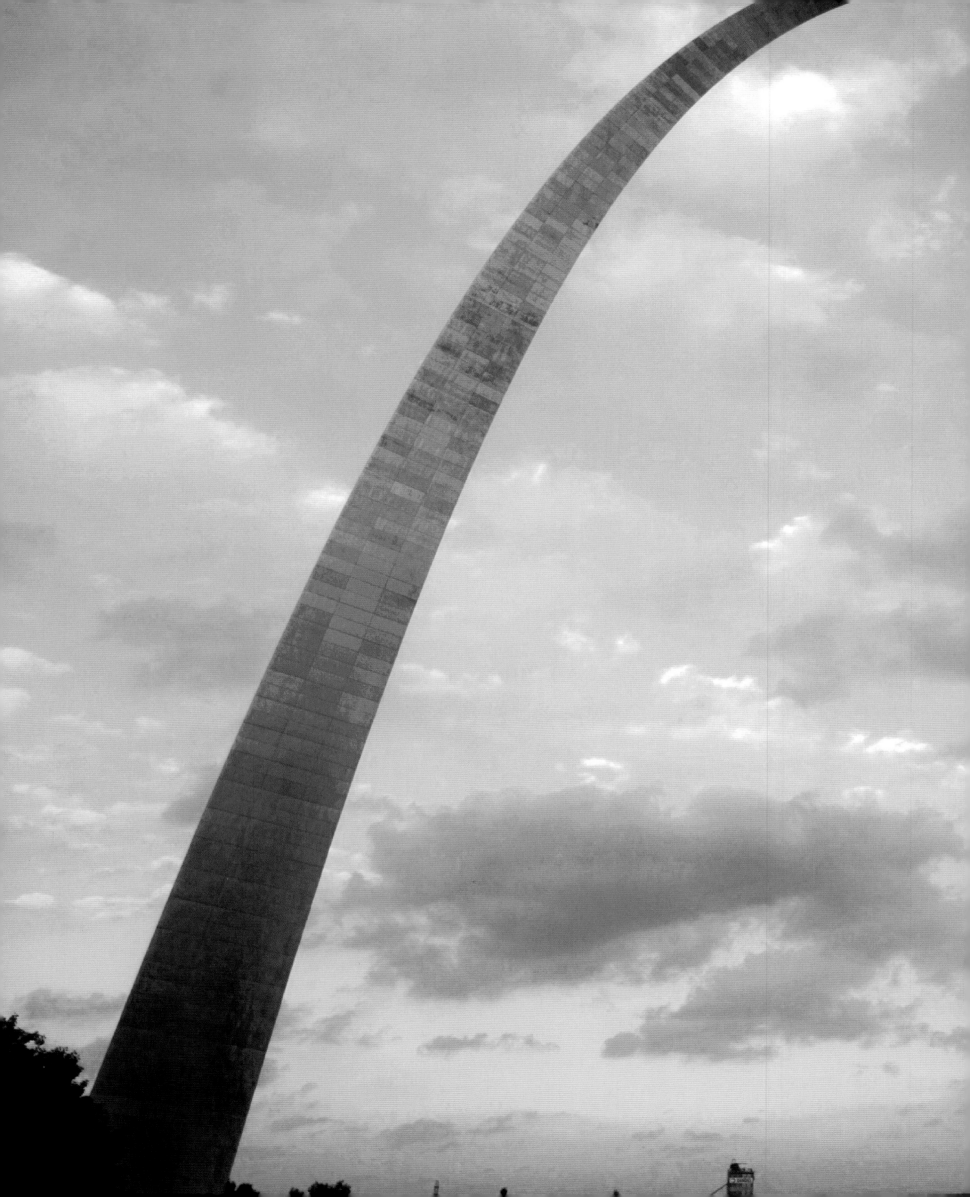

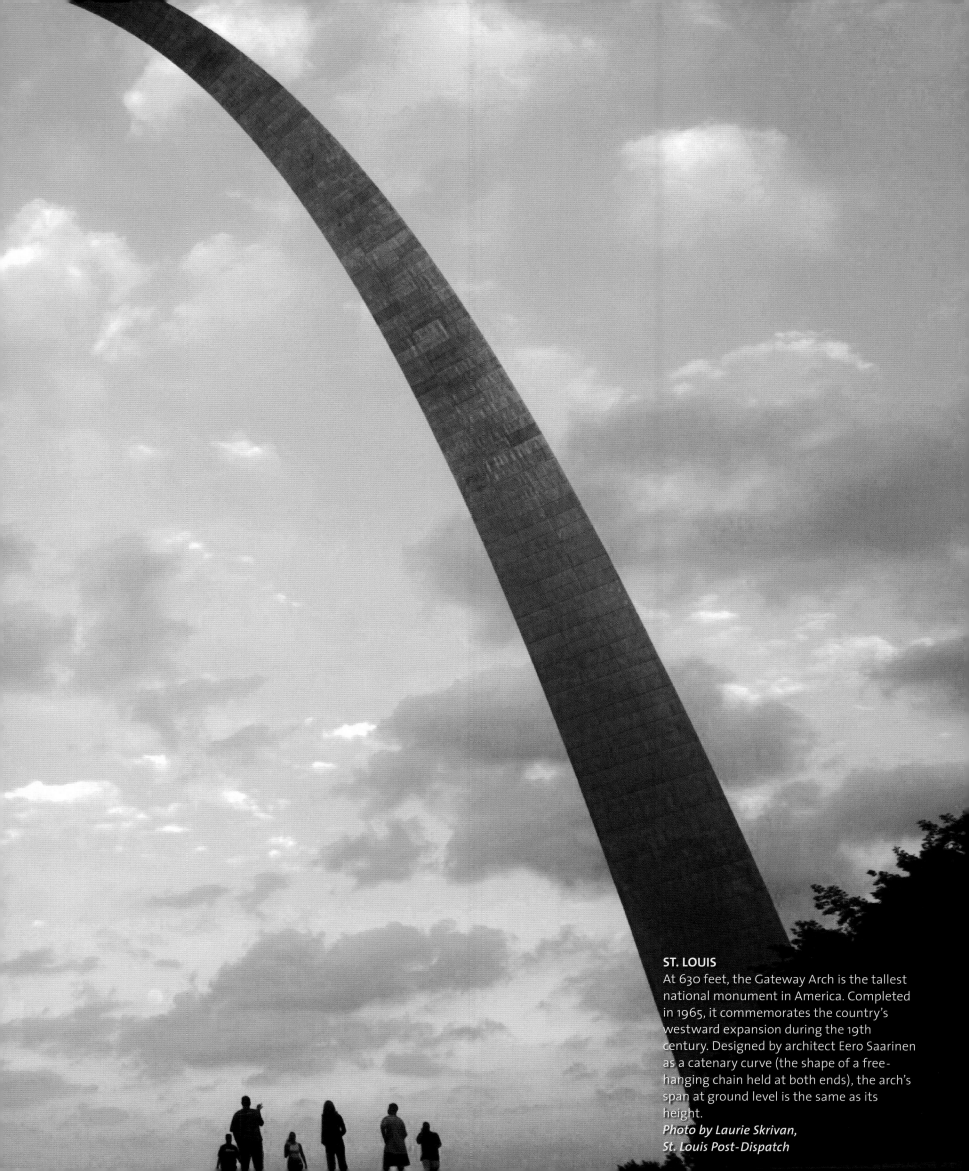

ST. LOUIS
At 630 feet, the Gateway Arch is the tallest
national monument in America. Completed
in 1965, it commemorates the country's
westward expansion during the 19th
century. Designed by architect Eero Saarinen
as a catenary curve (the shape of a free-
hanging chain held at both ends), the arch's
span at ground level is the same as its
height.
Photo by Laurie Skrivan,
St. Louis Post-Dispatch

ST. JOSEPH
Once a 400-acre mecca for buying and selling cattle, the St. Joseph's auction arena is now a shadow of its former self. During the 1920s, stockyards, slaughterhouses, and nine railroad lines converged here to facilitate the trade of four million head of cattle annually. After the meatpacking industry left town, the auction downsized and now moves just 150,000 feeder cattle annually.
Photo by Eric Keith

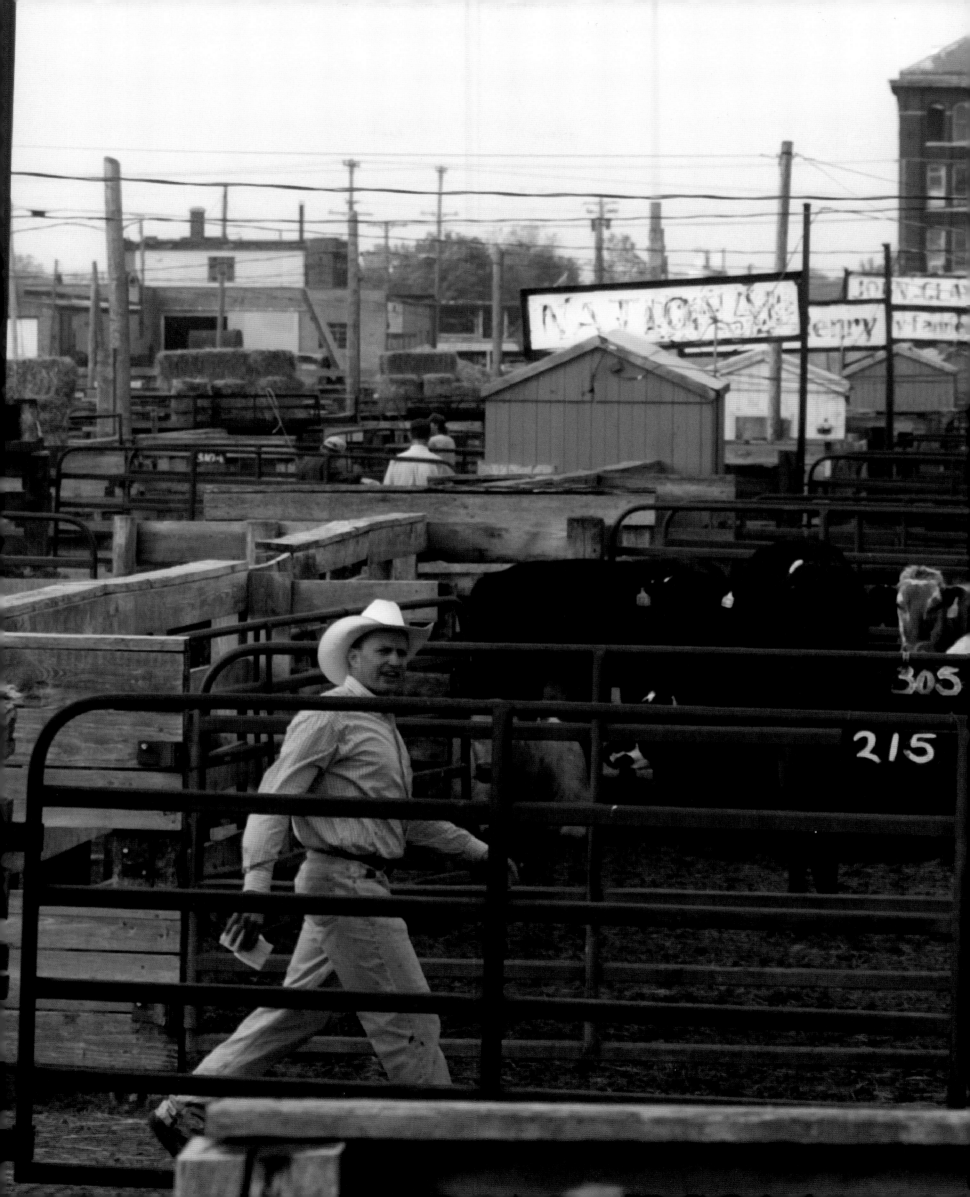

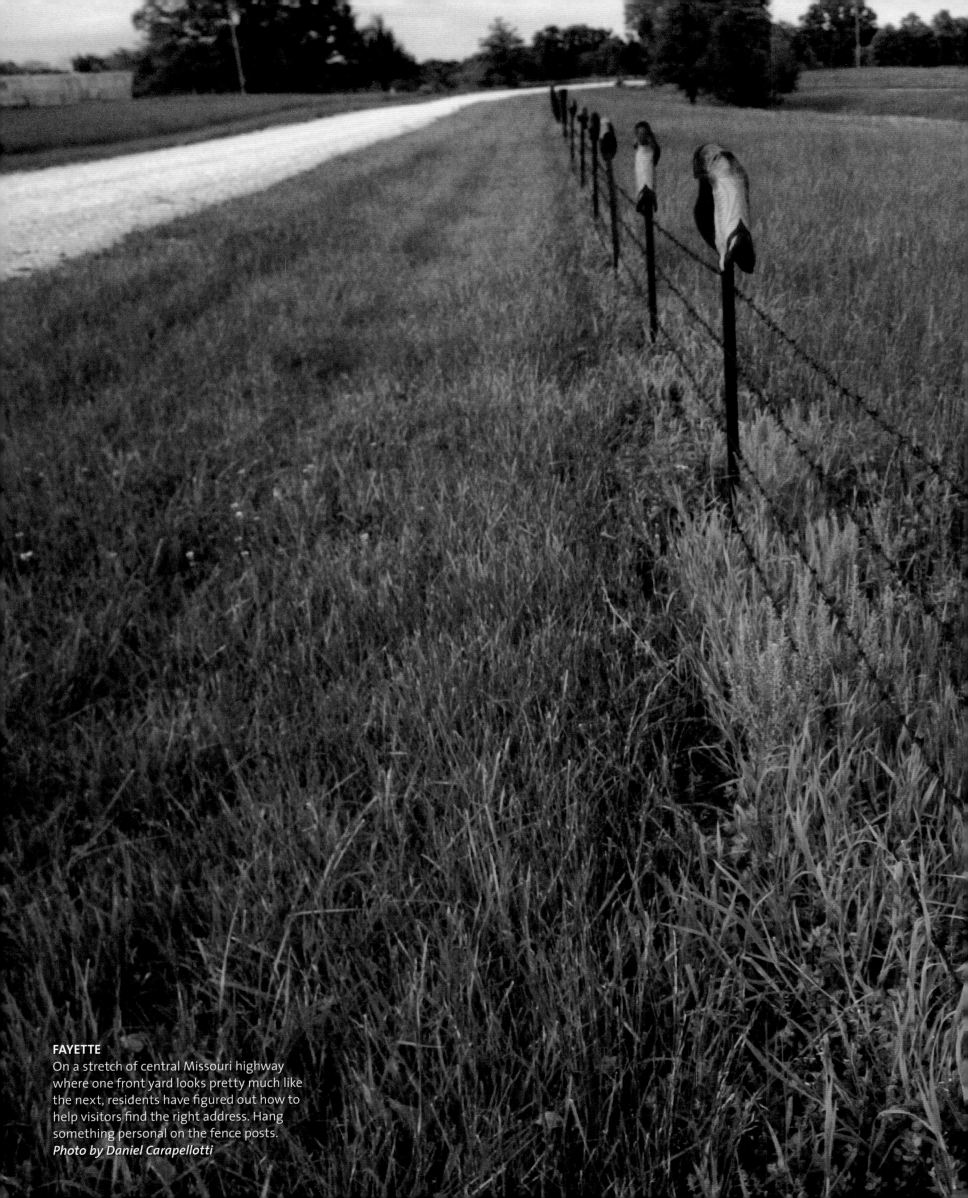

FAYETTE
On a stretch of central Missouri highway where one front yard looks pretty much like the next, residents have figured out how to help visitors find the right address. Hang something personal on the fence posts.
Photo by Daniel Carapellotti

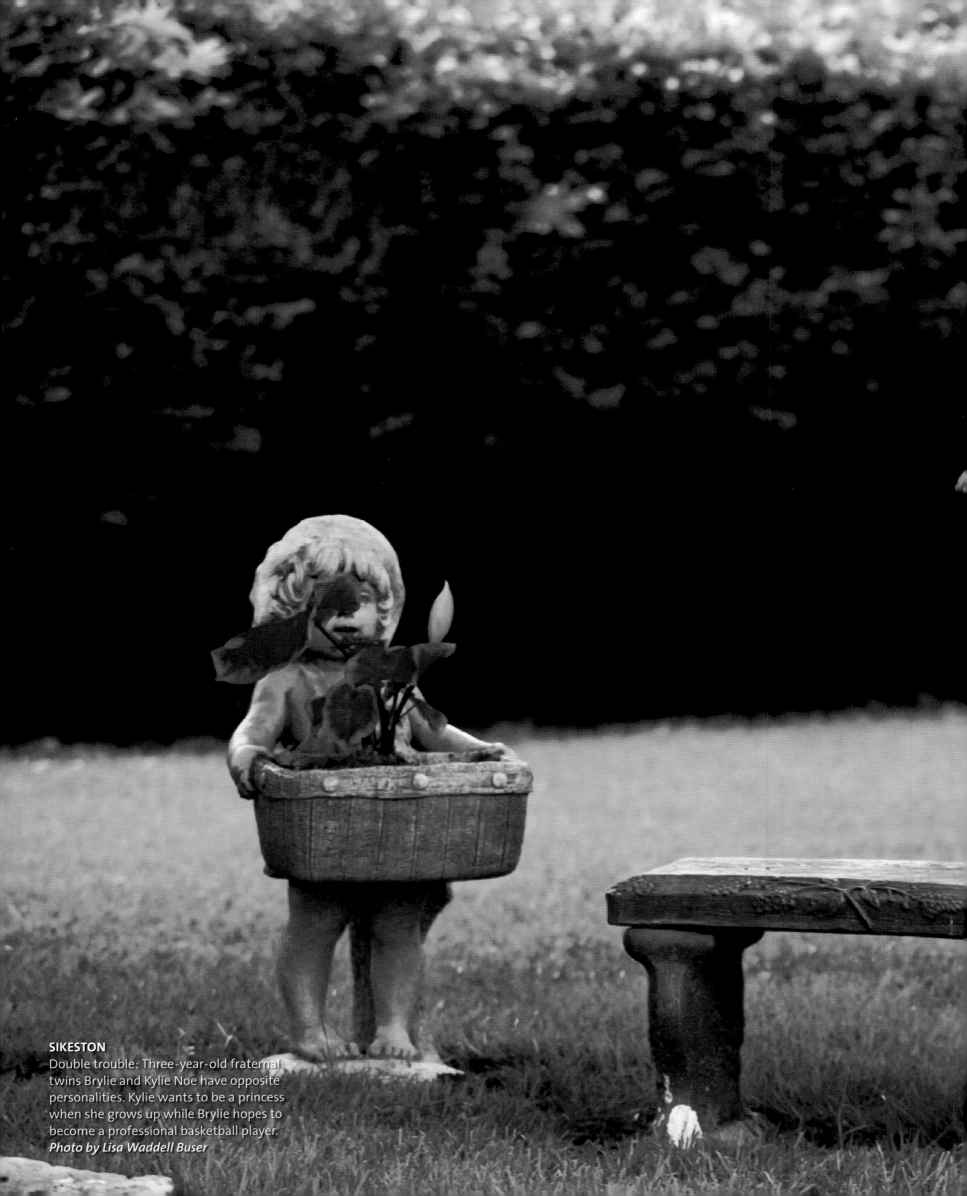

SIKESTON
Double trouble: Three-year-old fraternal twins Brylie and Kylie Noe have opposite personalities. Kylie wants to be a princess when she grows up while Brylie hopes to become a professional basketball player.
Photo by Lisa Waddell Buser

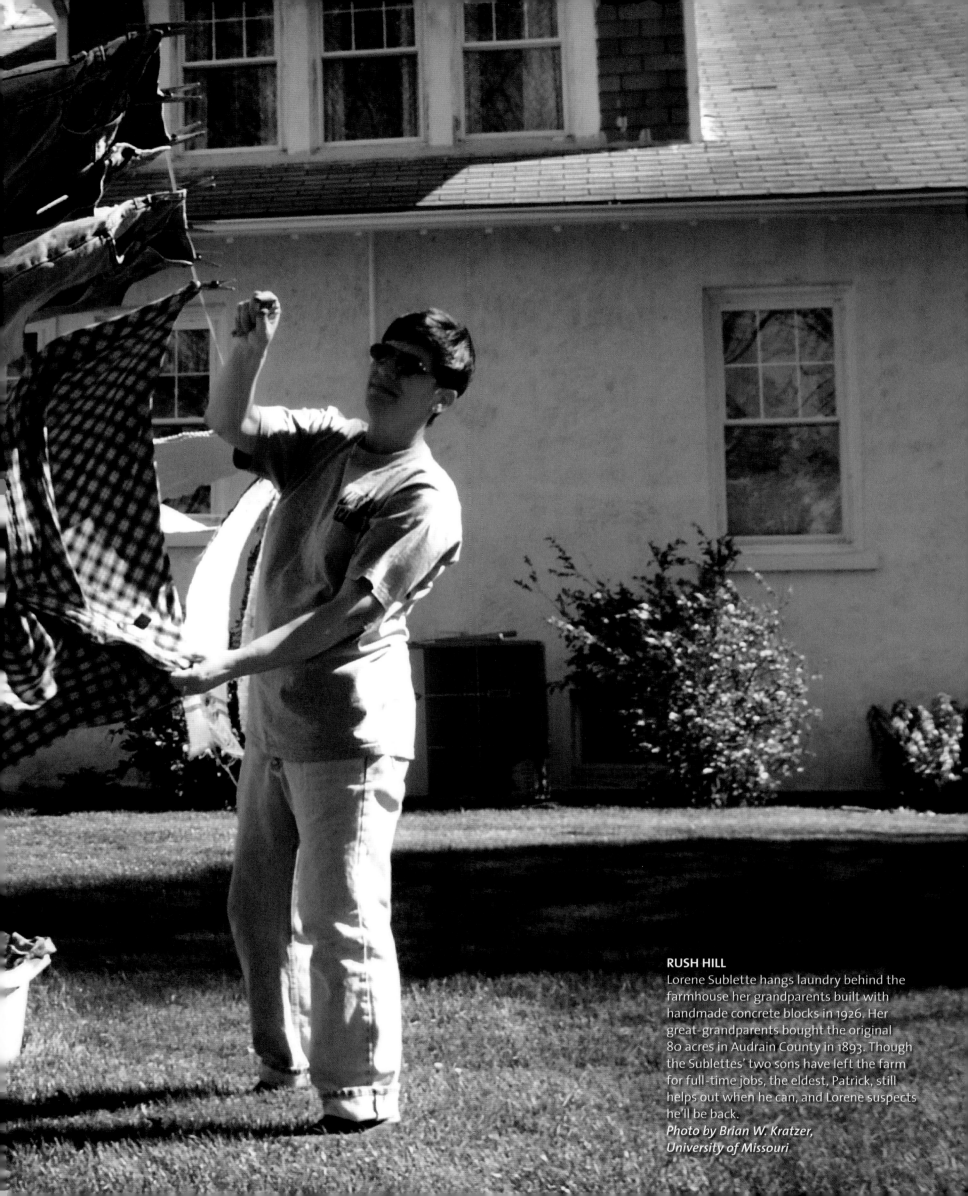

RUSH HILL

Lorene Sublette hangs laundry behind the farmhouse her grandparents built with handmade concrete blocks in 1926. Her great-grandparents bought the original 80 acres in Audrain County in 1893. Though the Sublettes' two sons have left the farm for full-time jobs, the eldest, Patrick, still helps out when he can, and Lorene suspects he'll be back.
Photo by Brian W. Kratzer,
University of Missouri

RUSH HILL
David Sublette grills homegrown hamburgers from cattle raised on the now 160-acre family farm. The Sublettes both work full-time jobs to make ends meet, but they still run 50 head of cattle and plant corn, soybeans, and hay—all for sale.
Photo by Brian W. Kratzer, University of Missouri

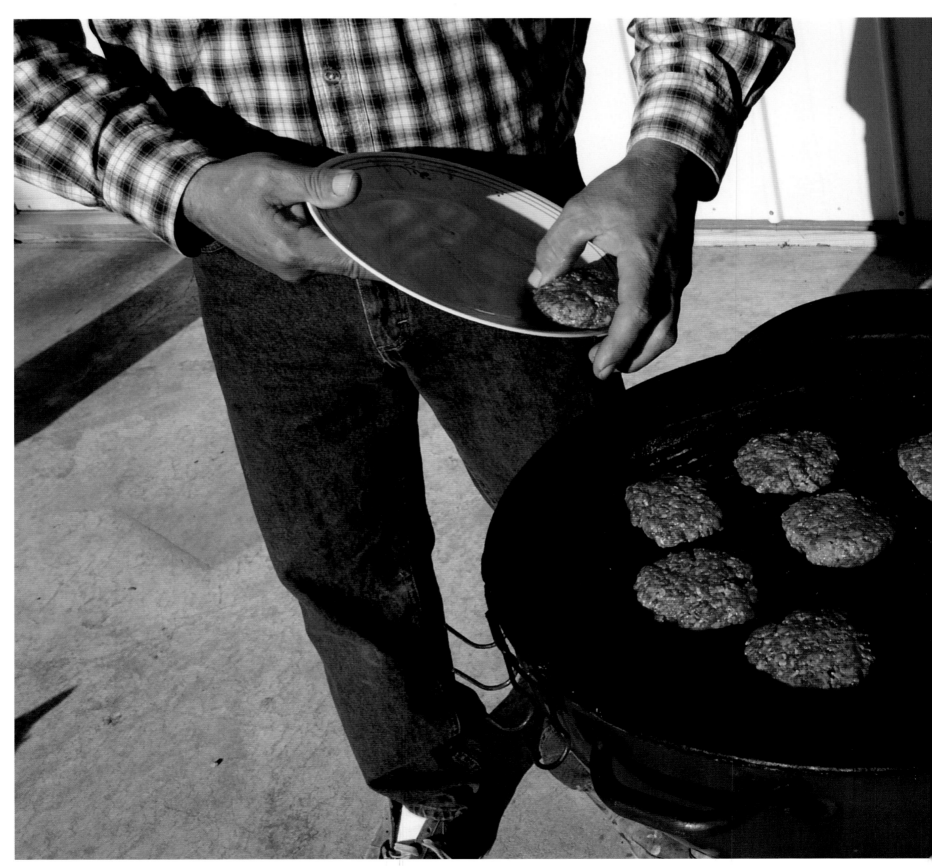

LA BELLE

Chester and Leanne Florea had seven kids between them when they met through Heartland Ministries' recovery program. They both worked up to management positions at Heartland's dairy, which milks 3,200 cows and 1,000 goats. When the Floreas married, they and their combined brood became eligible for a house in the Heartland community.

Photo by Sherry Skinner

MILAN

From Milan to Guanajuato, Mexico, Petra Luna's tamales are known for their authentic taste and piquant bite. Together with daughter Ana, 7, Luna prepares the *masa*, or cornmeal dough, spoons it into cornhusks, and stuffs it with spiced meats and chilies.

Photo by Sara Andrea Fajardo

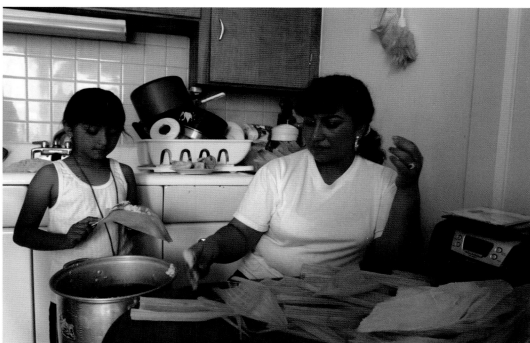

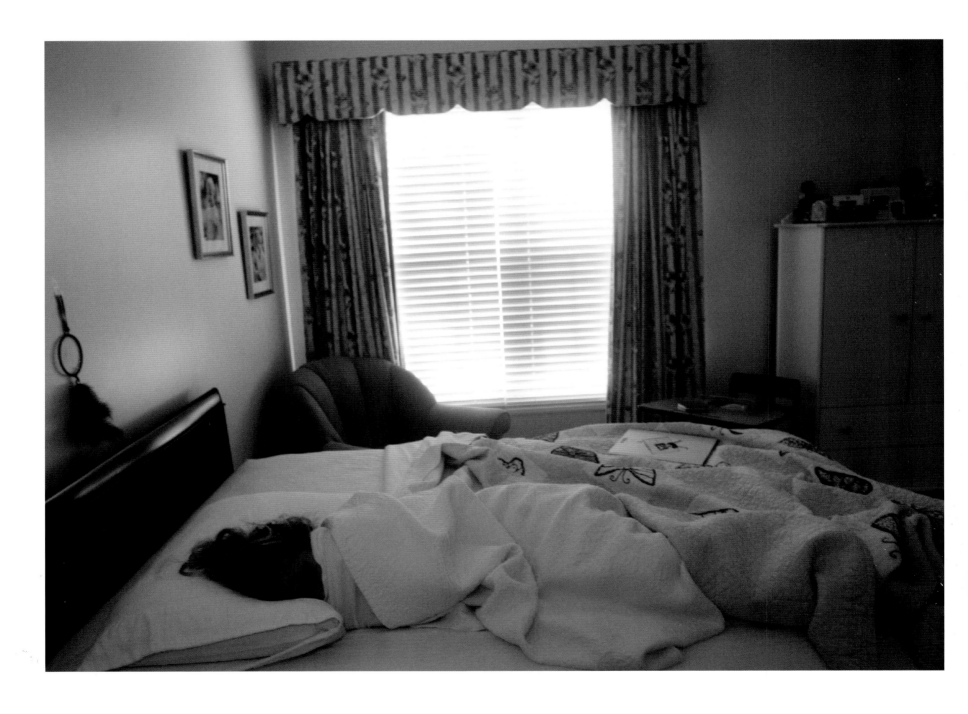

TOWN AND COUNTRY
Hit the snooze button: Waiting for her mom
to get her out of bed for school, first-grader
Grace Hildreth snuggles back under the covers.
Photo by Laurie Skrivan, St. Louis Post-Dispatch

BETHEL

Up in the northeast corner of the state, after a long Saturday night of pizza, popcorn, and movies at grandma Skinner's, Taylor Starr sleeps well into Sunday between Uncle Nathan and mom Alyssa.

Photo by Sherry Skinner

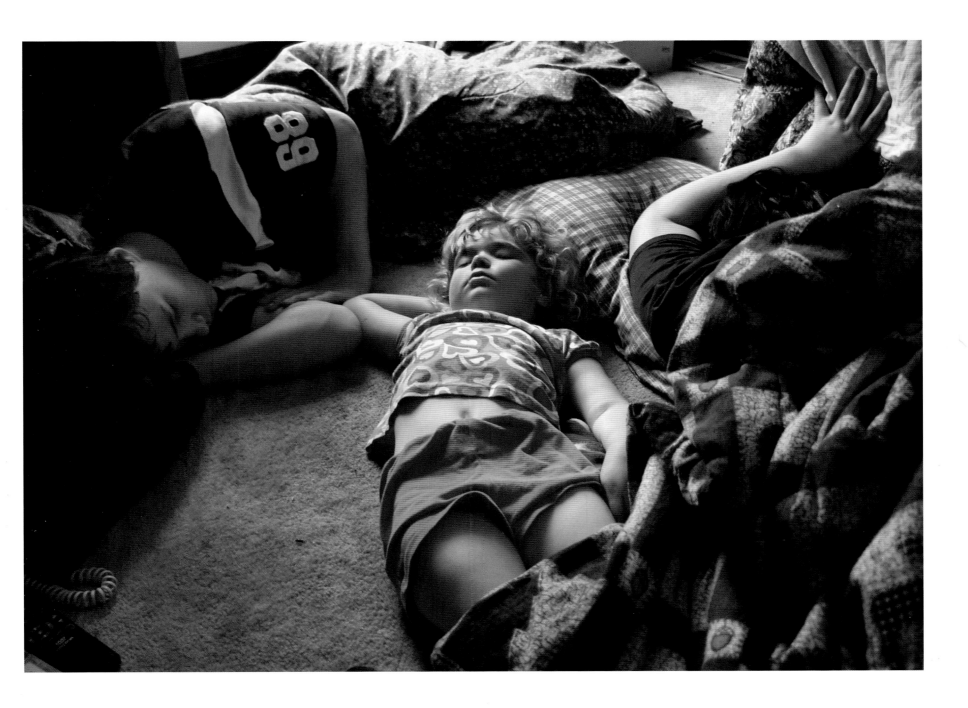

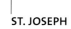

ST. JOSEPH
Paige Dilley, 13, takes a load off while her
nephews Kyle and Brandon Knowles, 8 and 6,
scoot around the yard in northern St. Joseph.
Photo by Ival Lawhon, Jr.

BLACKWATER

The future looks fine for Alex Breshears's leafy hometown in central Missouri. A decade ago, the block-long downtown of Blackwater (pop. 200) was nearly dead. Then a resident saved three of the oldest buildings from demolition. A civic revival was sparked, the little farming town now thrives, and Alex's dad, an insulator for Thermatex, is busy and happy.

Photo by Seth Wenig

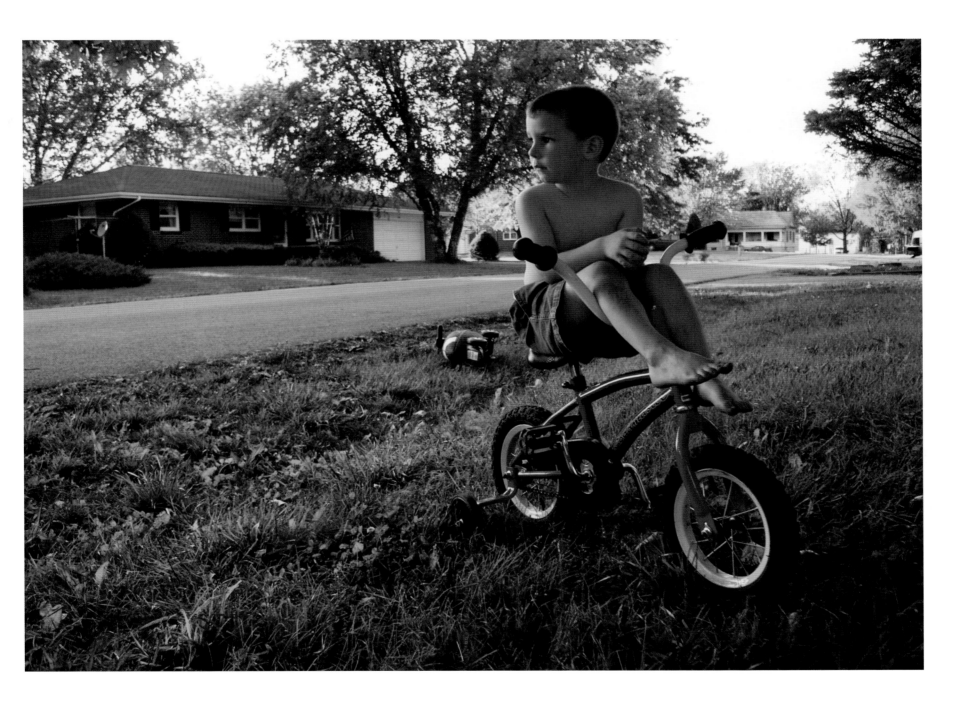

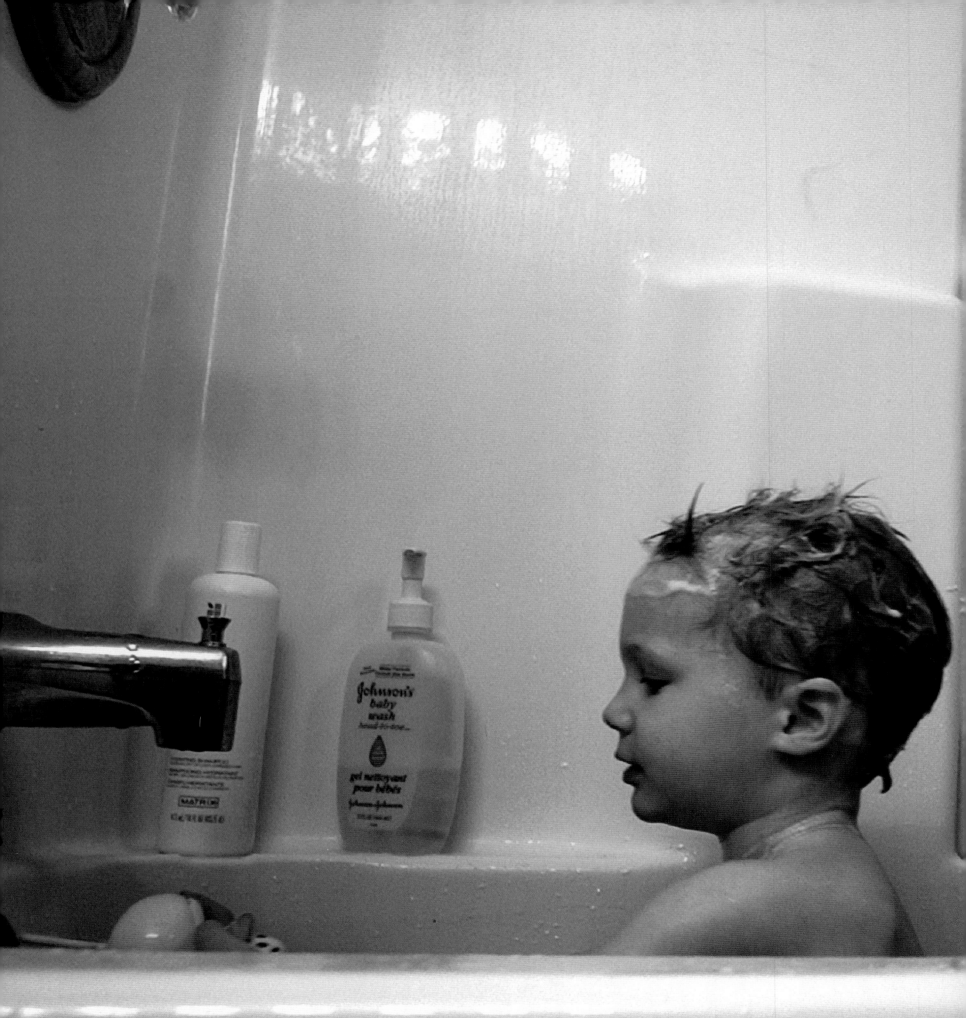

COLUMBIA
It's bath time, and civil engineer Joe Knapp
has some suds fun with his kids Isaac, 3, and
Trinity, 2. Three years ago, the family down-
sized their lives, selling their big house and
big cars so mom Melissa could stay home
with the kids.
Photo by Chris Stanfield

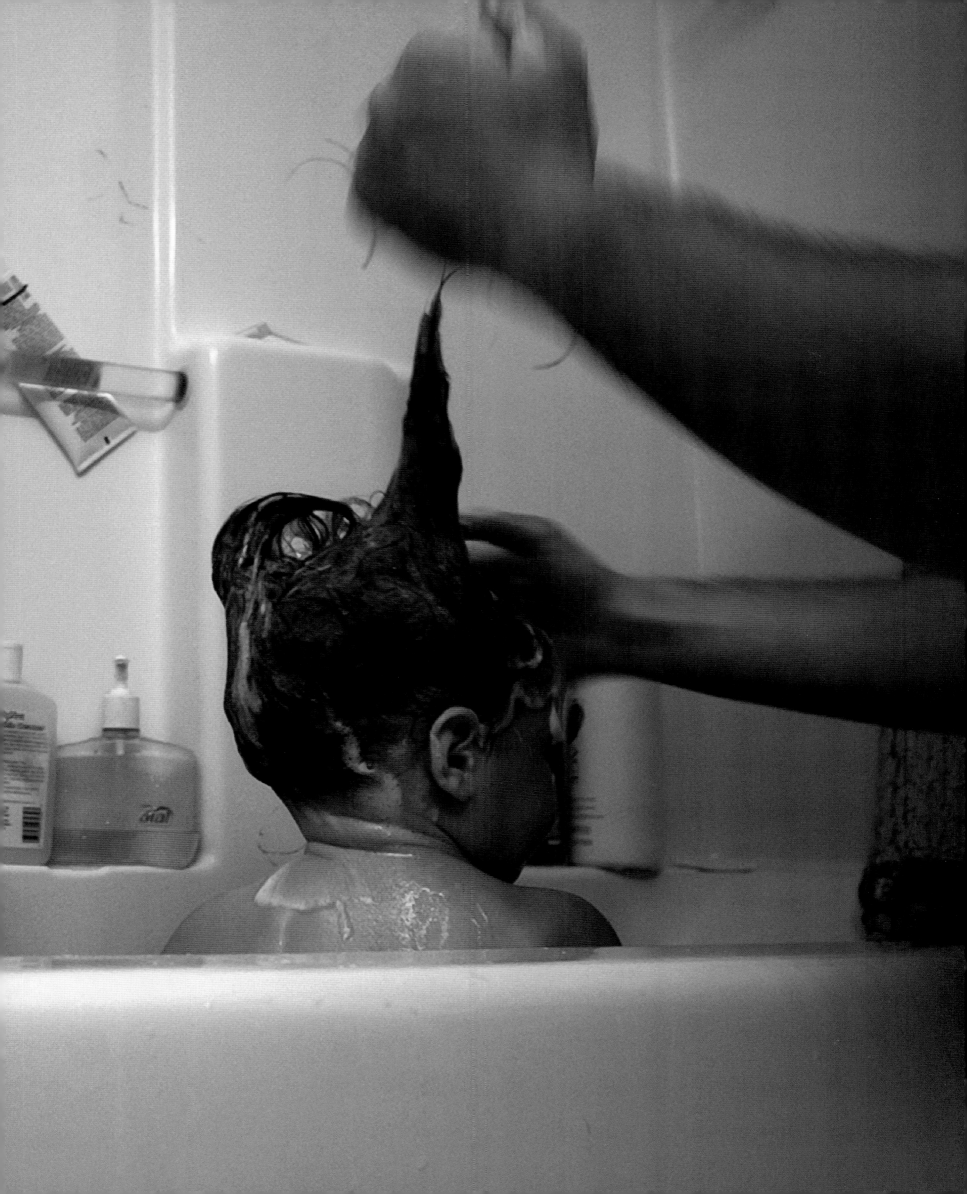

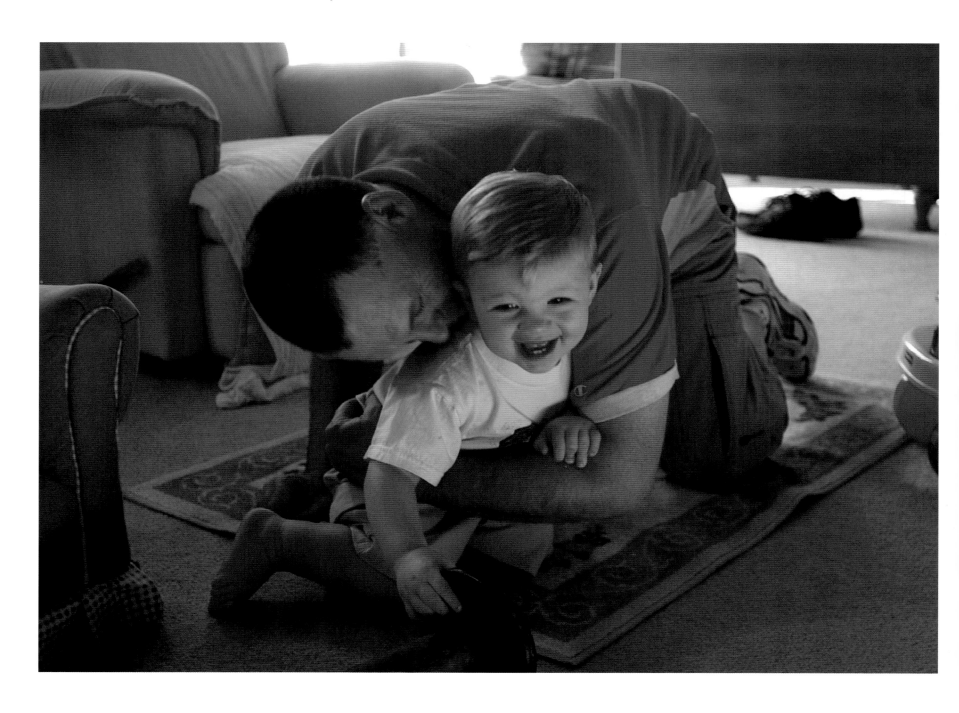

ST. JOSEPH
When they found out they were pregnant, Jerry and Laurie Grainger had to make a decision about day care. He was a maintenance mechanic at a factory that made McDonald's buns; she had a higher-paying job as an engineer. "Then 9/11 kind of crystallized everything for me," Jerry says. He quit work and became a stay-at-home dad to sixteen-month-old Dawson.
Photo by Jessica A. Stewart

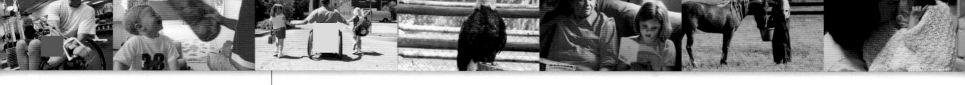

COLUMBIA

Kevin Brown says he would not trade his life for anybody's. After a motorcycle accident in 1993 left him a paraplegic, doctors said he'd never be able to manage a wheelchair, much less have a child. He and his wife thought otherwise. Now their 5-year-old daughter Lauren, right, and her friend Lucy Kingsley pull him toward his van for the ride home.

Photo by L.G. Patterson

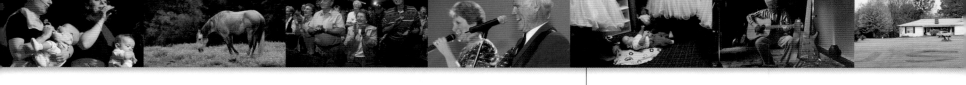

BRANSON

Matriarch Sheila Dutton, husband Dean, their six married children and a raft of grandkids populate the Dutton family's 12-year-old musical/dance/comedy theater. The clan does 300 shows a year in Branson, a Las Vegas–styled pleasure dome in the Ozarks given to old-fashioned, country-inflected entertainment.

BRANSON

In true Dutton form, the family's latest crop is part of the act. It's showtime in the 840-seat theater, and Amy Dutton Arámbula sings "Mr. Sandman." The Duttons, along with the Presleys, the Haygoods, and the Lowes have Branson's family entertainment market cornered.

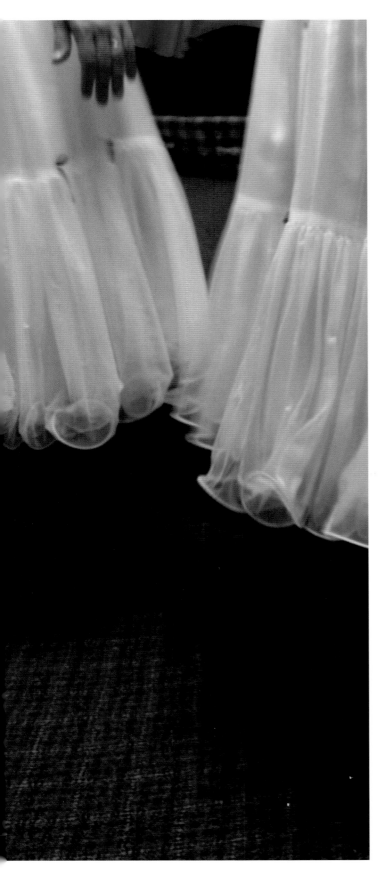

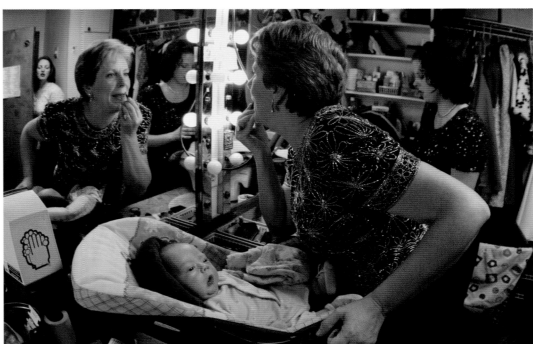

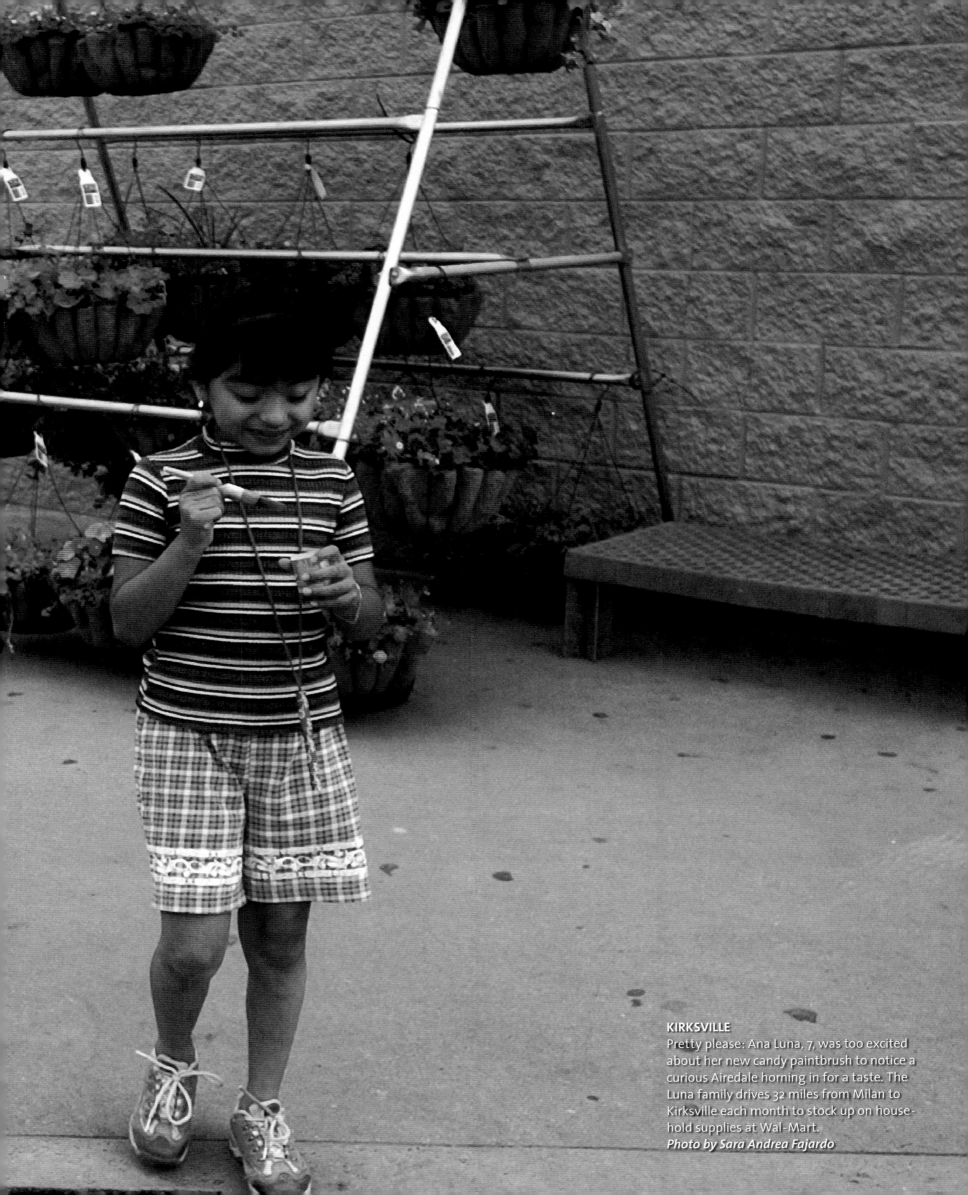

KIRKSVILLE
Pretty please: Ana Luna, 7, was too excited about her new candy paintbrush to notice a curious Airedale horning in for a taste. The Luna family drives 32 miles from Milan to Kirksville each month to stock up on household supplies at Wal-Mart.
Photo by Sara Andrea Fajardo

After Haley Danner's family stopped their car and saved "Pux" from getting run over, they brought him home, where he took to litter-box training. Now the groundhog comes when called. In Missouri, groundhogs are classified as game animals that may be hunted year-round. According to one University of Missouri study, the stout rodent makes "excellent table fare."

Photos by Seth Wenig

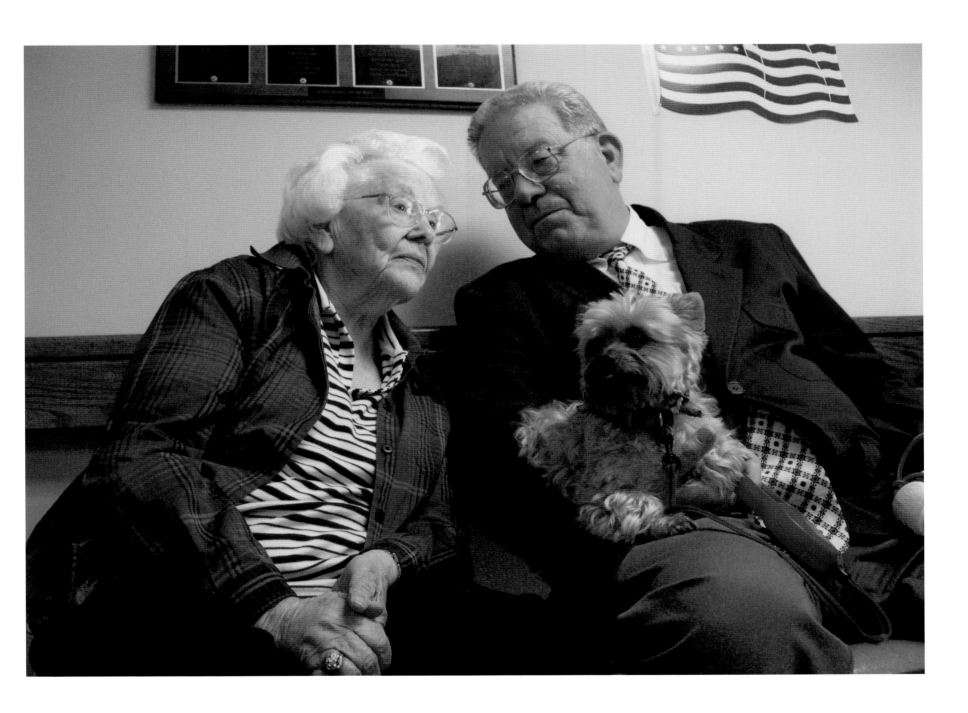

MEXICO

Once a year, residents of Mexico stage a pet show at the King's Daughters Home for Aged Women. Lois Dowell already knows Petey, a Yorkshire terrier. When the Reverend Robert Marty preaches at King's Daughters, he brings along Petey, who sits quietly in a chair until the last amen.

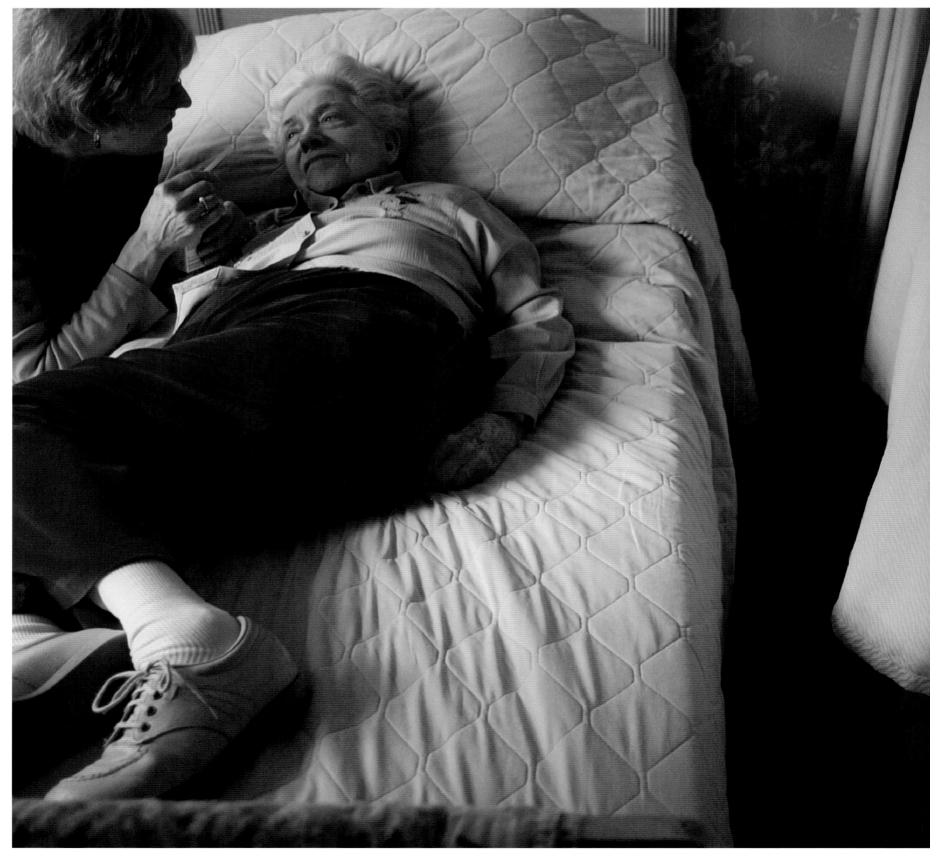

CREVE COEUR
Joan Uthe visits her 93-year-old mother Anna Wallis. Joan and her sisters have taken turns spending time with Anna every day since her move to the Delmar Gardens Nursing Home in 1999. She lived with each of her daughters until she needed more medical care than they could provide. "You reap what you sow," says Joan. "She lived a life of selflessness."
Photos by Andrea Haley Scott,
St. Louis Post-Dispatch

CREVE CŒUR
A good manicure brightens any mother's day.
Anna Wallis shows off daughter Nancy Valenti's
handiwork.

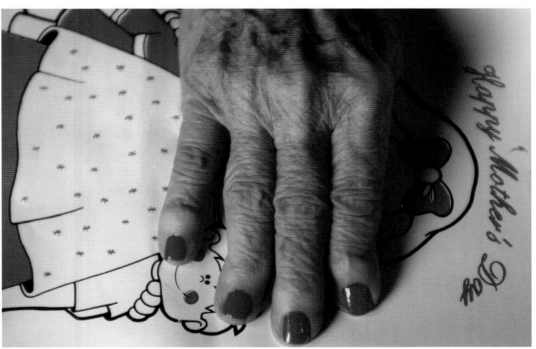

SIKESTON
When she's not caring for her 82-year-old mother, teenage daughter, 5-year-old grandson, and 3-year-old twin grand-daughters, Jane Pfefferkorn (right) runs a soup kitchen and drug recovery program. In 2003, she was named Sikeston Citizen of the Year, becoming the first woman to receive the honor in the award's 53-year history.
Photo by Lisa Waddell Buser

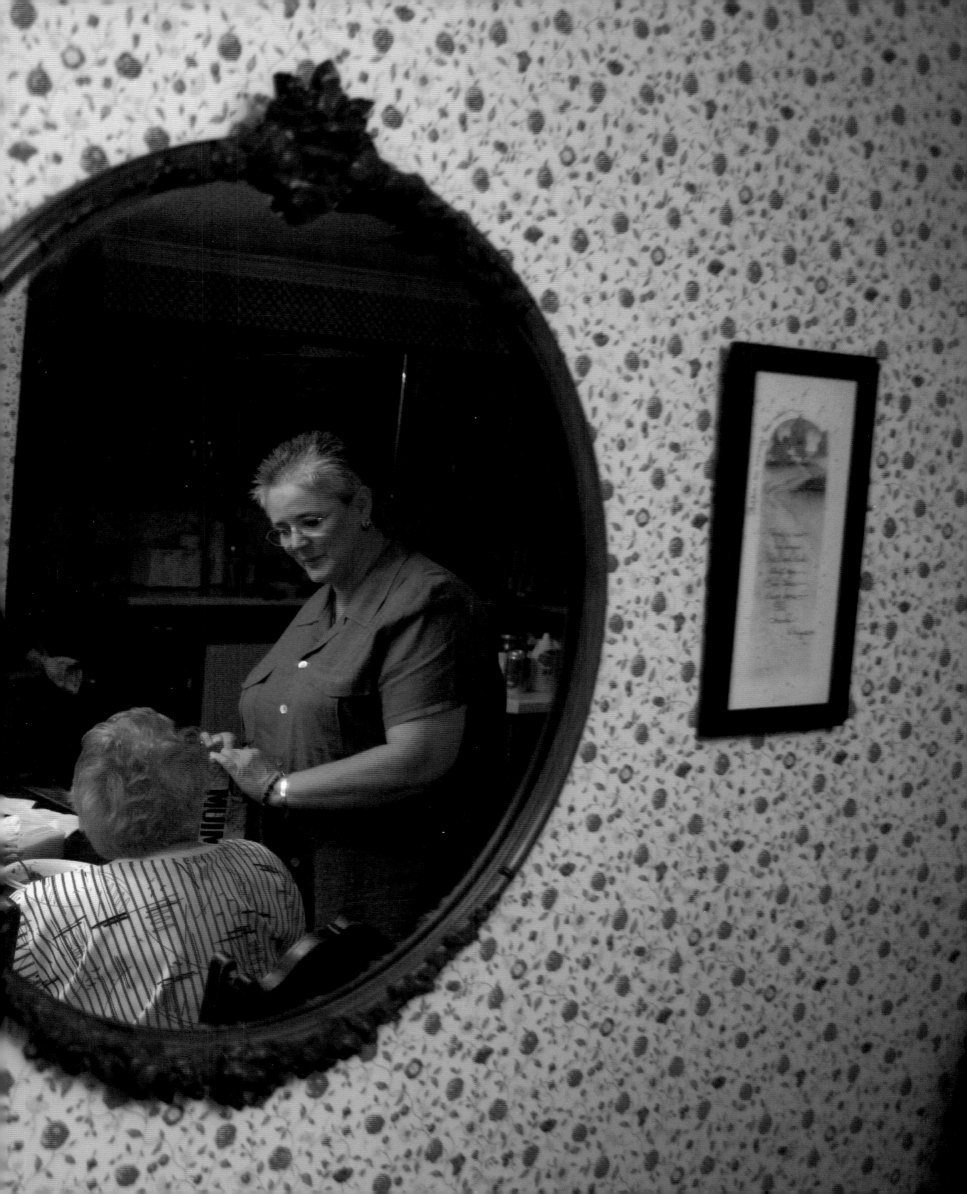

ST. LOUIS
Nathan Doughty, 45, adjusts the gas on his
Coleman stove before warming up some soup.
He has lived in this tent on the Mississippi River
just south of downtown St. Louis for almost a
year. Doughty works when he feels like it, posting
ads for odd jobs. "I live in America," he says.
"I am not homeless."
Photo by Justin Kase Conder

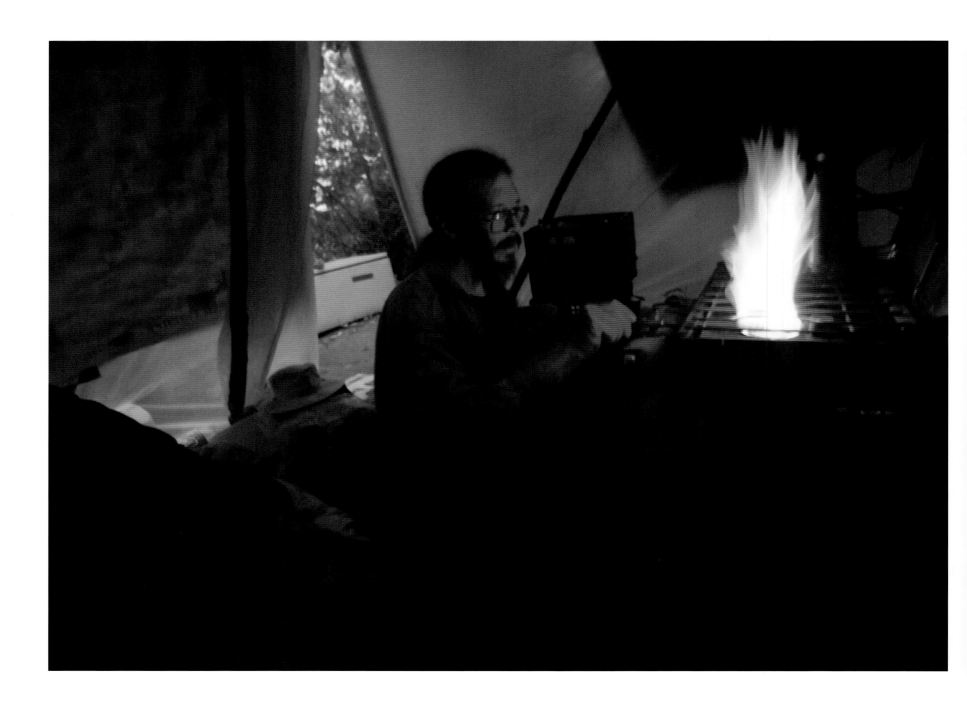

HANNIBAL

Director of the Hannibal Arts Council Michael Gaines brings his curatorial eye home with him. His renovated apartment in a 160-year-old building is a paean to his passion for new art. The Council actively recruits artists to move to Hannibal (pop. 18,000), where several galleries have opened in the past year.
Photo by Sherry Skinner

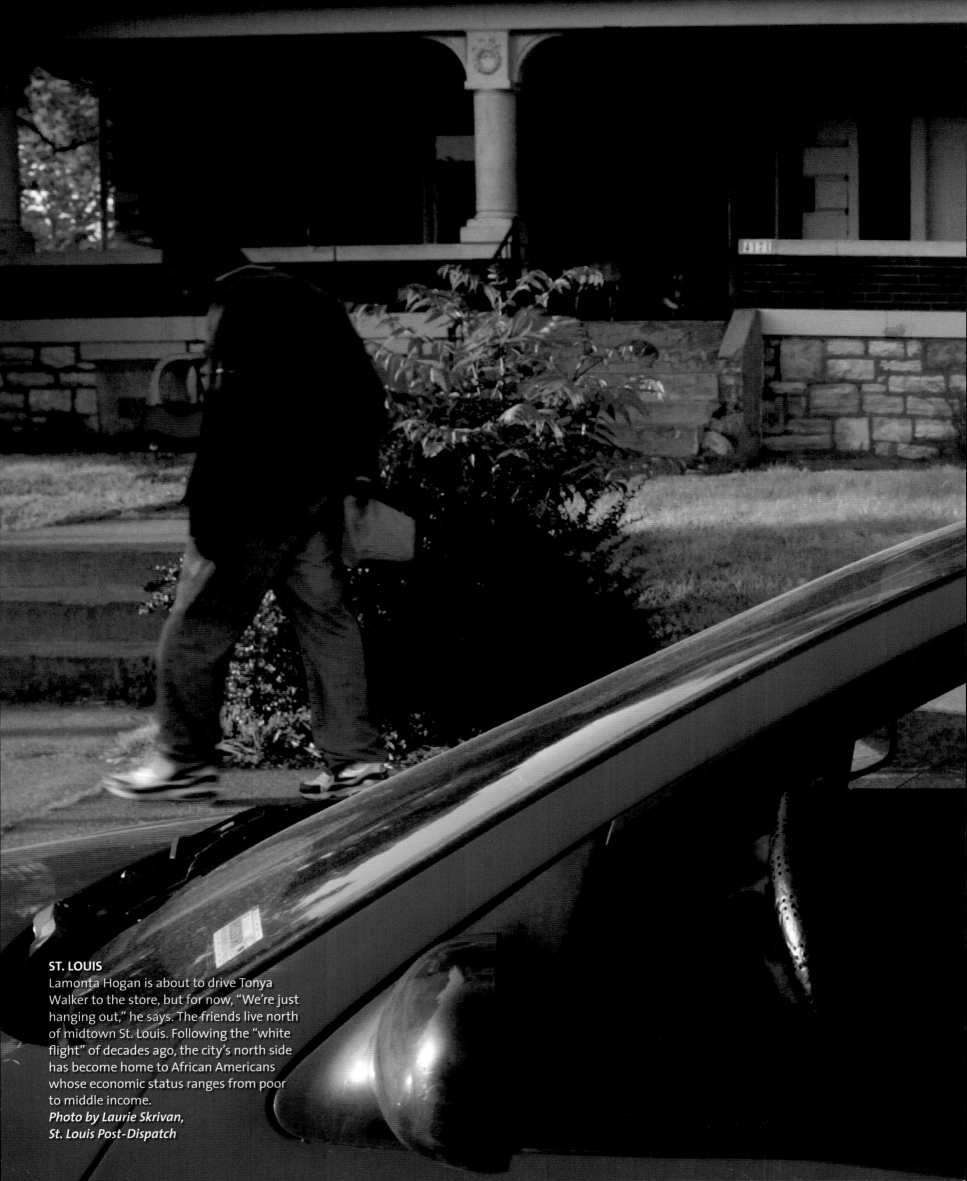

ST. LOUIS
Lamonta Hogan is about to drive Tonya
Walker to the store, but for now, "We're just
hanging out," he says. The friends live north
of midtown St. Louis. Following the "white
flight" of decades ago, the city's north side
has become home to African Americans
whose economic status ranges from poor
to middle income.
Photo by Laurie Skrivan,
St. Louis Post-Dispatch

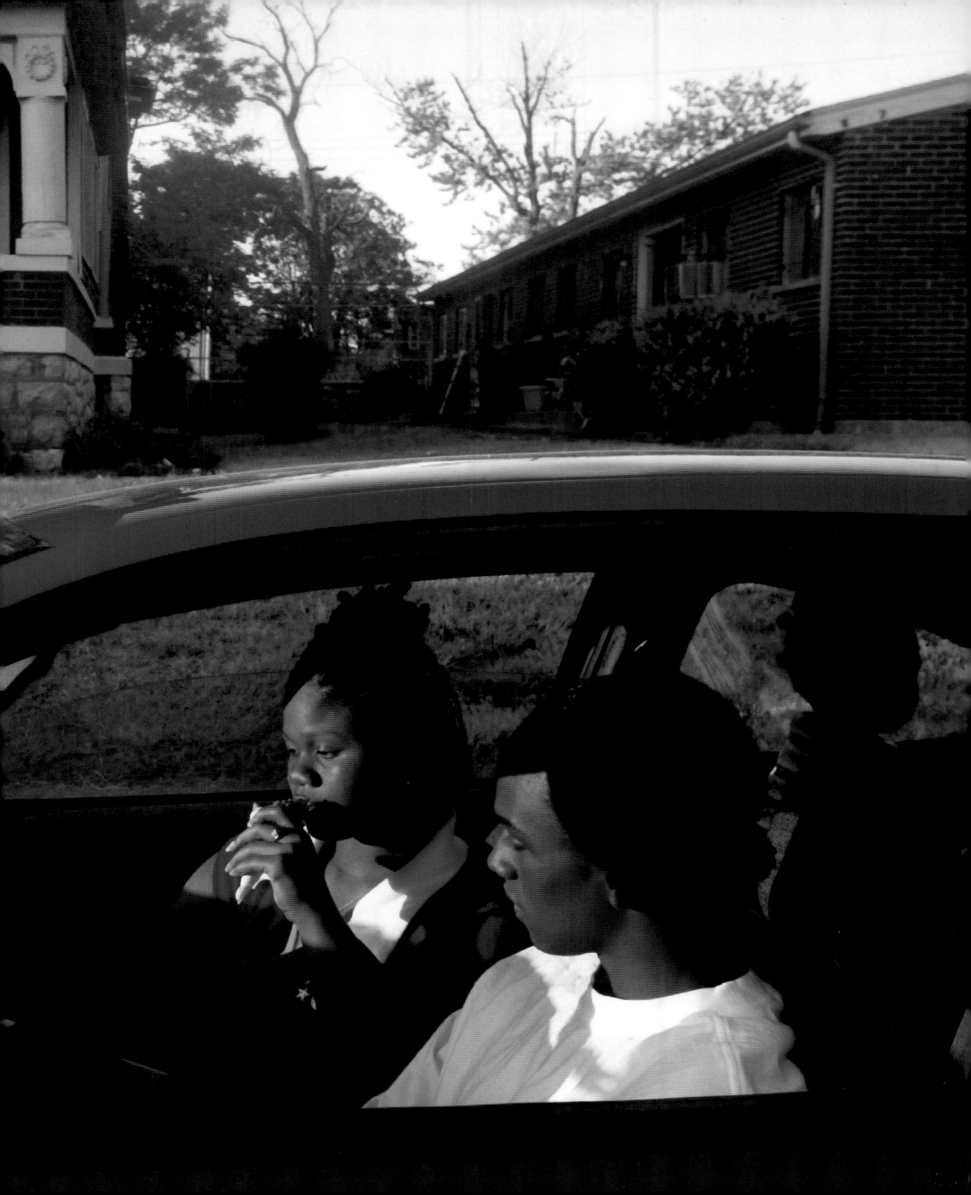

The Class of 2003: Cody Segar, Danielle Leeper, Brett Dyer, and Adam Duncan —aka the eighth-grade graduating class at Mirabile Elementary School—smile in unison for their teacher, Michelle O'Connor. With 28 students enrolled in grades K-8, Mirabile claims distinction as the smallest public school in Missouri.
Photos by Robert Cohen, St. Louis Post-Dispatch

Muffling a complaint from first-grader Sarah Flook, eighth-graders Cody Segar and Adam Duncan try to cut the Mirabile cafeteria breakfast line. The ploy doesn't work, however: Cafeteria manager Sidney Segar (right) is Cody's mom.

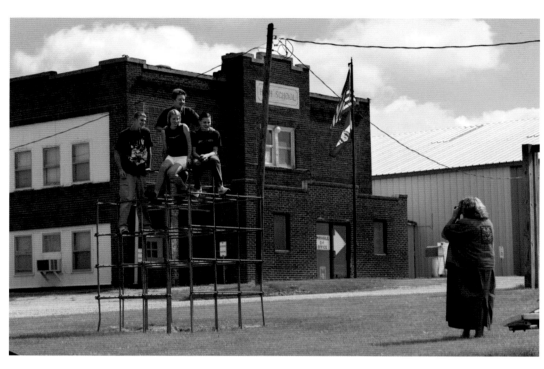

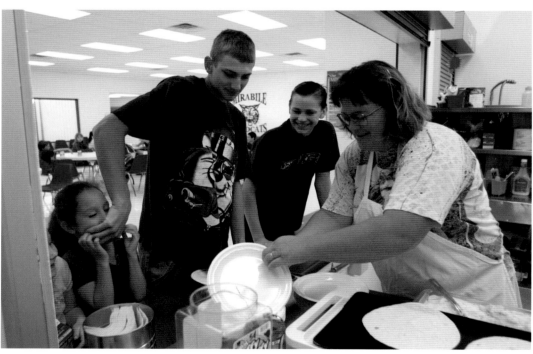

MIRABILE
The Mirabile Elementary School playground
fronts Caldwell County's Highway D.

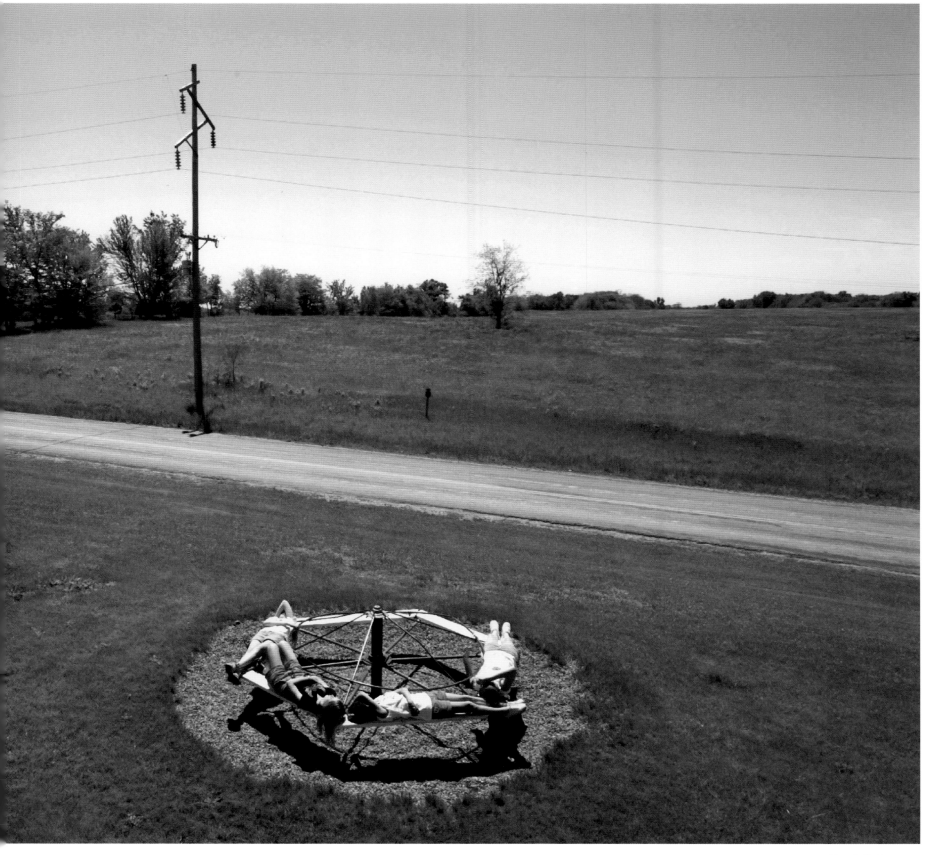

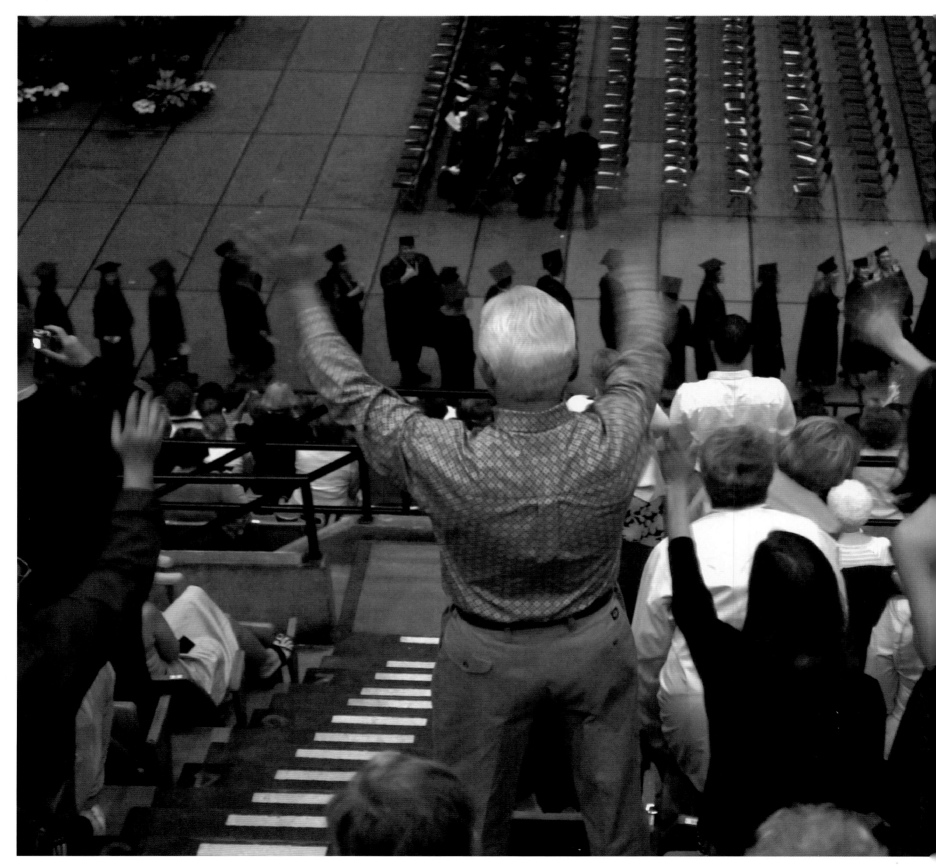

COLUMBIA
Now, get a job! Family and friends of graduating business majors at the University of Missouri whoop and holler to let the grads know where they are. The College of Business awarded undergraduate degrees to 366 students.
Photo by Seth Wenig

ST. LOUIS

Three Sisters revisited. Primping for senior prom at Clayton High School, Laura Rothbaum, 18, has a solid support team in older sisters, Rebecca, 20 (left) and Martha, 22. Both are Clayton prom vets.
Photo by Laurie Skrivan, St. Louis Post-Dispatch

BETHEL

Angela Pulse, 18, bids adieu to Knox County High School. She's headed for Indian Hills Community College in Ottumwa, Iowa, on a full scholarship.
Photo by Sherry Skinner

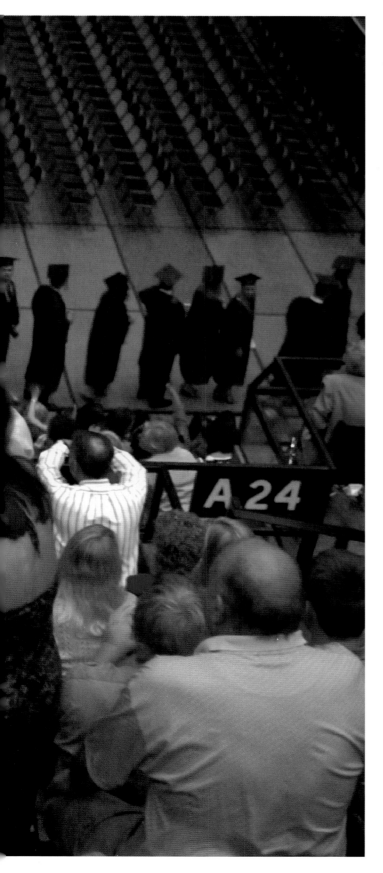

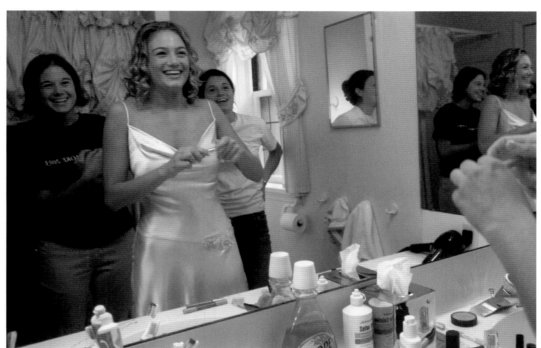

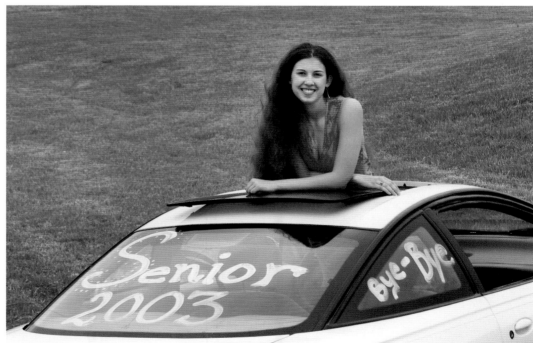

The year 2003 marked a turning point in the history of photography: It was the first year that digital cameras outsold film cameras. To celebrate this unprecedented sea change, the *America 24/7* project invited amateur photographers—along with students and professionals—to shoot and, via the Internet, submit digital images. Think of it as audience participation. Their visions of community are interspersed with the professional frames throughout this book. On the following four pages, however, we present a gallery produced exclusively by amateur photographers.

OZARK An early morning Ozark fog dims the lighting at Rapid Robert's fuel station on Highway 65.
Photo by Bud Kani

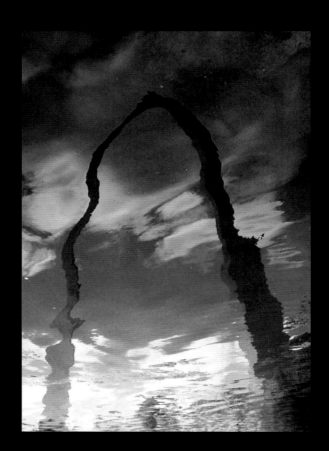

ST. LOUIS The Gateway Arch's reflection is downright Daliesque in the Arch Grounds North Pond.
Photo by Alex Duenwald

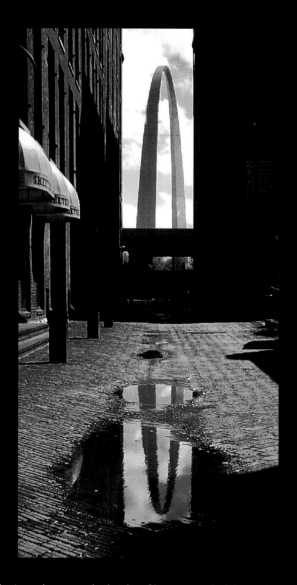

ST. LOUIS The Gateway Arch viewed among the bricks of historic Laclede's Landing in downtown St Louis.
Photo by Alex Duenwald

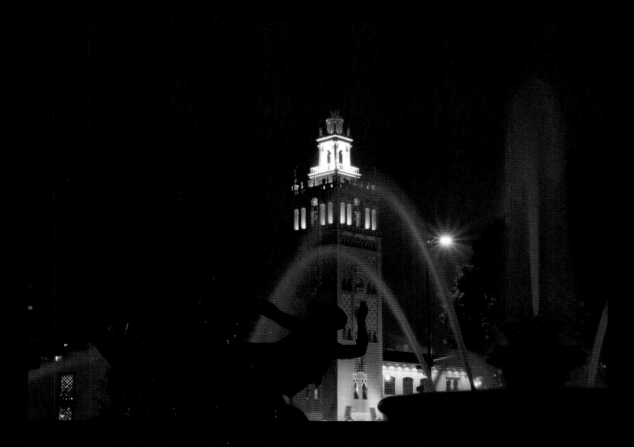

KANSAS CITY The Giralda Tower in Country Club Plaza, based on the original in Seville, Spain, lights up the night behind J.C. Nichols Memorial Fountain. *Photo by Tyson Hofsommer*

ST. LOUIS Unlike most of the animals at the Humane Society of Missouri's Bark in the Park fundraiser, these two cats weren't up for adoption. *Photo by Catherine Williamson*

BRANSON Carrie Wood and her brother-in-law Rick Wood defy gravity on Thunderation, an 80-foot-high rolle...

ST. PETERS Skyler Parsons, 5, puts Nanook, a champion American Eskimo dog, through his agility paces. Nanook has twice won first place for obedience. ***Photo by Don Parsons***

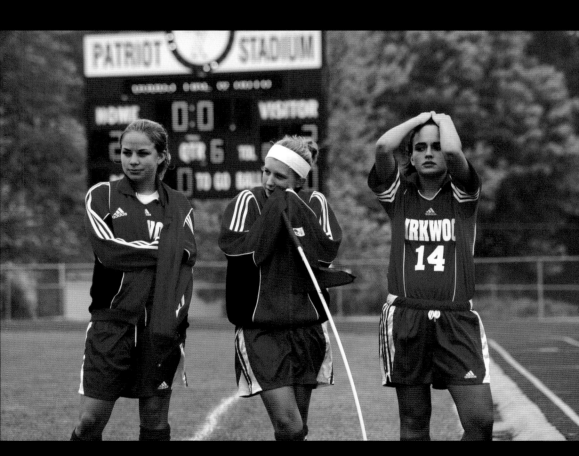

BALLWIN Kirkwood High School soccer players Robyn Dirnberger, Amanda Gaines, and Stephanie Matulek watch as their teammate misses a penalty kick, sealing the team's defeat to Parkway South in the district playoffs. ***Photo by Randall Kriewall***

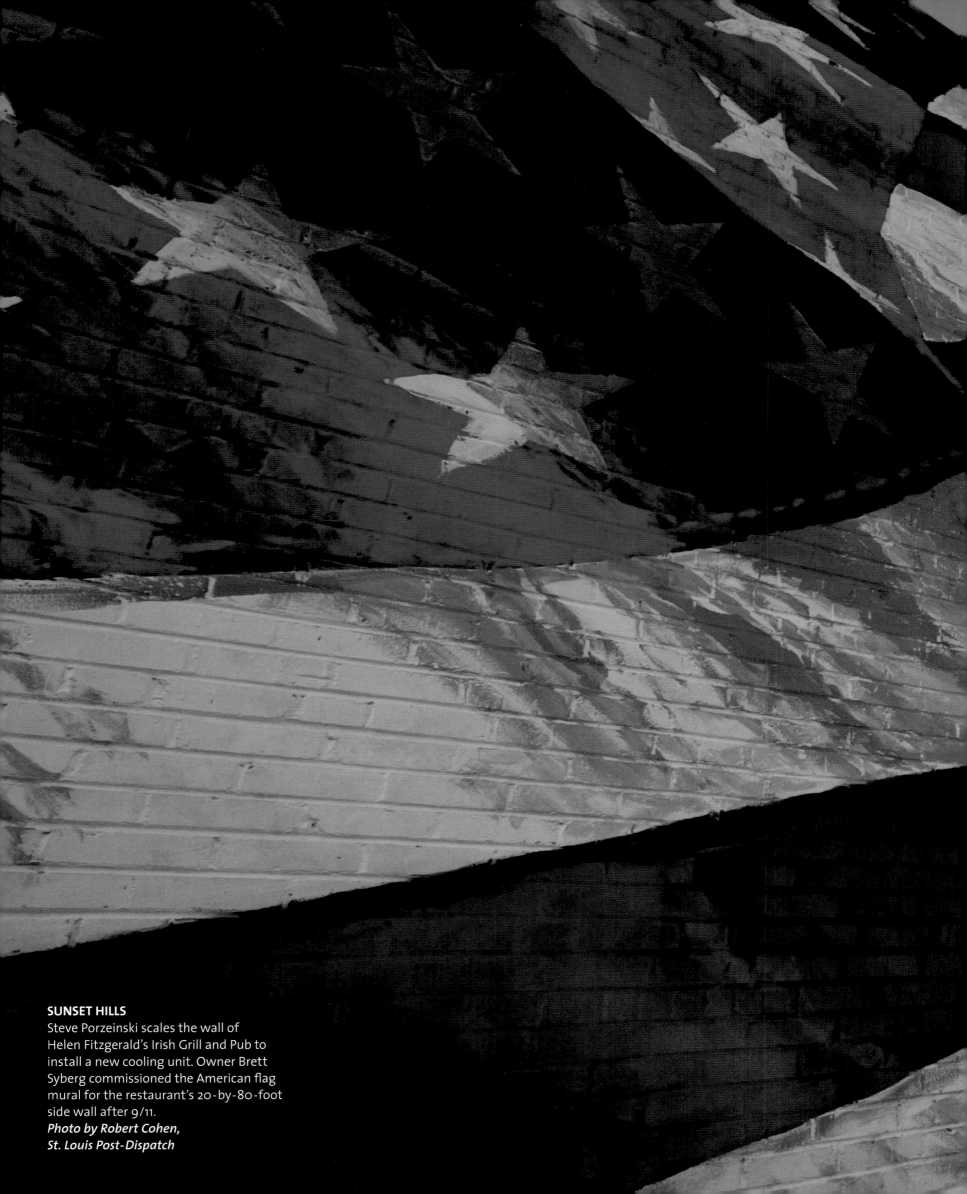

SUNSET HILLS
Steve Porzeinski scales the wall of
Helen Fitzgerald's Irish Grill and Pub to
install a new cooling unit. Owner Brett
Syberg commissioned the American flag
mural for the restaurant's 20-by-80-foot
side wall after 9/11.
Photo by Robert Cohen,
St. Louis Post-Dispatch

Hard At Work

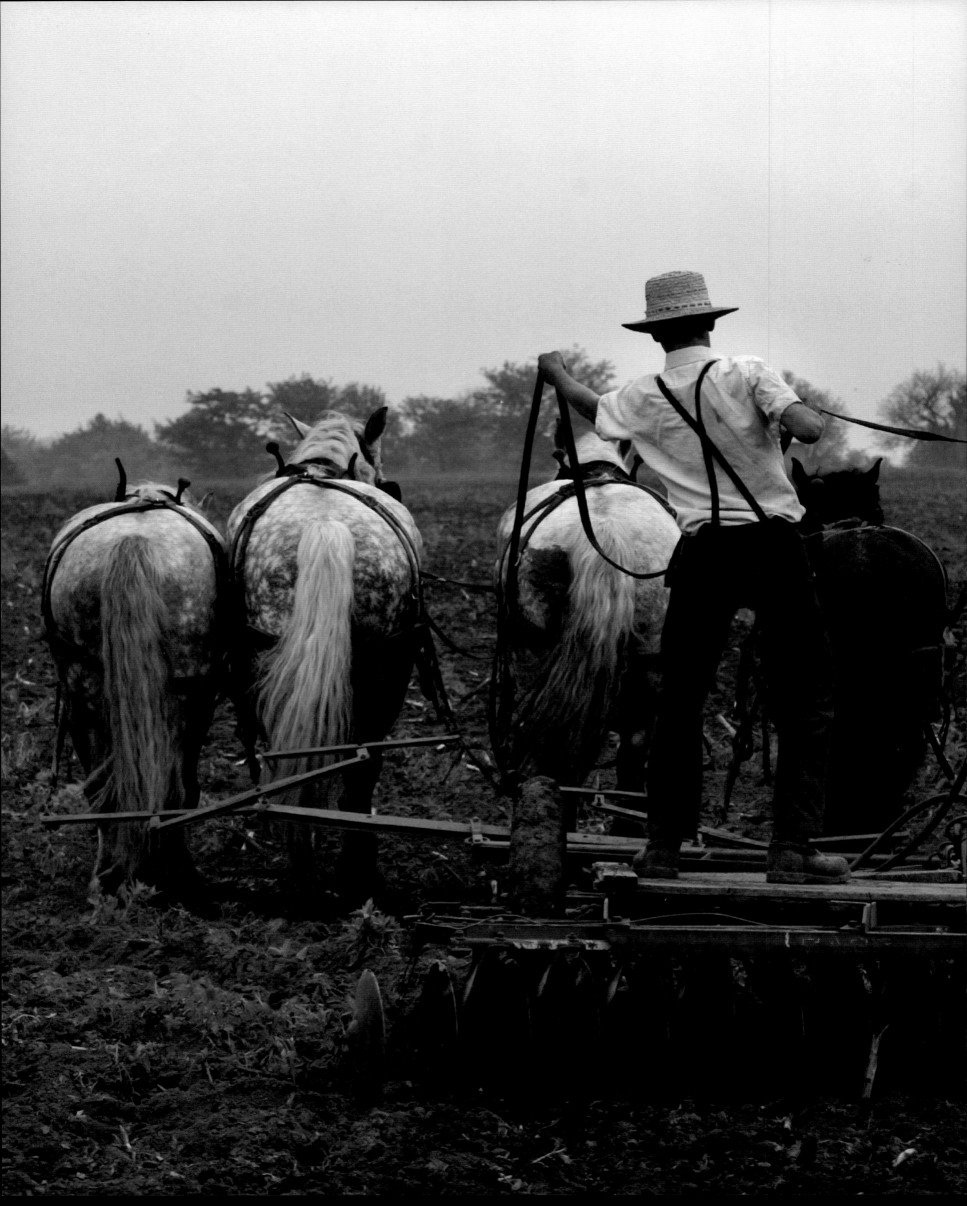

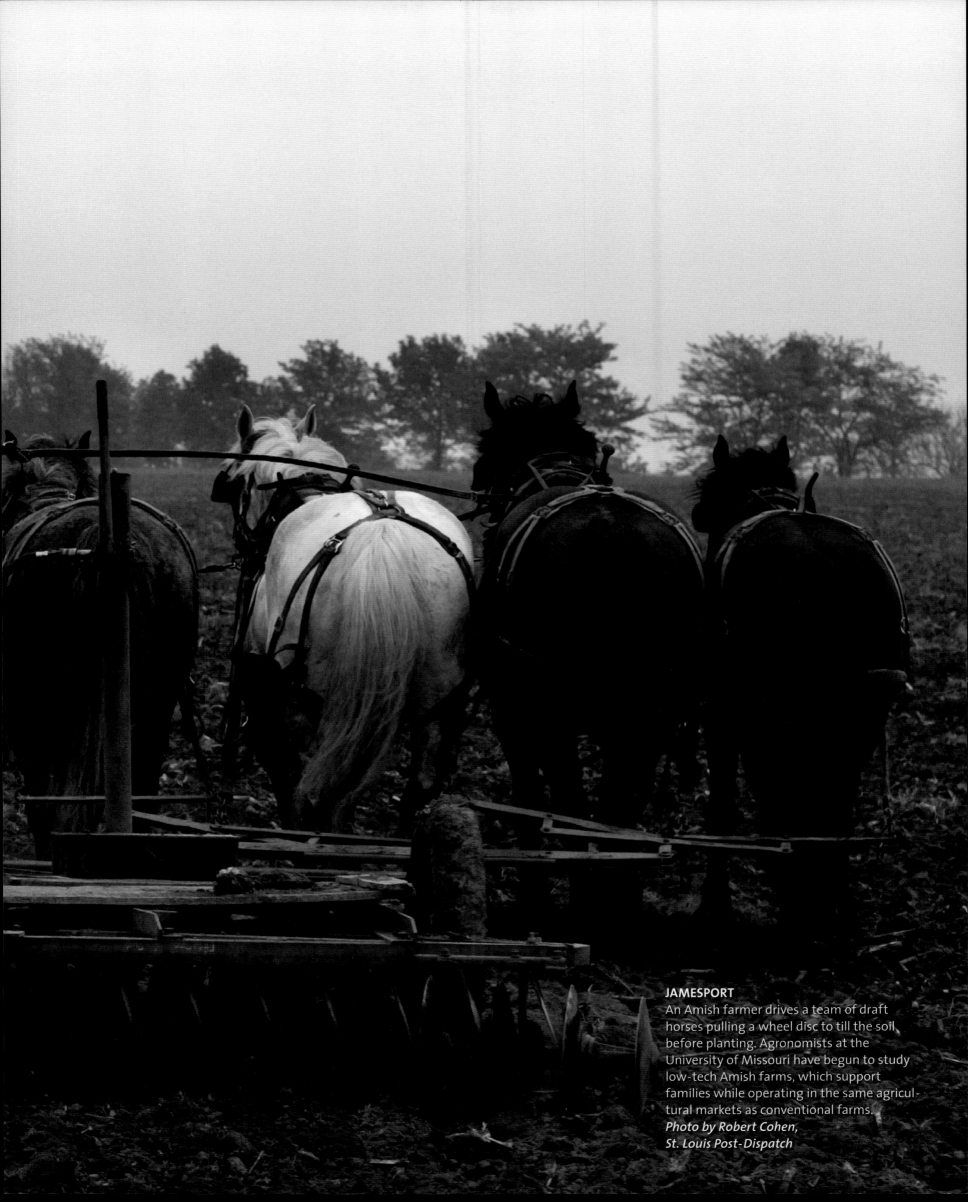

JAMESPORT
An Amish farmer drives a team of draft horses pulling a wheel disc to till the soil before planting. Agronomists at the University of Missouri have begun to study low-tech Amish farms, which support families while operating in the same agricultural markets as conventional farms.
Photo by Robert Cohen,
St. Louis Post-Dispatch

ST. LOUIS
Covered in the ash and grit of a house fire on Geraldine Avenue, firefighter Darren Brooks surveys the damage. A member of Hook and Ladder Truck 15, Brooks gains entry into burning buildings, ventilates them, and performs victim search and rescue.
Photos by Teak Phillips

ST. LOUIS
Battalion Chief Dennis Jenkerson leads his crew as they battle a blaze on Geraldine Avenue near Penrose Park. Flames first appeared in the kitchen of this two-story home. By the time the firefighters contained the fire later that night, the house was still standing—and salvageable.

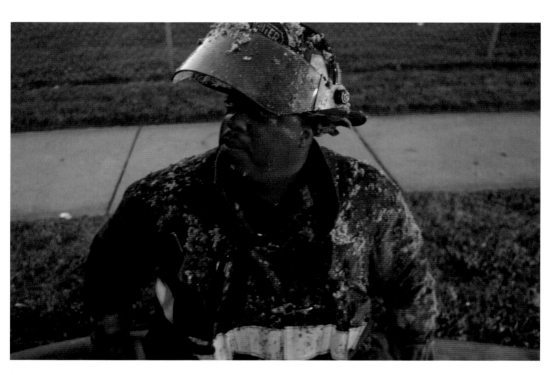

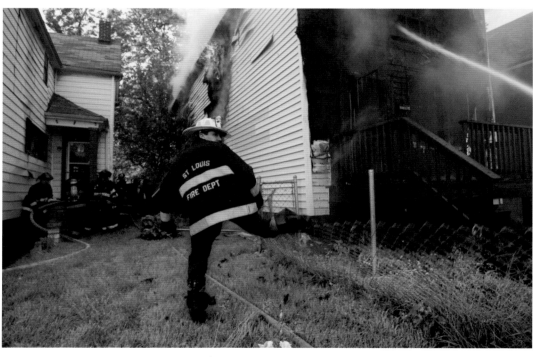

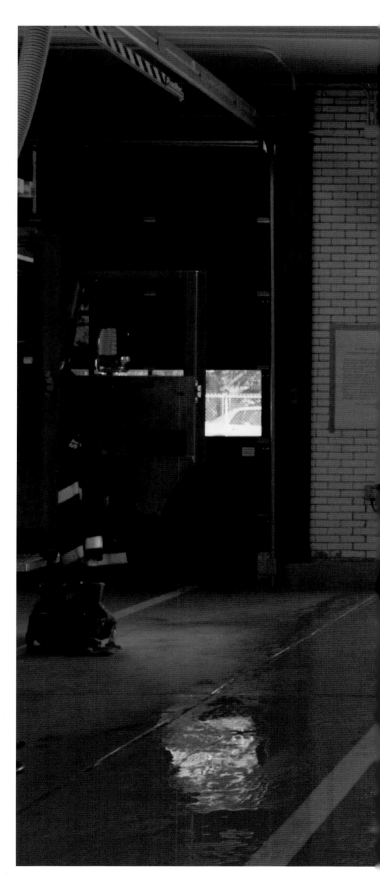

ST. LOUIS

Acting fire captain Billy Ellner hoses down the bay
at Engine House 28 in St. Louis's Central West
End. On the captain's days off, Ellner is in charge.
The fire station employs 38 firefighters, nine of
whom are always on duty. New firefighters in
St. Louis make about $40,000 per year.

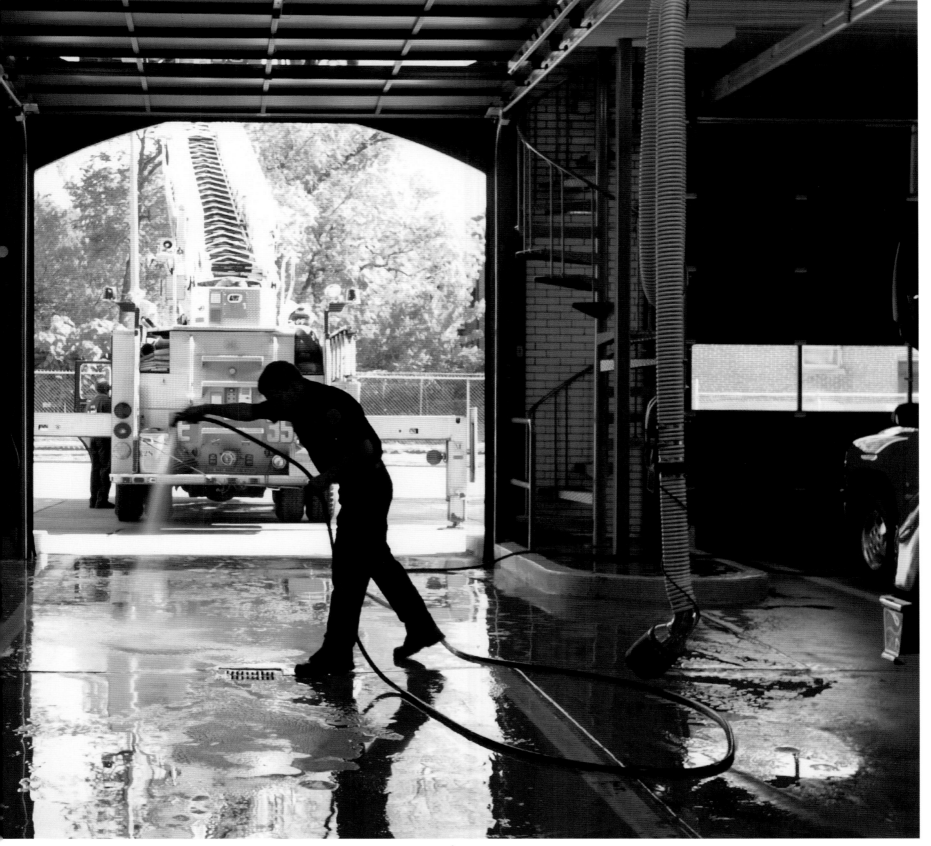

Cotton grower Scott Carter inspects a boll weevil
trap on his family farm. The simple device is
laced with the weevil's own pheromone, which
proves irresistible to both male and female bugs.
Traps like these are helping to eradicate the
cotton-devouring insects from the state's
390,000 acres of crops.
Photo by Lisa Waddell Buser

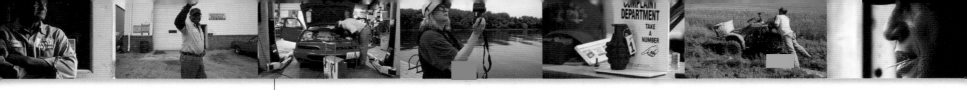

COLUMBIA

Homer Collins opened his auto repair shop 31 years ago. He likes the work and especially the one-on-one communication with customers. At 72, Collins has no plans to retire. "Retirement slows down the m nd and body," he says.

Photo by Chris Stanfield

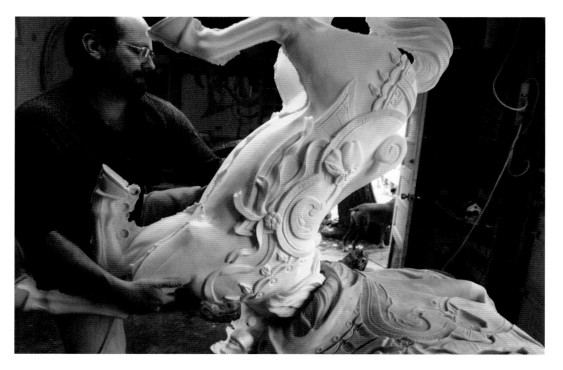

ST. JOSEPH
Craftsman Bruce White invented a process that allows him to make up to 150 polyurethane horses from the same rubber mold. The process begins when White carves a figure from basswood. It ends when the horses trot off to Applebee's restaurants to serve as décor.
Photo by Jessica A. Stewart

WESTON

"To be a good uilleann pipe maker, you have to be a machinist, metalworker, carpenter, and reed maker all rolled into one," says Kirk Lynch, who's been crafting the traditional Irish instruments in his Weston workshop for 10 years. The pipes have a two-octave range and are played by pumping a set of elbow (*uilleann* in Gaelic) bellows.
Photo by Earl Richardson

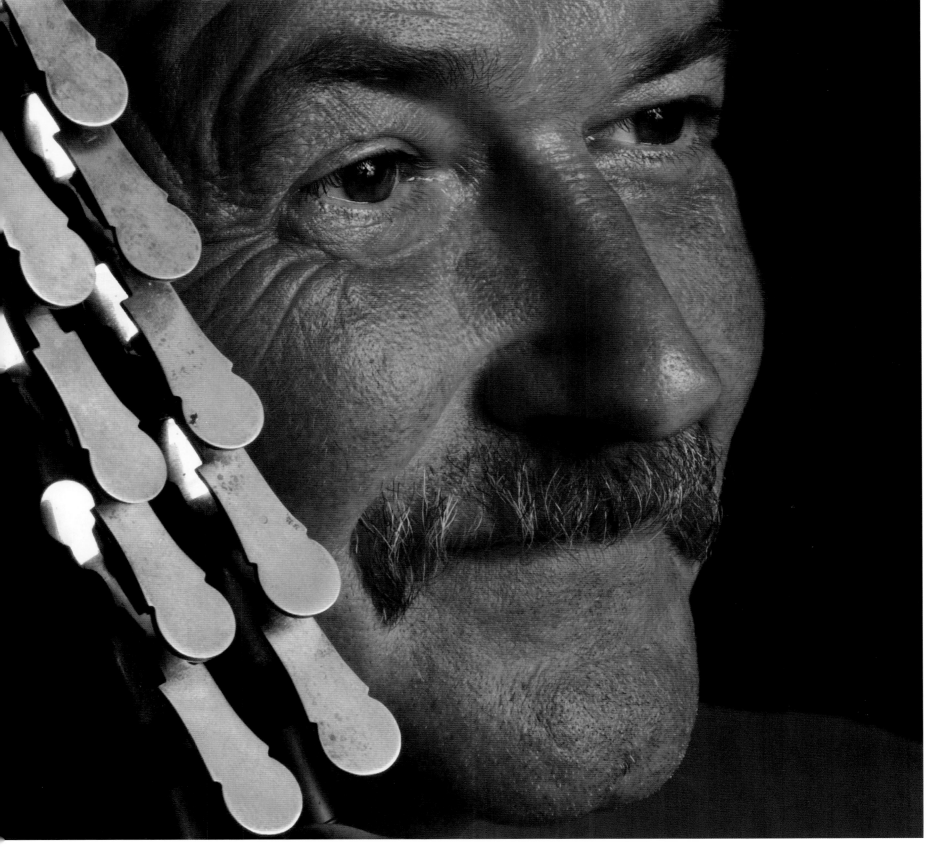

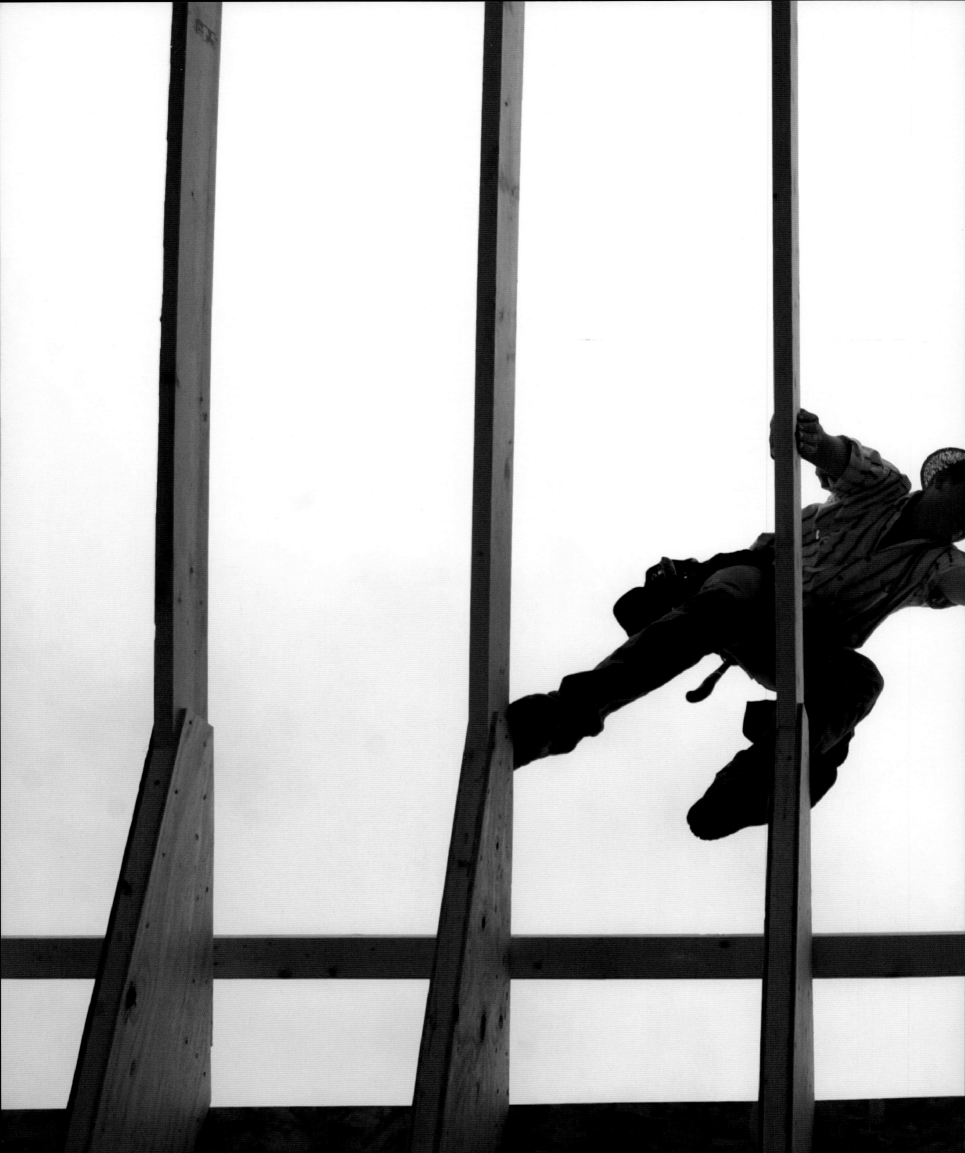

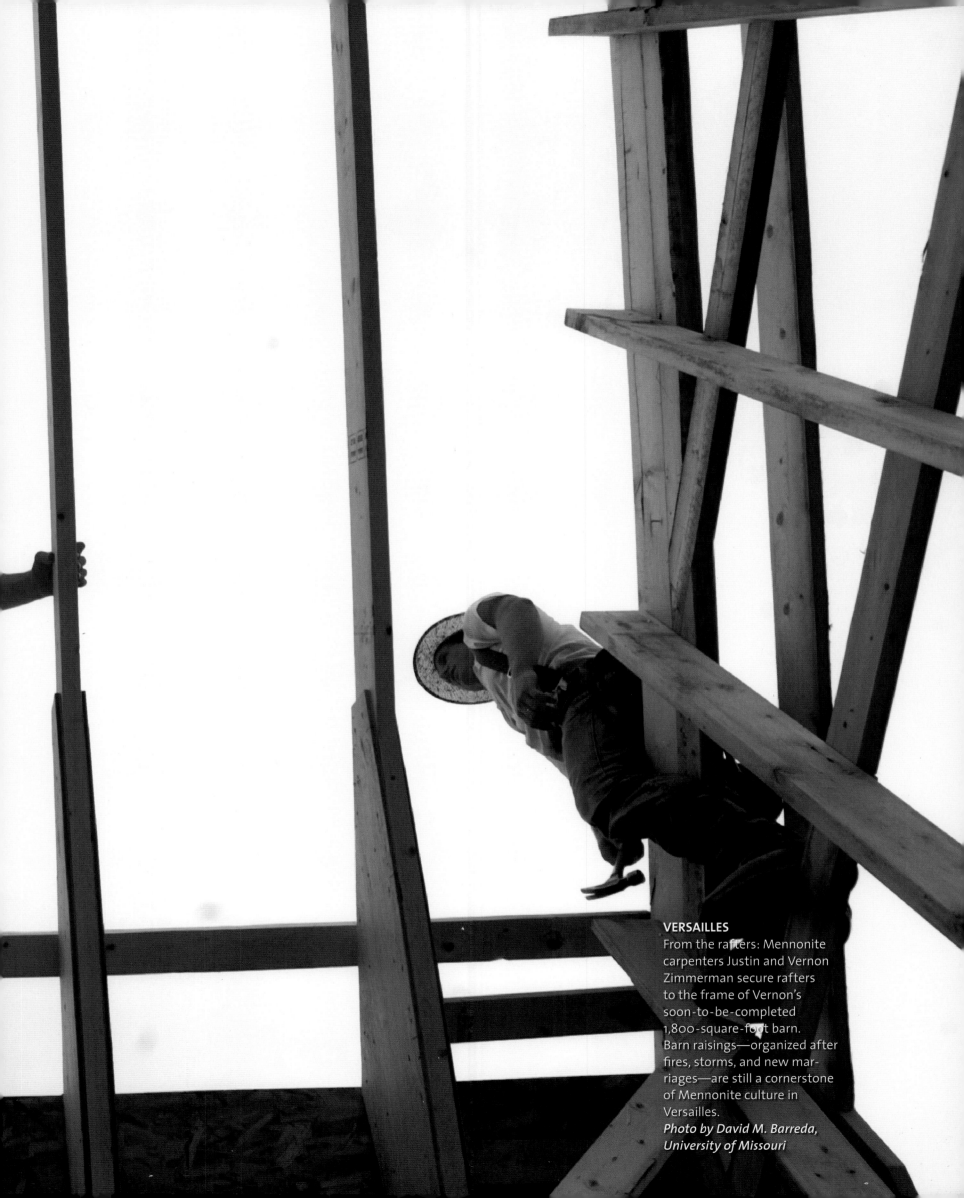

VERSAILLES
From the rafters: Mennonite carpenters Justin and Vernon Zimmerman secure rafters to the frame of Vernon's soon-to-be-completed 1,800-square-foot barn. Barn raisings—organized after fires, storms, and new marriages—are still a cornerstone of Mennonite culture in Versailles.
Photo by David M. Barreda, University of Missouri

ST. LOUIS
At J.B. Marine Service's dry dock, Bob King patches a barge hull. The 61-year-old has been repairing Mississippi River boats and barges since 1967, but King has no plans to retire any time soon. He counts on the company health insurance program's prescription drug benefit.
Photo by Justin Kase Conder

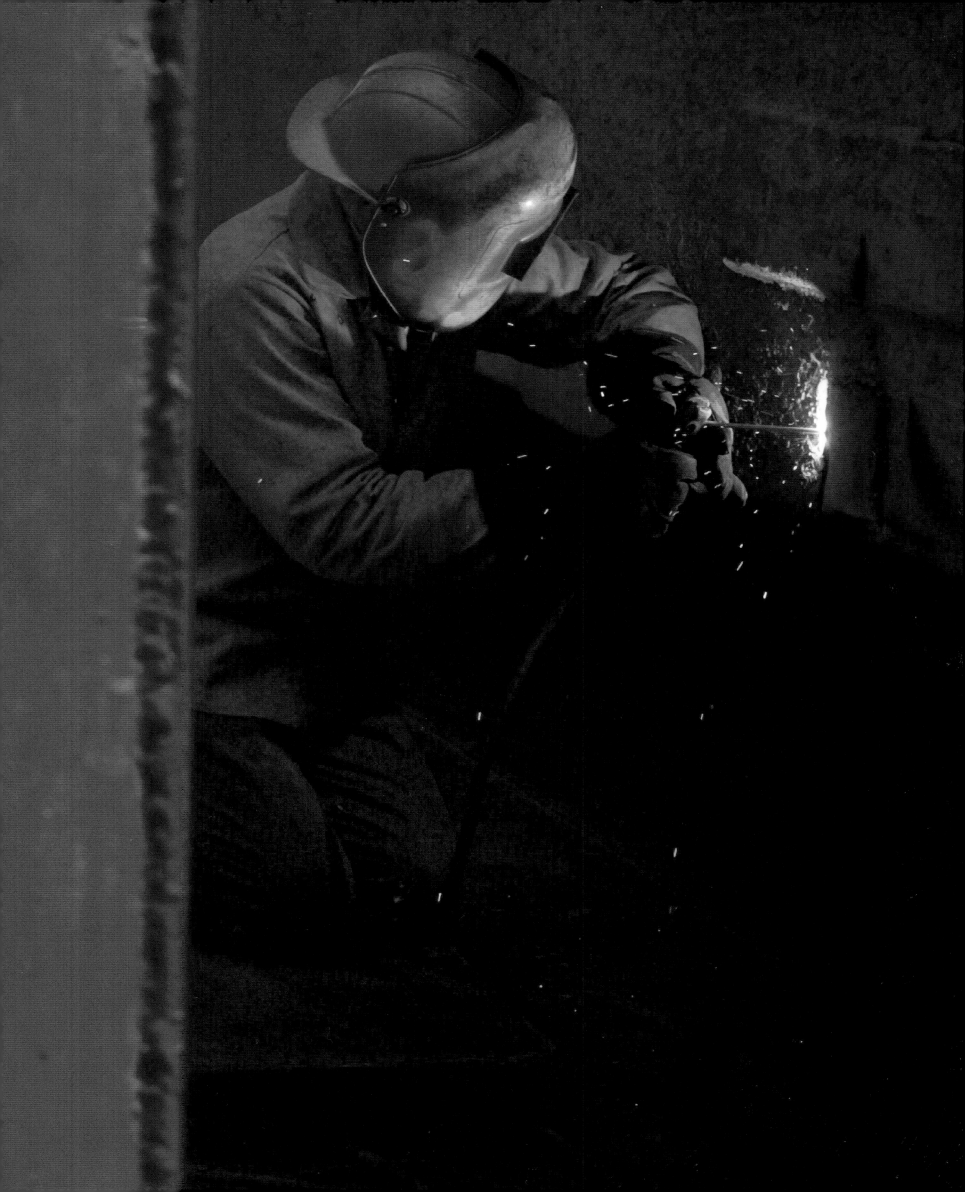

KANSAS CITY
Gary Hardin and Robert Davis manhandle a
cauldron of molten iron away from the furnace
at Clay & Bailey Manufacturing Co. The foundry,
which opened in 1913, started out forging
plumbing and other hardware. Now, products
range from oil field hatches to valves and
manhole covers.
Photo by Rich Sugg

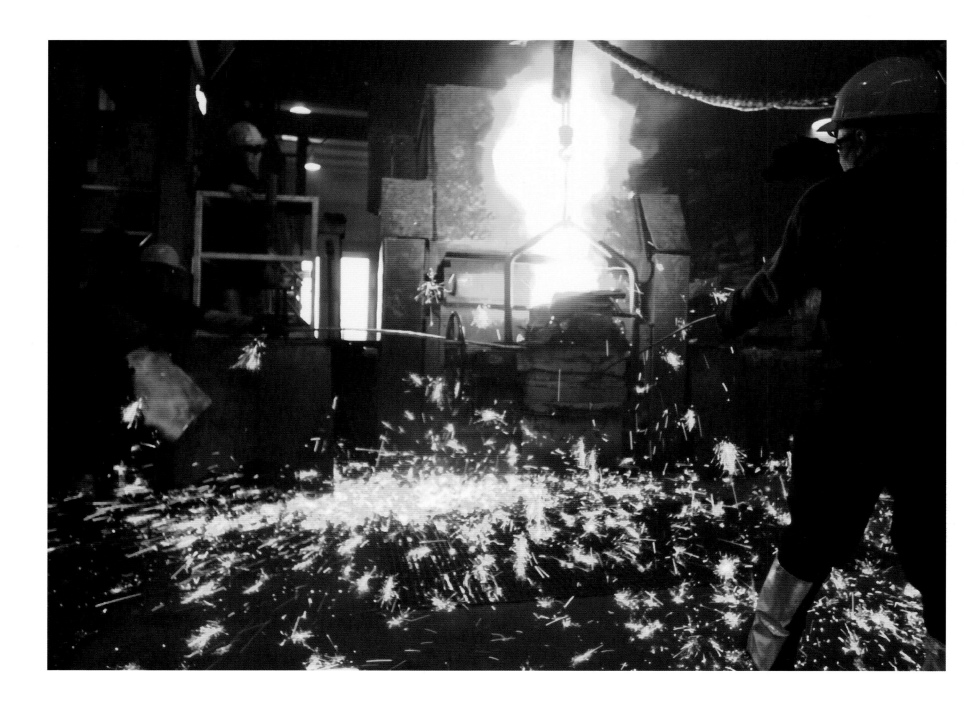

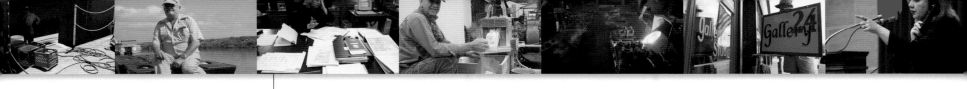

JEFFERSON CITY

It's the next-to-last day of the legislative session and Catherine Hanaway, Missouri's first woman Speaker of the House, faces a deskload of bills to be voted on. Hanaway, a Republican, is well known for going head-to-head with Democratic governor Bob Holden. She is not as well known for a private passion: smoking cigars.

Photo by L.G. Patterson

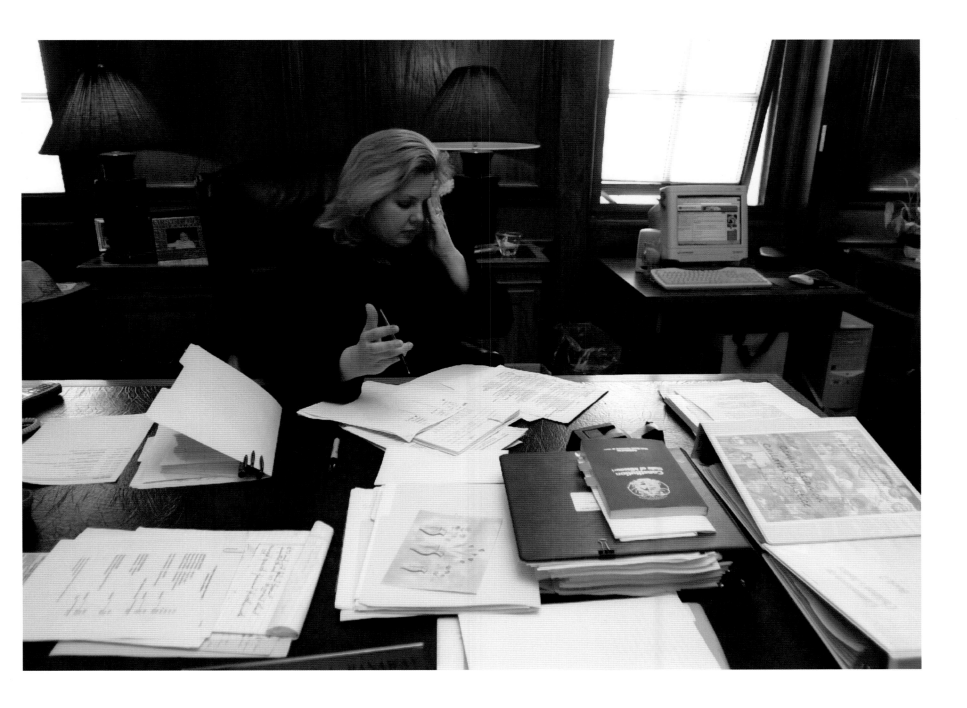

MIRABILE
Cristal Rood styles Danielle Leeper's hair for her eighth-grade graduation. In the beauty business for 15 years, Rood set up a salon in her home 10 years ago when her kids were young. It's a full-service salon of one, and in addition to hairstyling, she offers manicures, waxes, and tanning.
Photo by Robert Cohen,
St. Louis Post-Dispatch

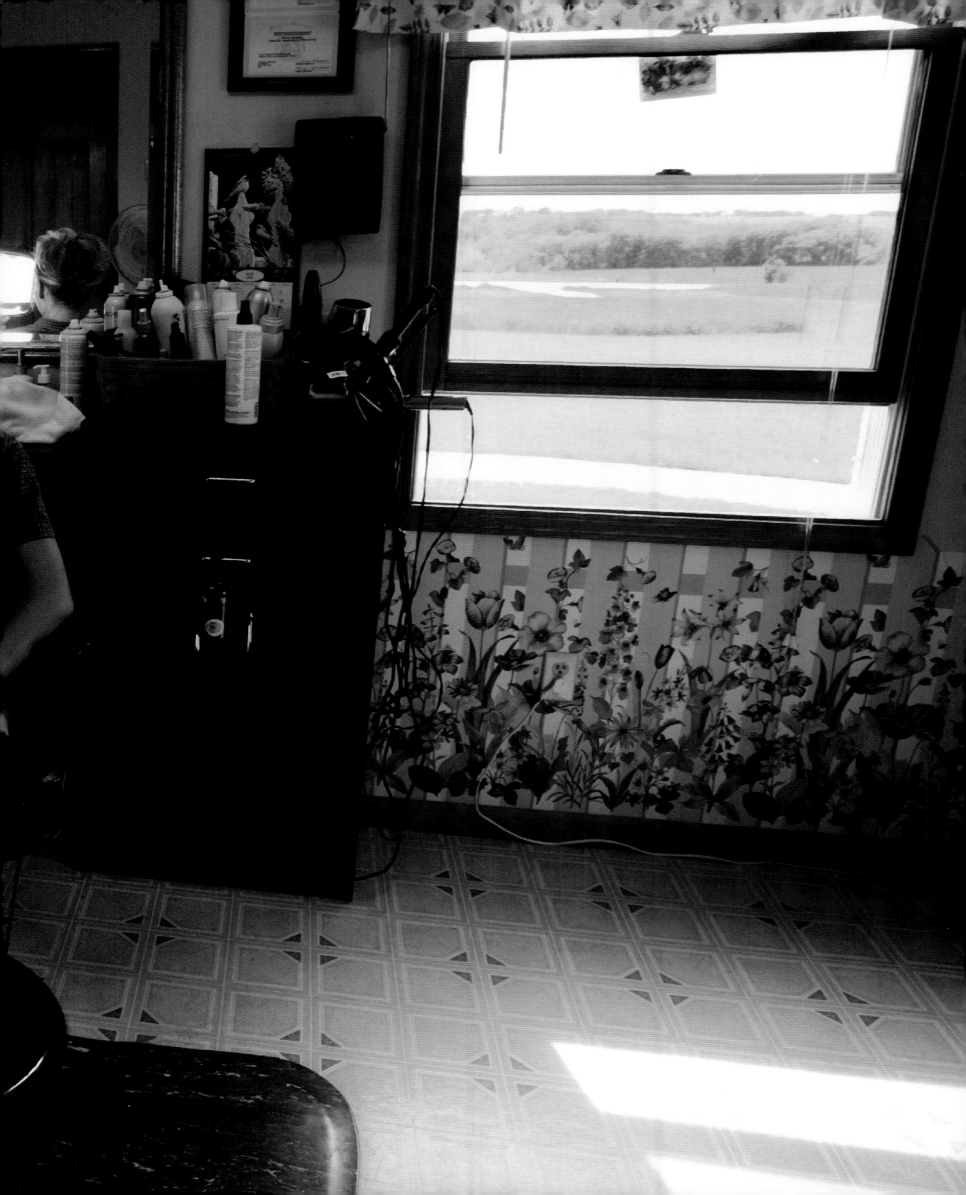

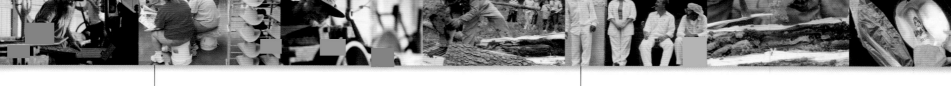

ST. JOSEPH

Peggy Patrylak, Brandie Jo Frazee, and Cheri Shepard take five at the Stetson hat factory. While panning for gold in the Old West, John B. Stetson designed his first hat with a waterproof interior so it could double as a water bucket. Ten gallons is an exaggeration, though, half a gallon is more like it.

Photo by Ival Lawhon, Jr.

ST. LOUIS

Keith Murphy, Susie Poitras, Kevin Hancock, and George Riester operate the machines that turn 1,800-pound bags of confectioners' sugar and calcium into TUMS antacid tablets. TUMS runs one of the nine remaining manufacturing plants in downtown St. Louis.

Photo by Laurie Skrivan, St. Louis Post-Dispatch

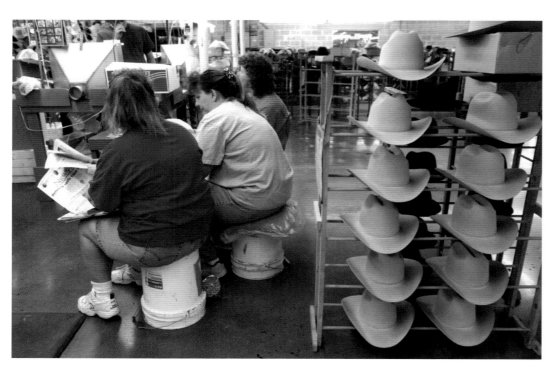

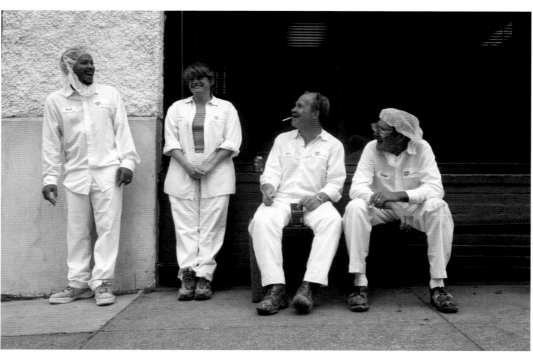

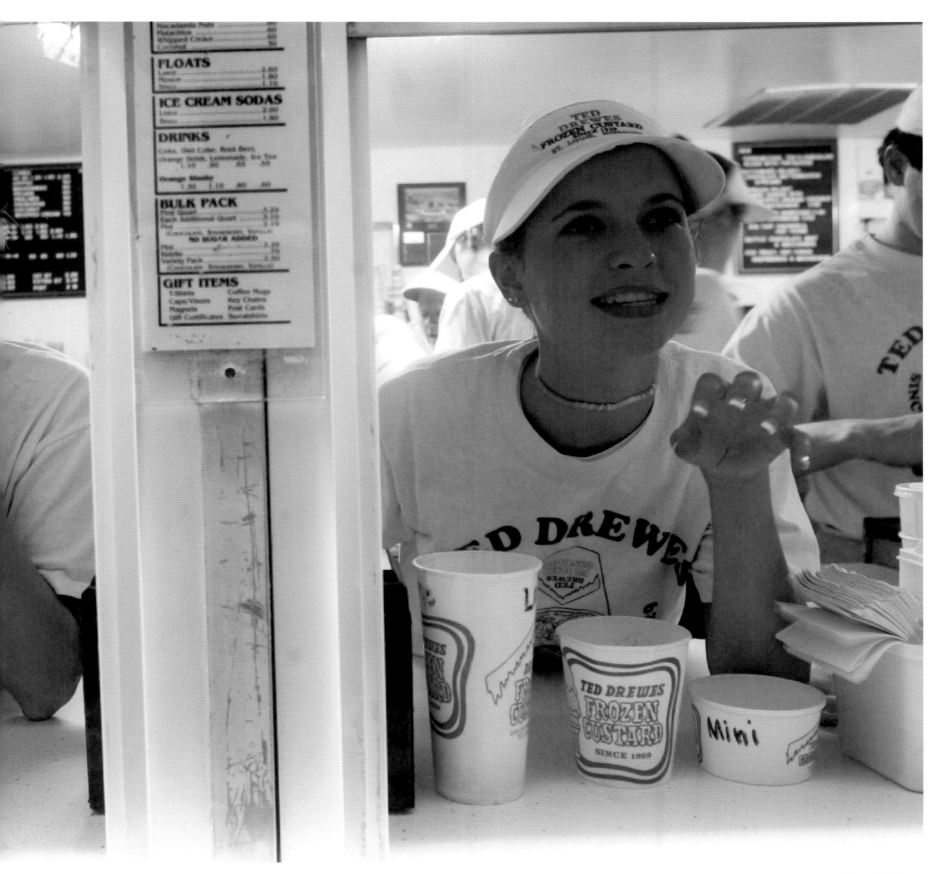

ST. LOUIS

For more than half a century, people in St. Louis have known where to go after supper. They head to Drewes Frozen Custard and get in line. "There's a lot of pressure on the window girls," says Michelle Carbone, right. She and co-worker Melissa Bannister dish out hundreds of gallons of custard a day.

Photo by Laurie Skrivan, St. Louis Post-Dispatch

SAVANNAH

Houdini, a Belgian draft horse, grazes
on the grass at M'Shoogy's Emergency
Animal Rescue. The 20-acre, no-kill shelter is
home to approximately 700 animals—dogs, cats,
turtles, snakes, hawks, wolves, deer, and even a
cougar. For 19 years, Lisa and Gary Silverglat
have operated the rescue as a charity.
Photos by Eric Keith

SAVANNAH

SAVANNAH

Houdini, a Belgian draft horse, grazes
on the grass at M'Shoogy's Emergency
Animal Rescue. The 20-acre, no-kill shelter is
home to approximately 700 animals—dogs, cats,
turtles, snakes, hawks, wolves, deer, and even a
cougar. For 19 years, Lisa and Gary Silverglat
have operated the rescue as a charity.
Photos by Eric Keith

Puppy love: Kennel attendant Betty Wampler
cleans the pens at M'Shoogy's. Owner Gary
Silverglat bankrolled the rescue service with
$6 million of his own money, acquired through
investments in the meatpacking industry. But his
savings are drying up and the shelter may soon
close. "Suddenly, we need someone to rescue us,"
says Silverglat.

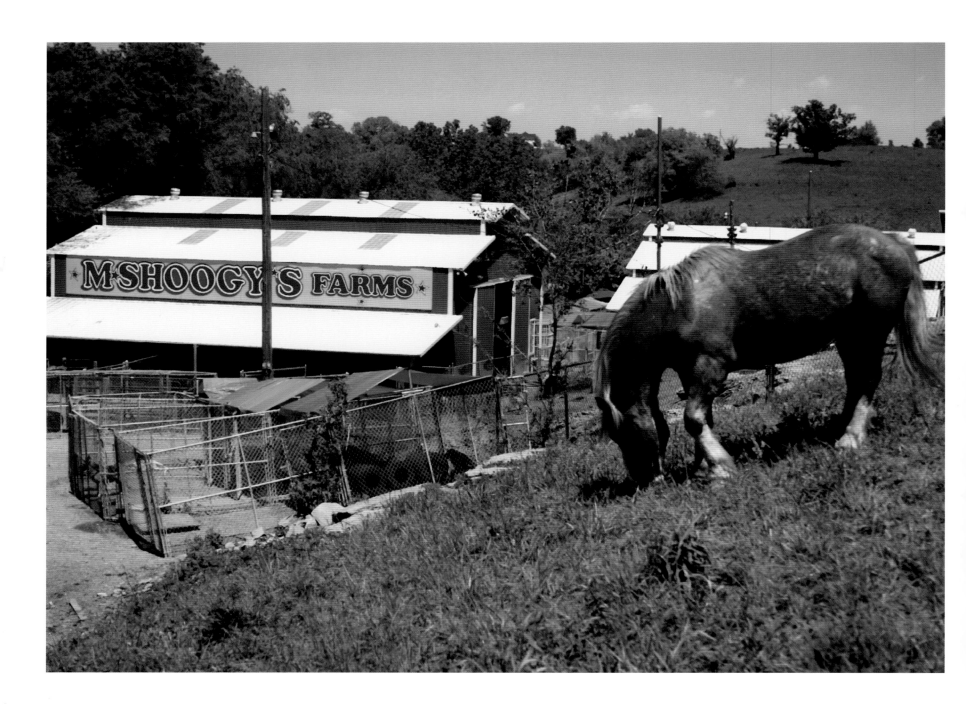

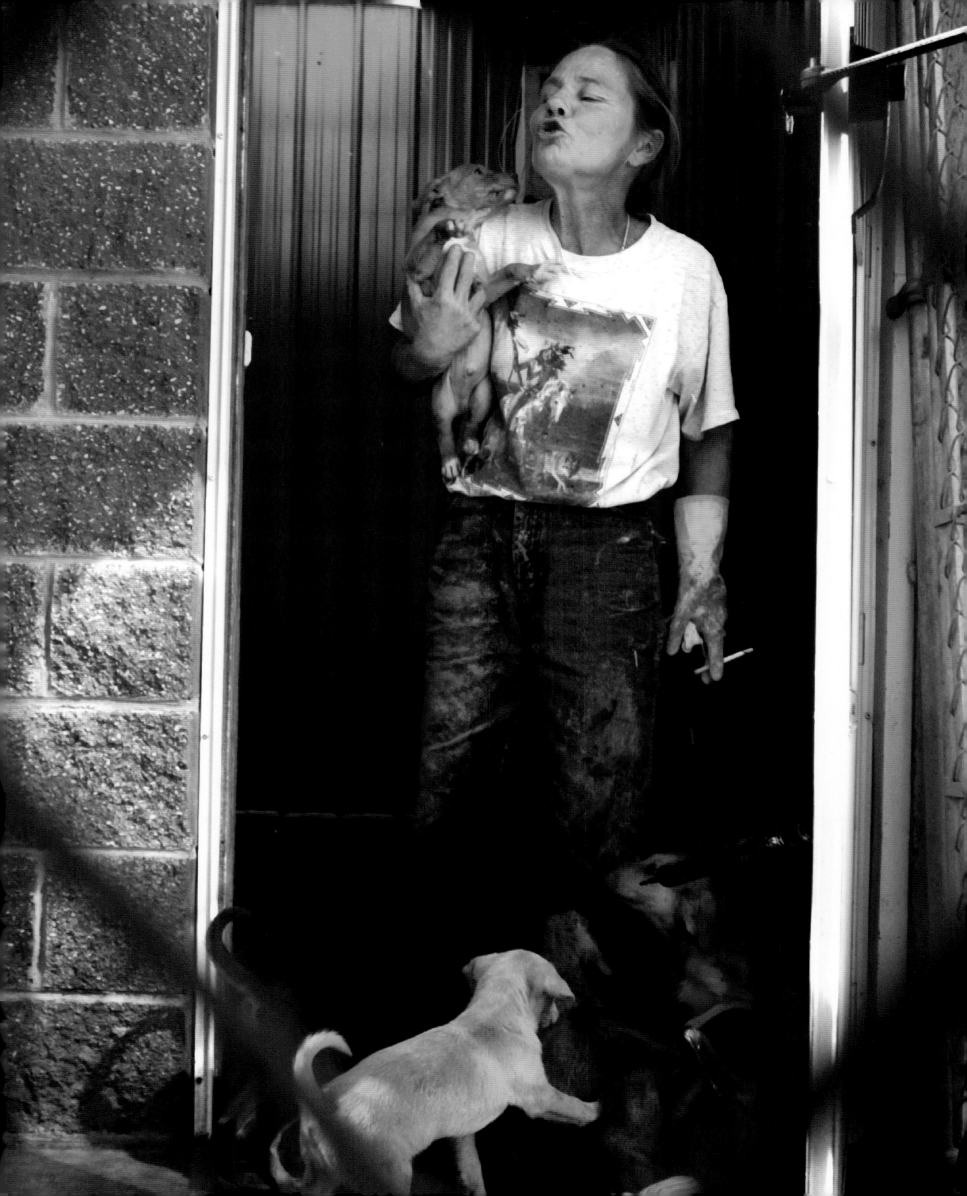

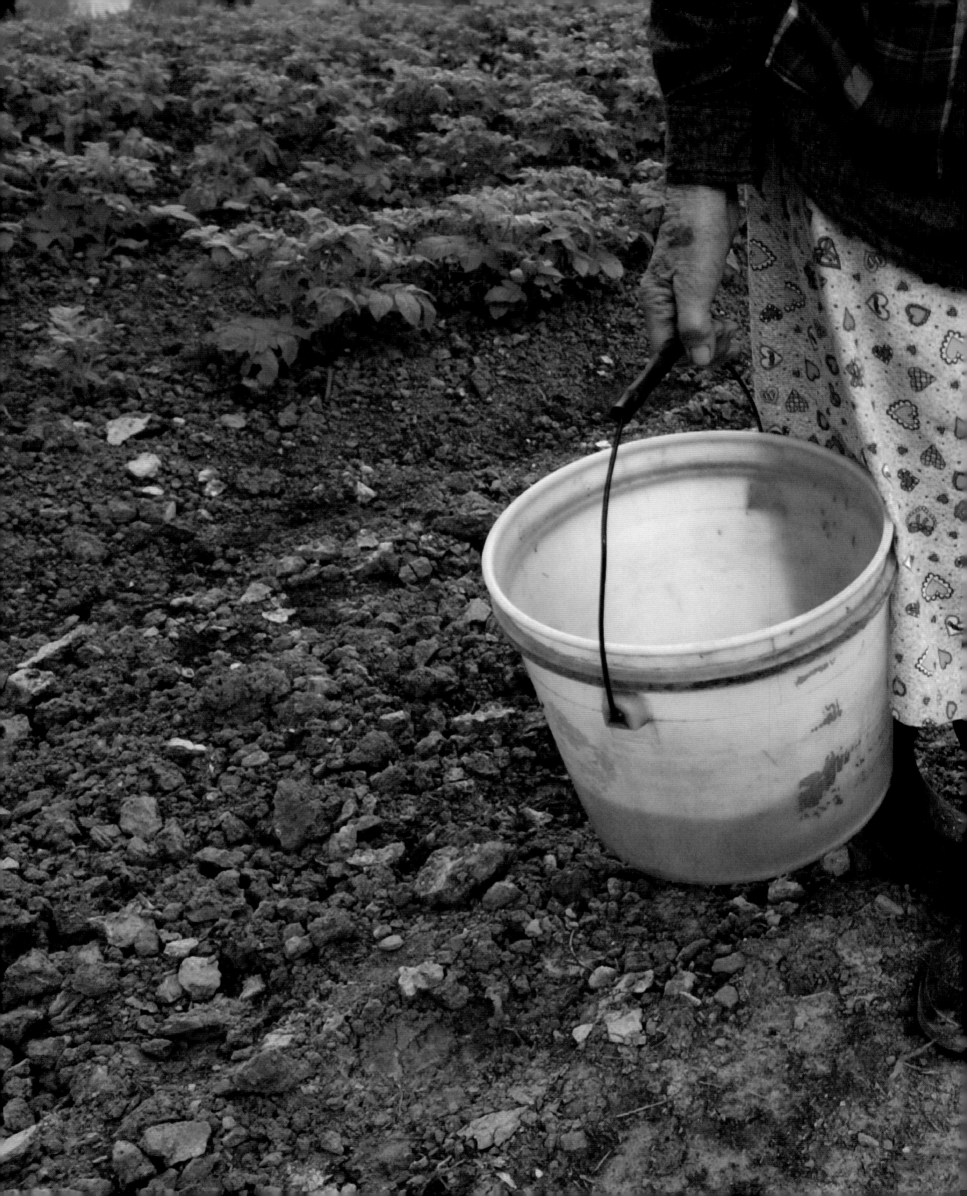

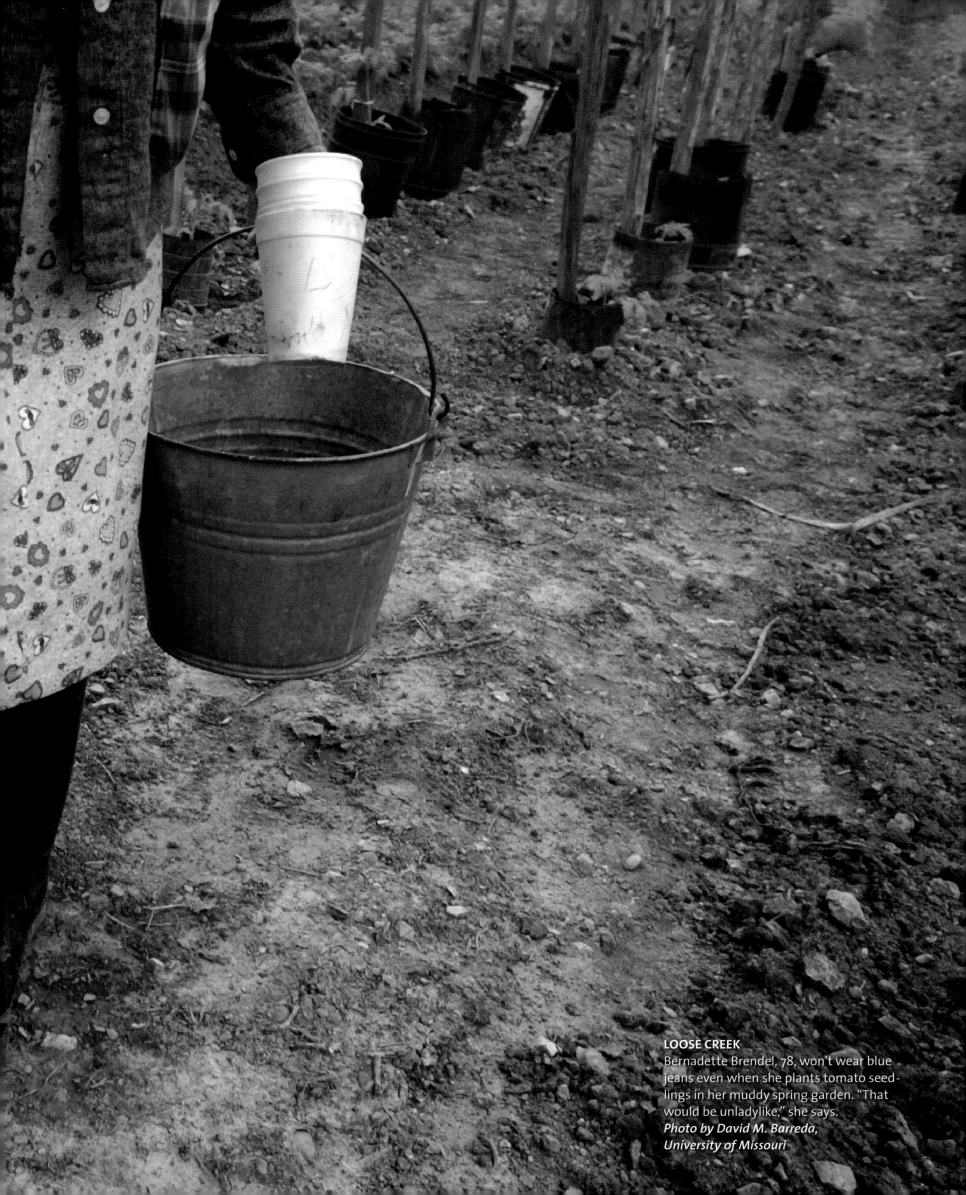

LOOSE CREEK
Bernadette Brendel, 78, won't wear blue jeans even when she plants tomato seedlings in her muddy spring garden. "That would be unladylike," she says.
Photo by David M. Barreda,
University of Missouri

SPRINGFIELD

"If the truth is known," Isaac Jenkins says, "I am the only master shoemaker and orthopedic shoe repairer in Springfield who knows what he's doing." Jenkins, 76, has owned Ike's Shoe Shop for more than 20 years. He's also an active Baptist preacher and Mason, and he gives away much labor and many shoes. He calls himself "poor, but independent."
Photo by Dean Curtis

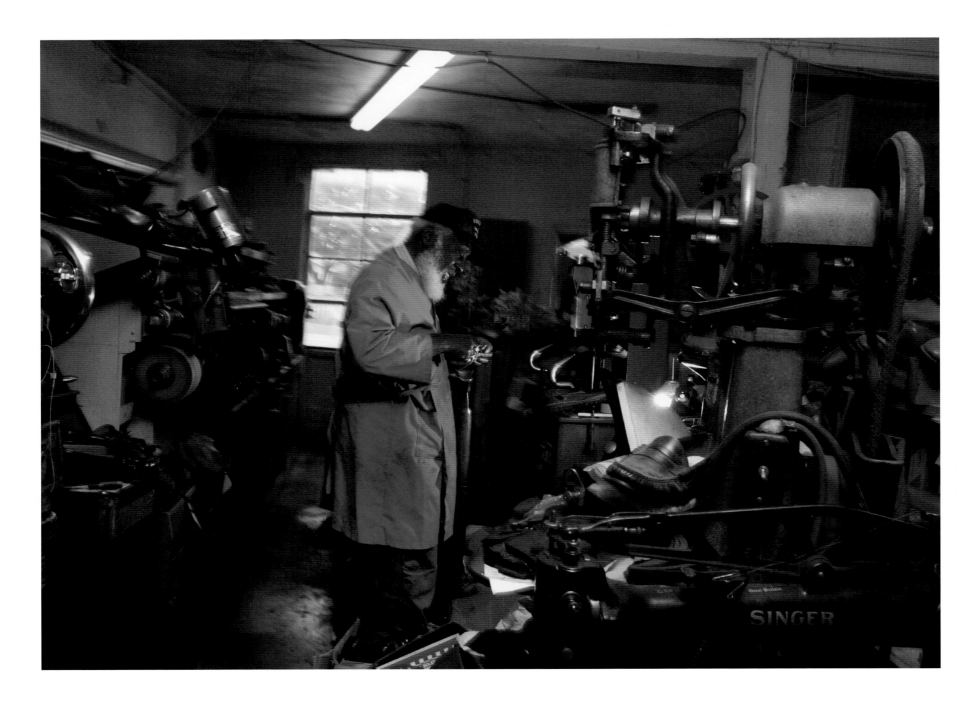

COOPER'S LANDING

Mid-state Pad Thai: After leaving her native Thailand, Pramuan "Chim" Duncan settled in Cooper's Landing on the Missouri River. For the past three summers, she's turned out authentic Thai food from a converted trailer. With the help of sous chef Bruce Lynch, Chim's Thai Kitchen is a hit.

Photo by Daniel Carapellotti

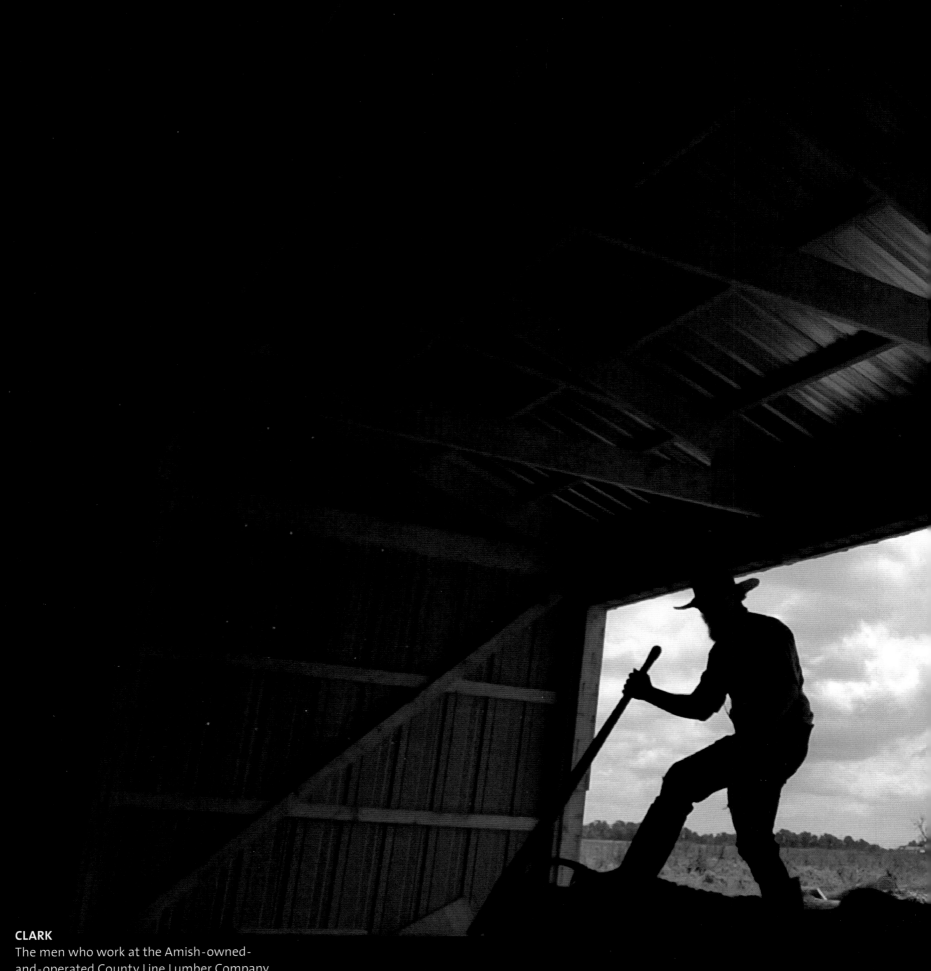

CLARK
The men who work at the Amish-owned-and-operated County Line Lumber Company put in eight hours a day, six days a week. With the time left, they tend their farms and milk their cows. The Amish settled in the area around this north-central Missouri village 45 years ago, and now number 165 families.
Photo by Chris Stanfield

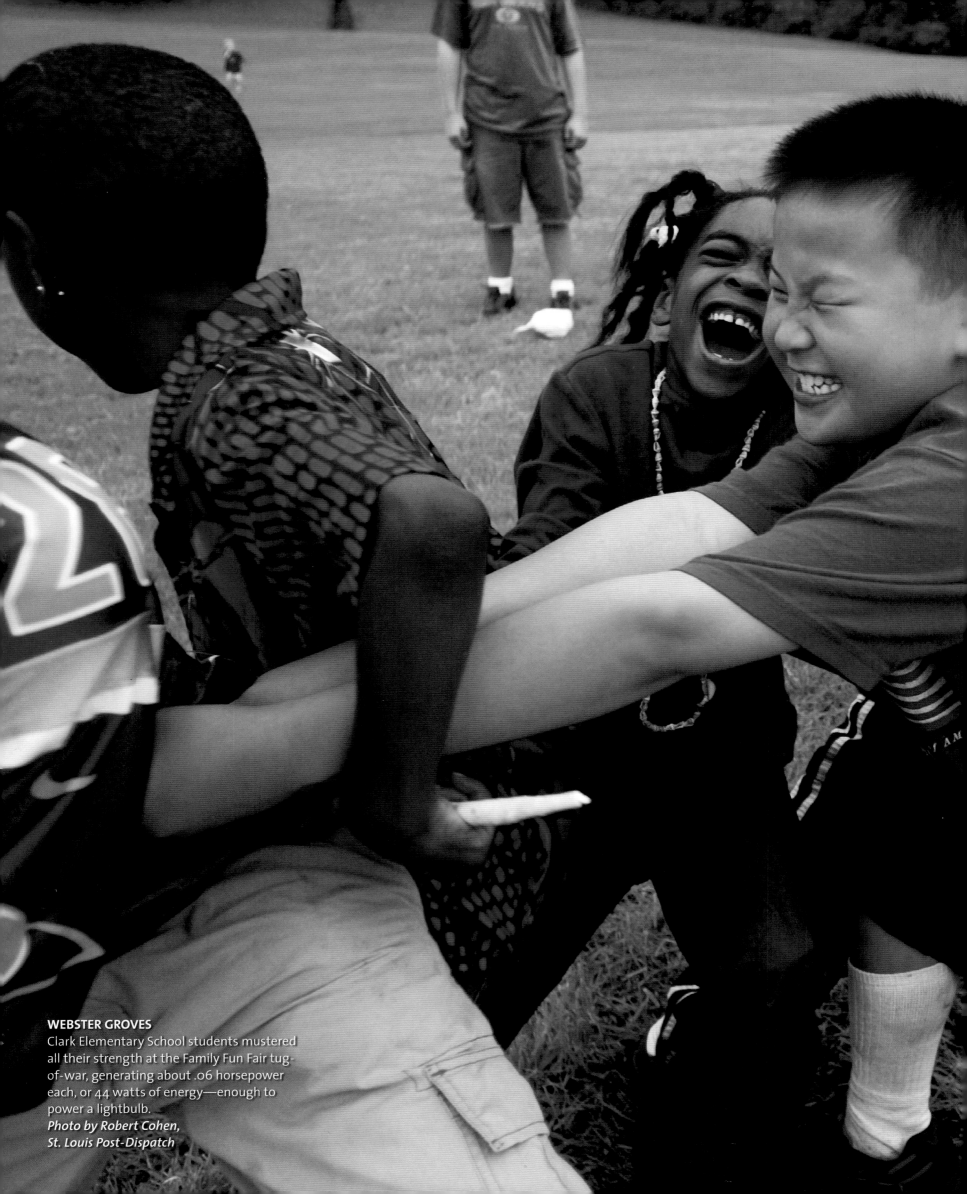

WEBSTER GROVES
Clark Elementary School students mustered all their strength at the Family Fun Fair tug-of-war, generating about .06 horsepower each, or 44 watts of energy—enough to power a lightbulb.
Photo by Robert Cohen,
St. Louis Post-Dispatch

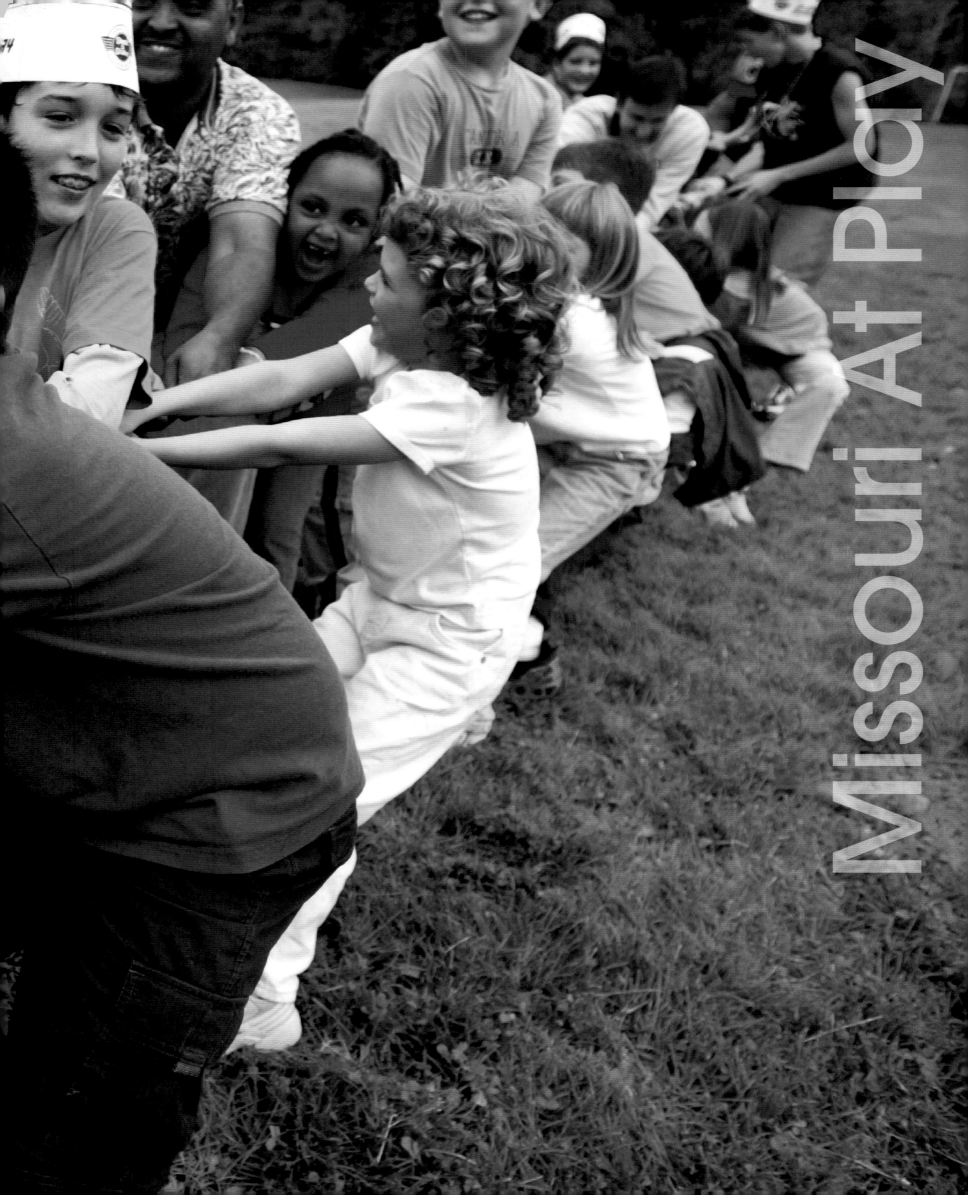

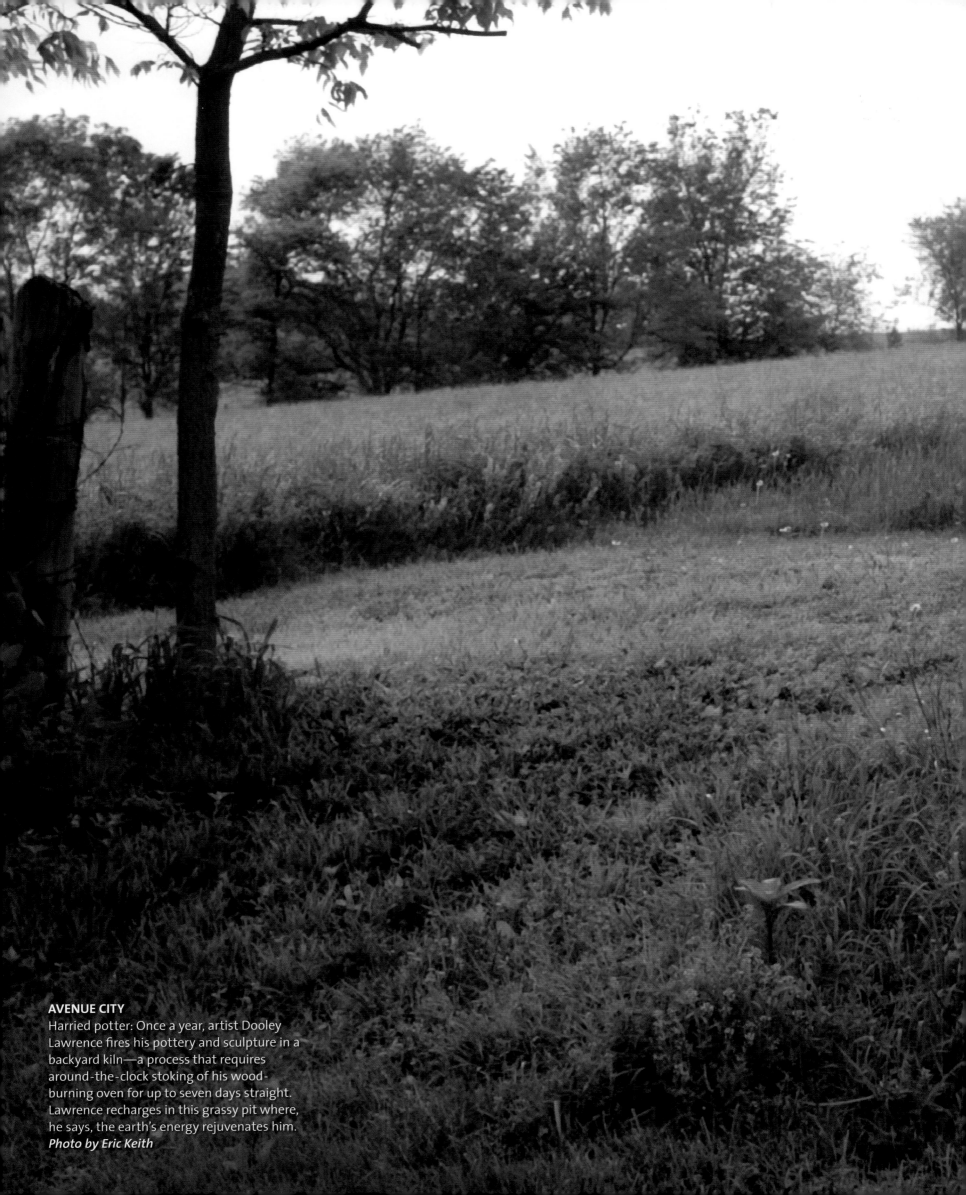

AVENUE CITY
Harried potter: Once a year, artist Dooley Lawrence fires his pottery and sculpture in a backyard kiln—a process that requires around-the-clock stoking of his wood-burning oven for up to seven days straight. Lawrence recharges in this grassy pit where, he says, the earth's energy rejuvenates him.
Photo by Eric Keith

FAYETTE

Umpire Gene Jouret confers with coach Geoff Morehead before the start of the Senior Day game, put on by Fayette High School to honor senior players. The visiting Centralia Panthers (left) ignored the occasion and pasted the Fayette Falcons, 5–0.
Photo by Daniel Carapellotti

ST. LOUIS

Is there a cardinal in the sky, too? Sandwiched between parents John and Karen, John James Belobrajdic-Bosch keeps his eye on something other than the field at Busch Stadium during pregame warm-ups. Later that afternoon, the St. Louis Cardinals beat their biggest rivals, the Chicago Cubs, 6–3.
Photo by Laurie Skrivan, St. Louis Post-Dispatch

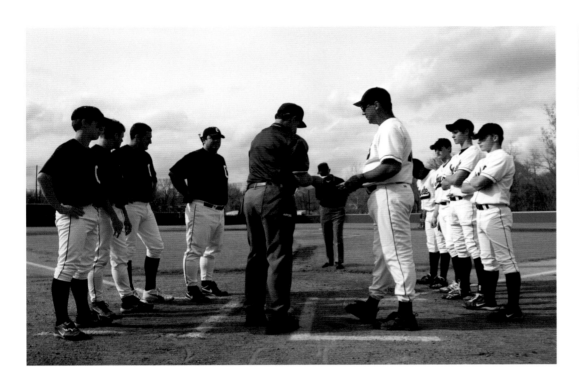

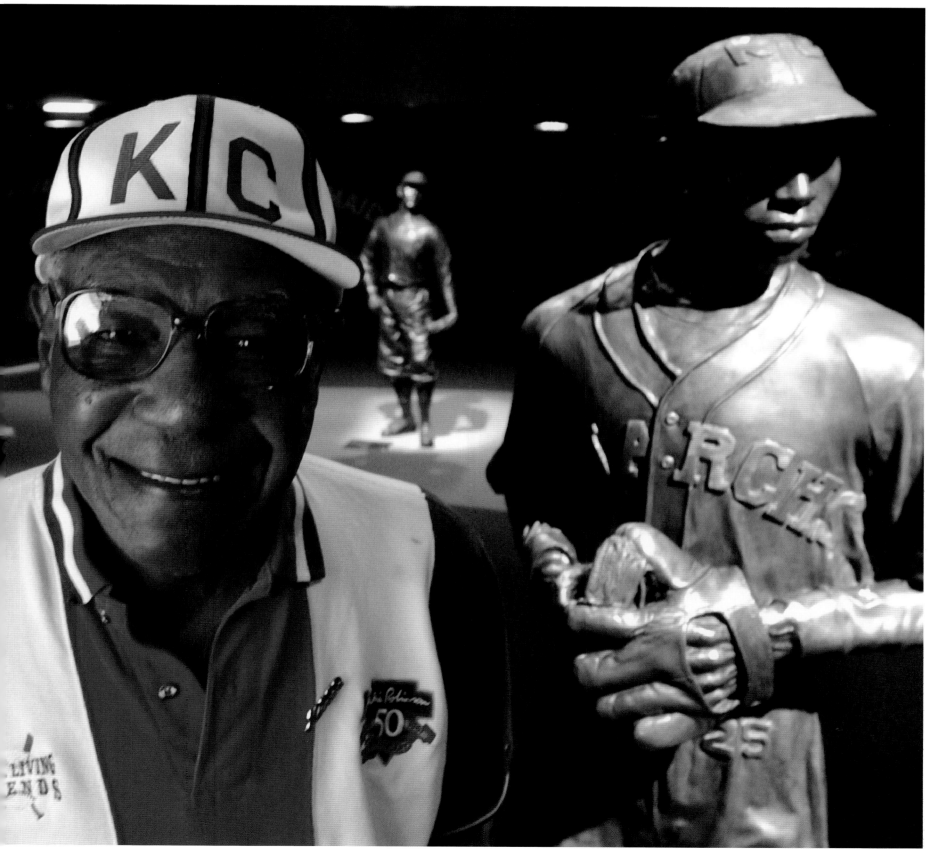

KANSAS CITY

Among the stars at the Negro Leagues Baseball Museum is its chairman, Buck O'Neil 91. After a successful career with the Kansas City Monarchs, O'Neil broke the color barrier in 1962 when he was named a coach for the Chicago Cubs. O'Neil stands beside a statue of his old Monarch teammate, friend, and roommate, pitching phenomenon Satchel Paige.

Photo by Jessica A. Stewart

ST. JOSEPH

"Let's go, St. Joe!" shouts exercise pioneer Richard Simmons to a class of 2,000 at the Civic Arena. Simmons did his thing on behalf of Heartland Health Hospital's Women's Health Initiative. There's abundant reason for Missourians to get a move on: 59 percent of adults in the state are overweight or obese.
Photo by Jessica A. Stewart

COLUMBIA

Bend it like Beckham: Smith-Cotton High School forward Jessica Ferguson curves the ball past Hickman High School defender Lydia Gaboury.
Photo by Jimmie Presley,
University of Missouri

OLD PATTONSBURG

After surviving 33 floods, Old Pattonsburg school met its demise when two students set it on fire in 1996. The entire 261-person farm town, located at the junction of Big Creek and the Grand River, had relocated to higher ground in 1994. The junior softball team still returns to the charred site of the old school for weekly practice.
Photo by Eric Keith

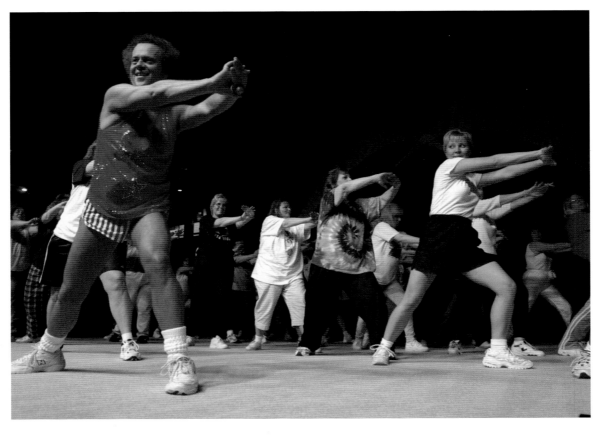

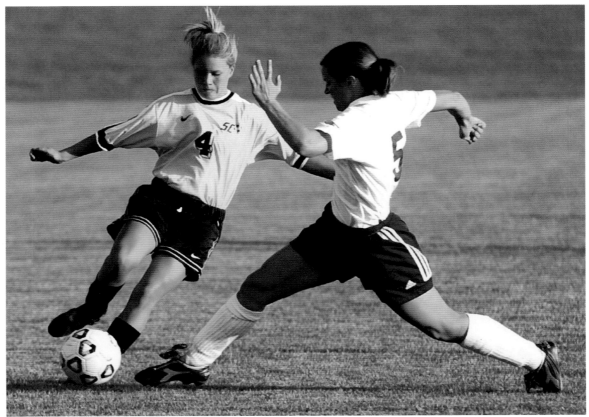

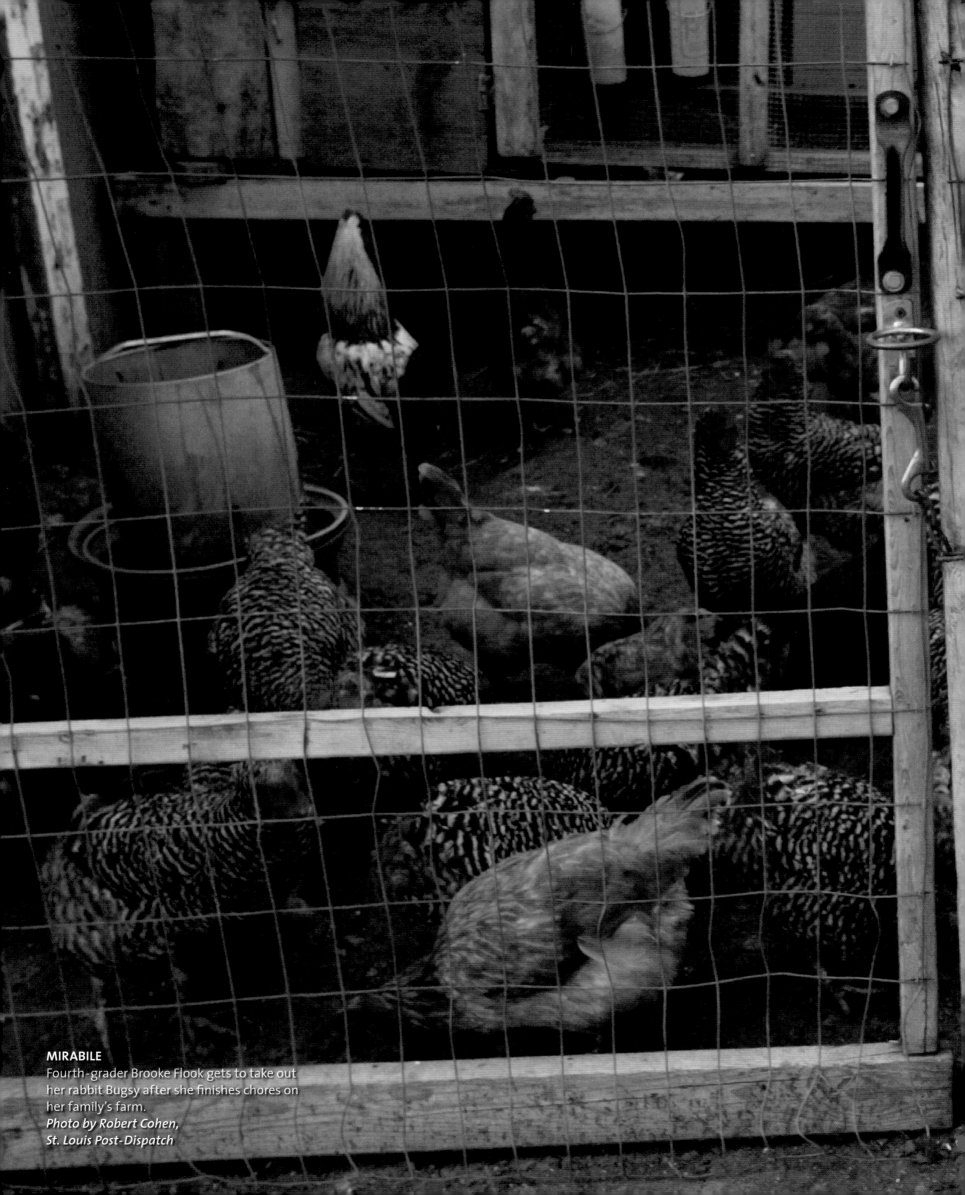

MIRABILE
Fourth-grader Brooke Flook gets to take out
her rabbit Bugsy after she finishes chores on
her family's farm.
Photo by Robert Cohen,
St. Louis Post-Dispatch

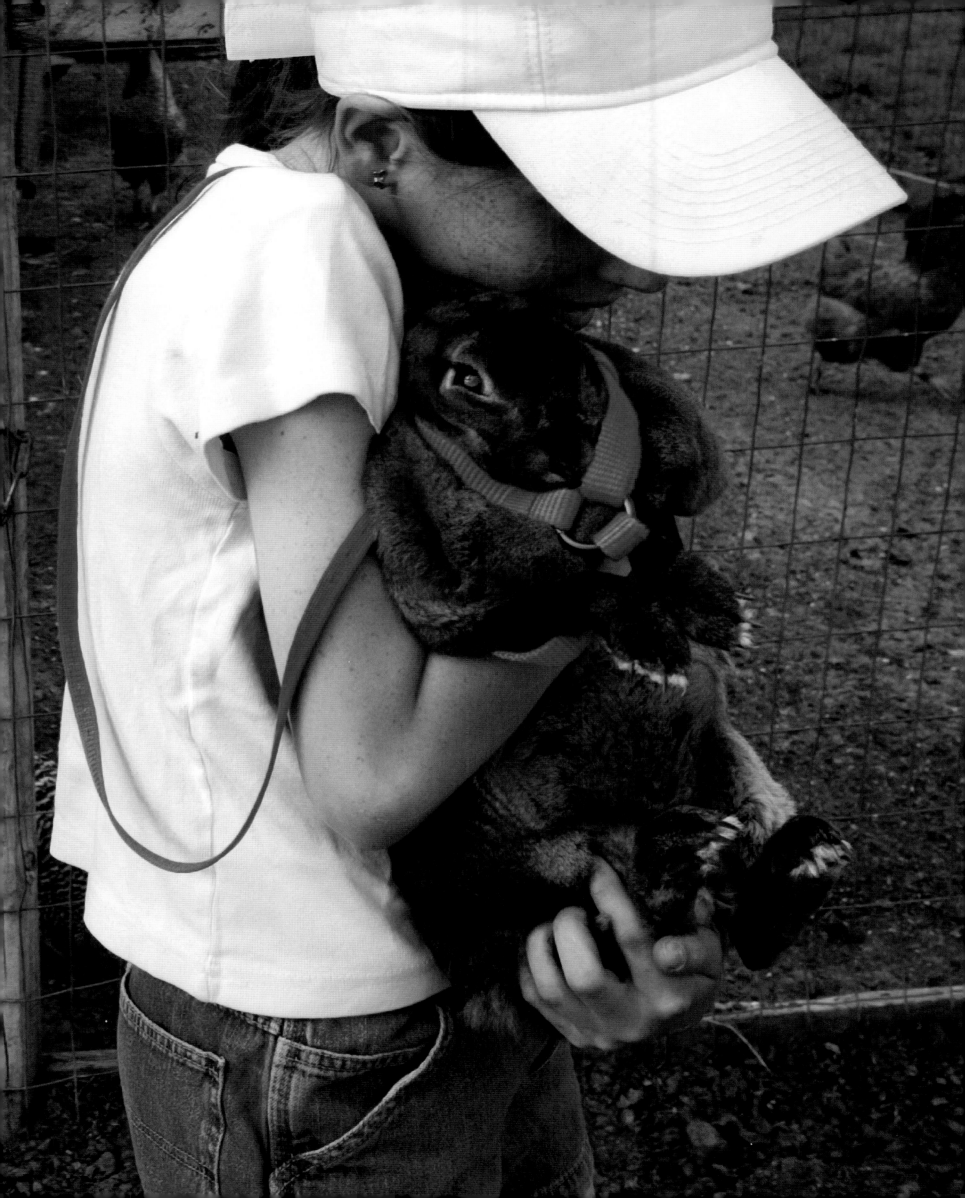

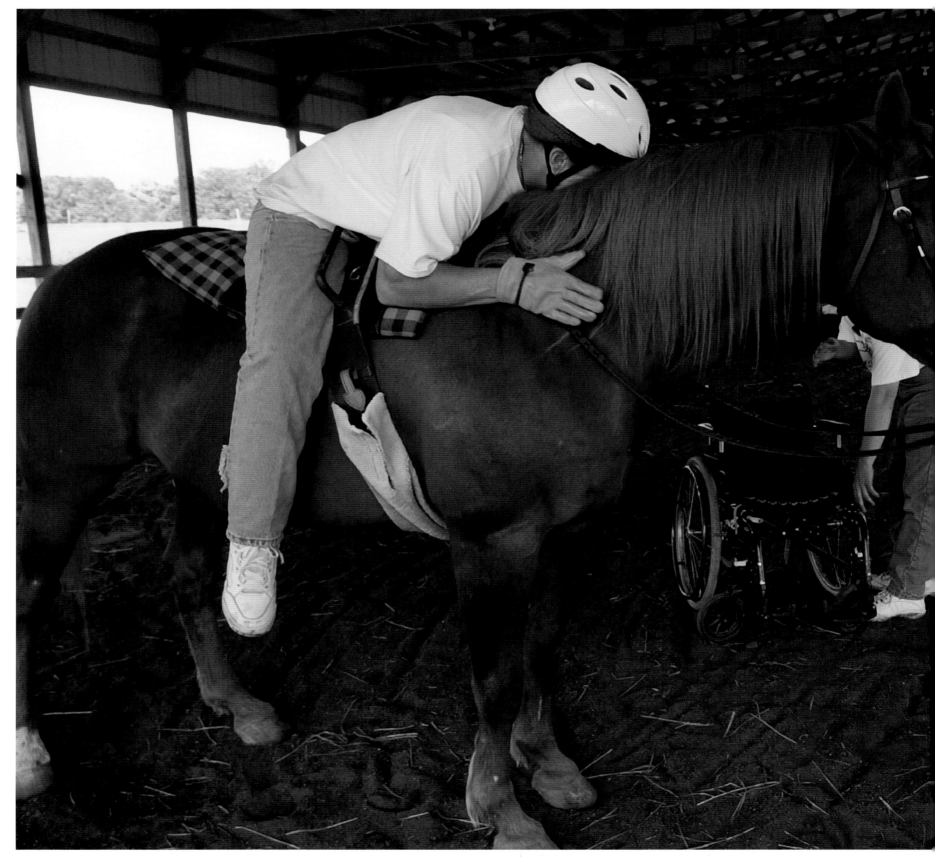

COLUMBIA

"Riding is good for my sanity and my soul," says Nelly Owen, one of 100 disabled riders who takes lessons at the Cedar Creek Therapeutic Riding Center. Owen is paralyzed from the waist down but controls the quarter horse Kidd with her arms and balance. The gentle motion of riding helps loosen Owen's joints and increases her muscle tone and flexibility.

Photo by Sara Andrea Fajardo

MARY'S HOME

Radar can clear 74 inches from a standstill. Mule jumping competitions developed out of coon hunting. Hunters threw their coats over the top of barbed wire fences so the mules could clear them without injuring themselves. It was a short step to seeing whose mule could jump highest.

Photo by Brian W. Kratzer, University of Missouri

MARY'S HOME

Mike Call inherited 10-year-old Radar from his father. The champion jumping mule is a favorite family pet. "He's spoiled just like a kid," says Call.

Photo by Brian W. Kratzer, University of Missouri

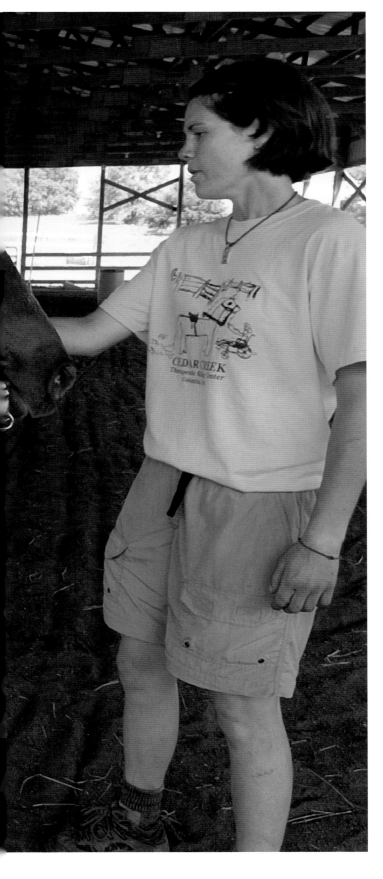

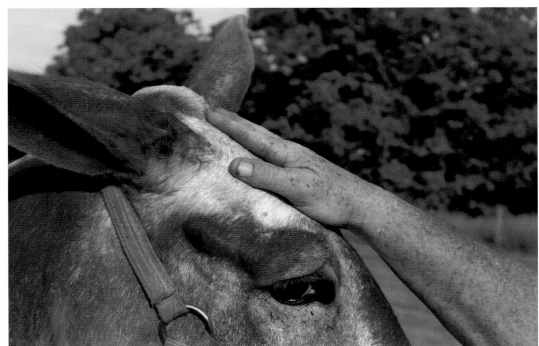

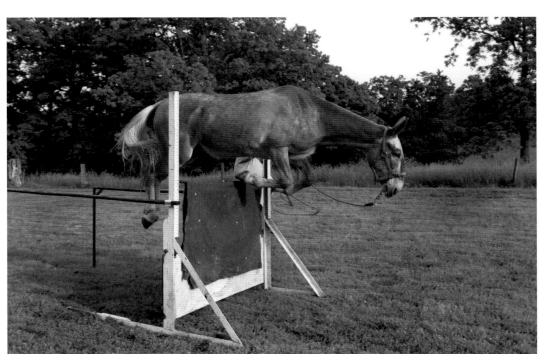

SIKESTON

Abby Pfefferkorn, 21, is a power lifting legend. She holds the United States Association of Blind Athletes world record in her weight category and won the 1999 Missouri High School championships. Since enrolling as a full-time student at Southeast Missouri State University, Pfefferkorn prefers to lift recreationally. She's accompanied by Faith, her seeing-eye dog.
Photo by Lisa Waddell Buser

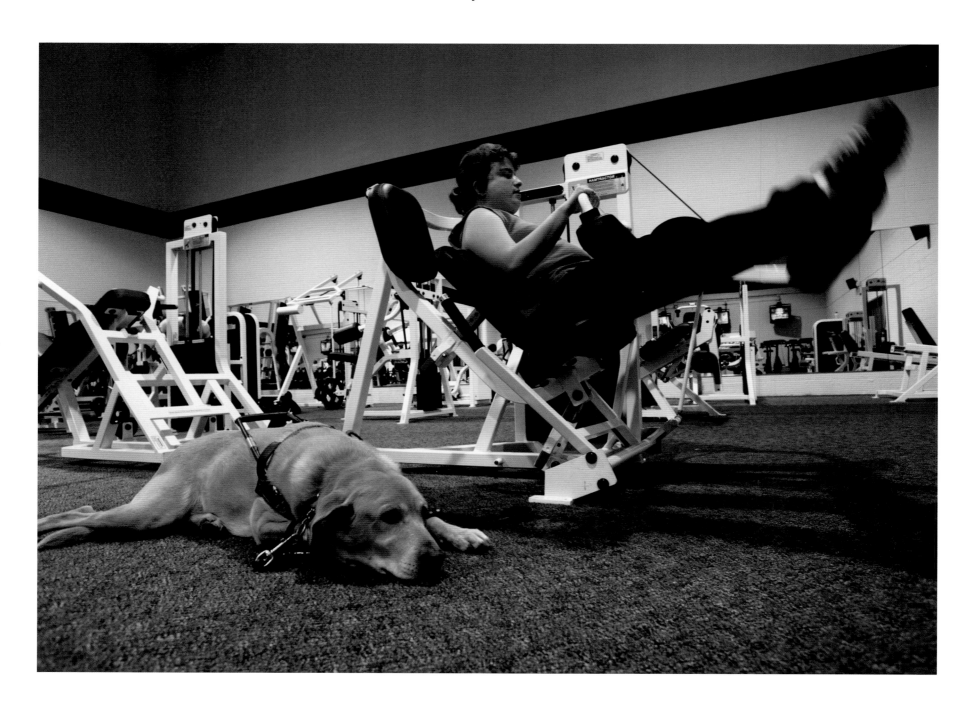

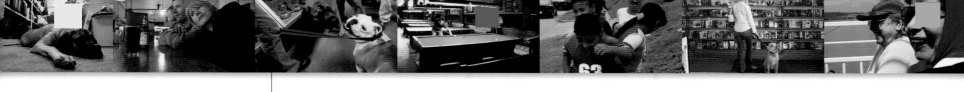

UNIVERSITY CITY

Helloooo! Lucy, a 115-pound mastiff, tries to get the attention of Milla, an English bulldog, while their owners chat at the Baton Music store in University City.

Photo by Justin Kase Conder

WEBSTER GROVES
The Dadditudes practice their dance routine backstage at Clark Elementary School's Family Fun Fair. The group of dads, formerly known as the Backache Boys, has expanded from five to 20 members in four years.
Photo by Robert Cohen,
St. Louis Post-Dispatch

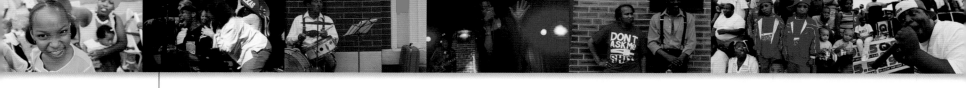

COLUMBIA
Fans charge the stage at The Blue Note during
an appearance by pedal steel virtuoso
Robert Randolph and his band. He doesn't
seem to mind at all.
Photo by L.G. Patterson

ST. LOUIS

Drummers Quinton Jackson and Lewis Johnson limber up before hitting the pavement in the annual Annie Malone Parade. The second largest African-American parade in the country, it honors Annie Malone, a St. Louis cosmetologist and philanthropist who made millions in the early 20th century with her hair-straightening Poro Products.

Photo by Justin Kase Conder

ST. LOUIS

St. Louis's own Charles Edward Anderson Berry—aka Chuck Berry—plays monthly at Blueberry Hill. For Berry, the first person inducted into the Rock and Roll Hall of Fame, it's been half a century since "Maybellene." At 76, Berry performs as if he's just getting going. Son Charles Berry, Jr., who works in computer technology during the day, moonlights with dad.

Photo by Laurie Skrivan, St. Louis Post-Dispatch

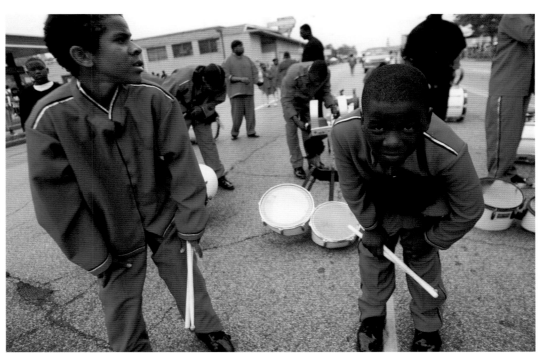

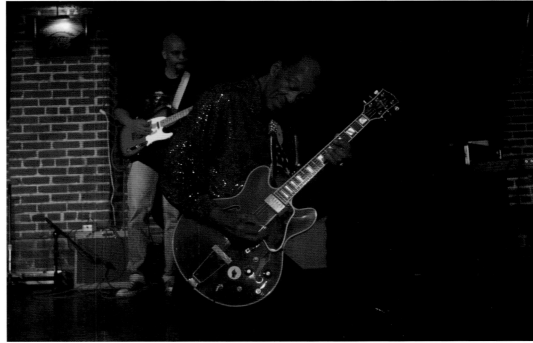

KANSAS CITY
A family monkeys around at the Worlds of Fun
Amusement Park's squirt gun game booth.
Photo by Sara Andrea Fajardo

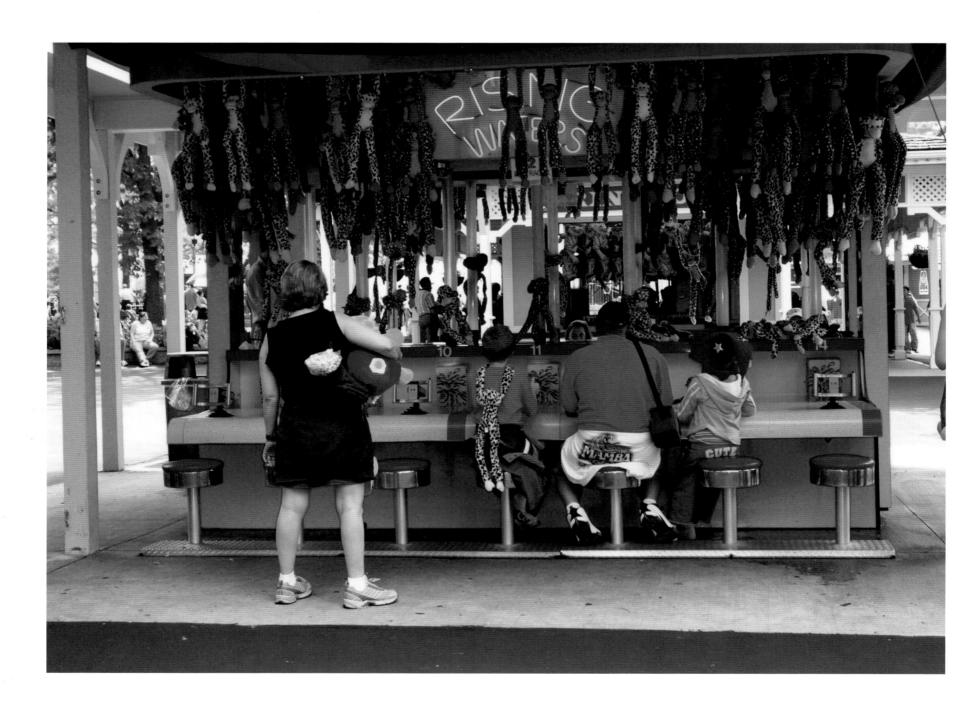

ELLISVILLE

The Tiny Tots ballet class at Dance Incorporated gets ready for an end-of-year recital. Teacher Tammy Conrad checks the costumes, makeup, and hairdos of her 3-year-old students.

Photo by Richard Petty Photography

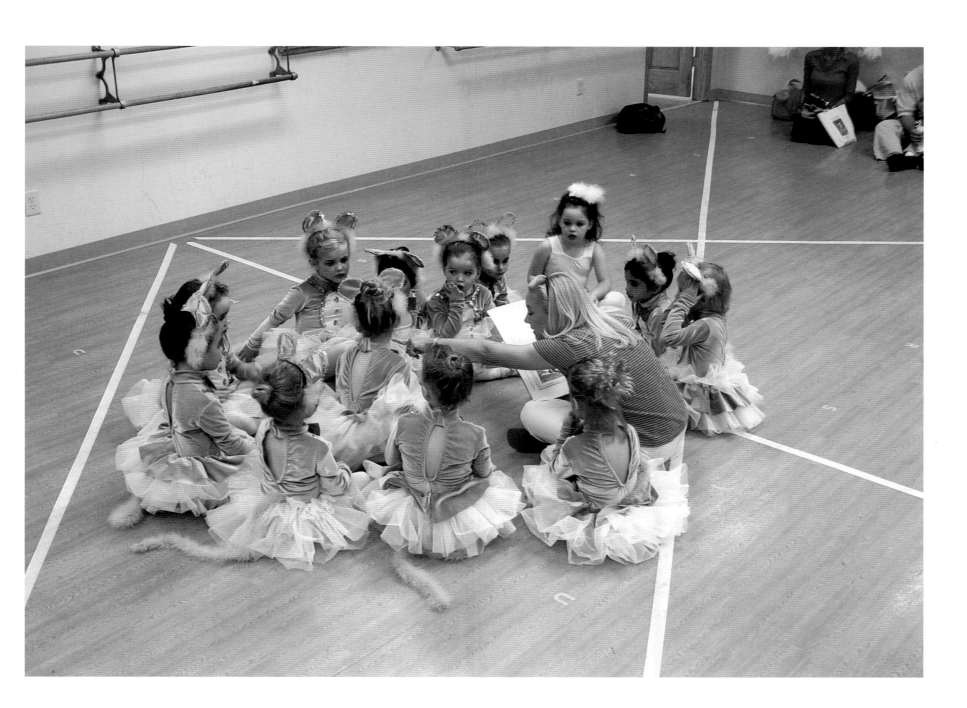

WESTPHALIA

These hands were made for quilting: Viola Weber's needle-pricked fingertips bear testament to the hundreds of hours she spends with St. Anne's Sewing Circle stitching quilts to raise money for St. Joseph's Catholic School.
Photos by David M. Barreda,
University of Missouri

WESTPHALIA

Ice cream social: Quilters take a break at Trudy Conine's house, formerly Sonnen's Saloon, which opened in 1882.

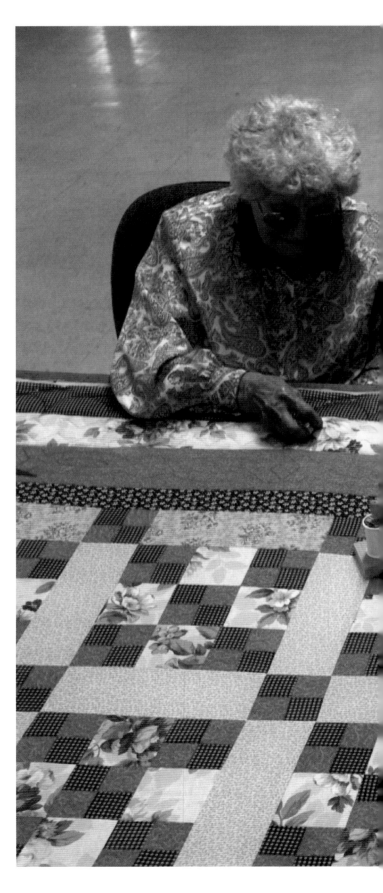

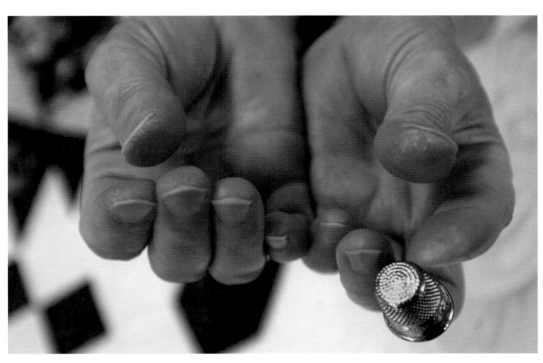

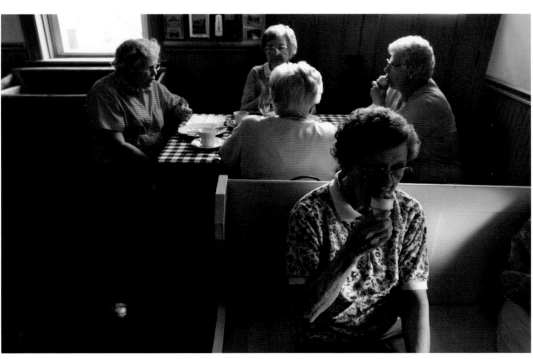

WESTPHALIA

"Quilting is really all about socializing," says sewing circle member Viola Weber. This tight-knit group, which also includes Marie Heckman, Dorothy Kleffner, and Martha Fennewald, quilts and chats every Wednesday during the school year. Each quilt they create sells for $500 at St. Joseph's spring picnic and auction.

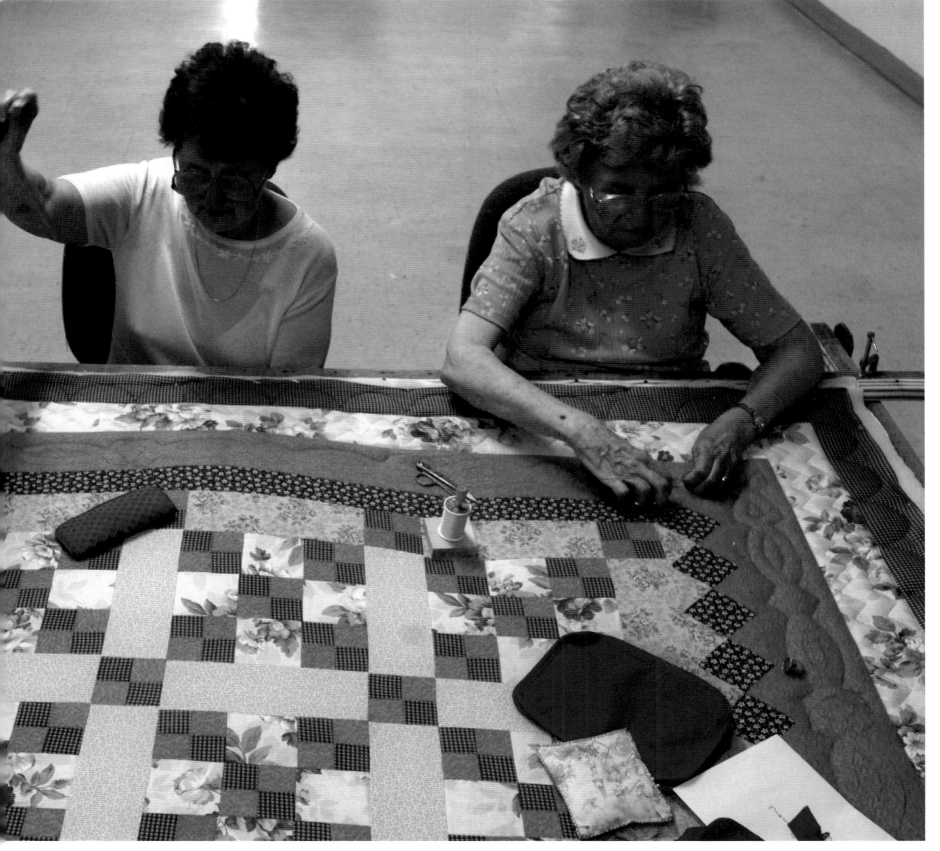

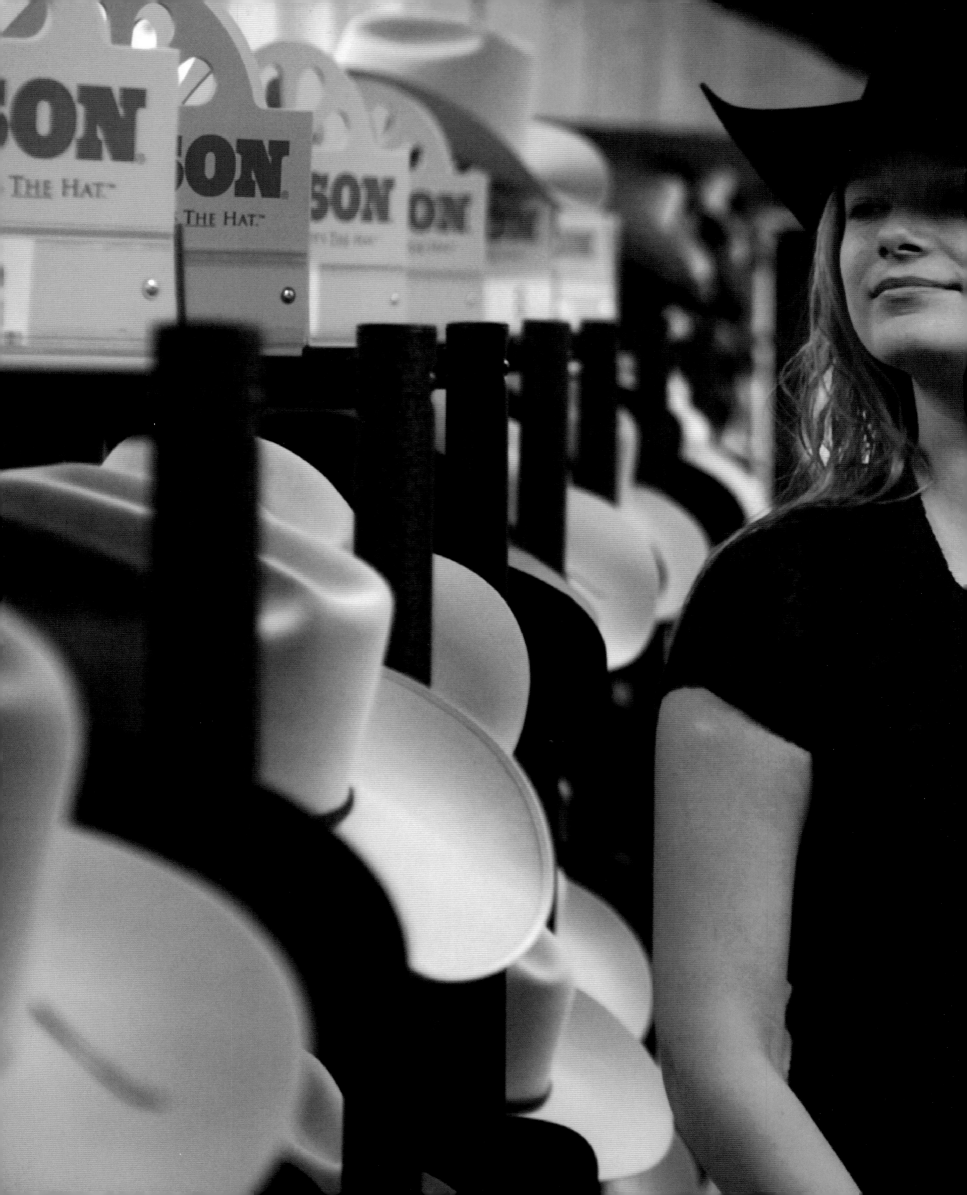

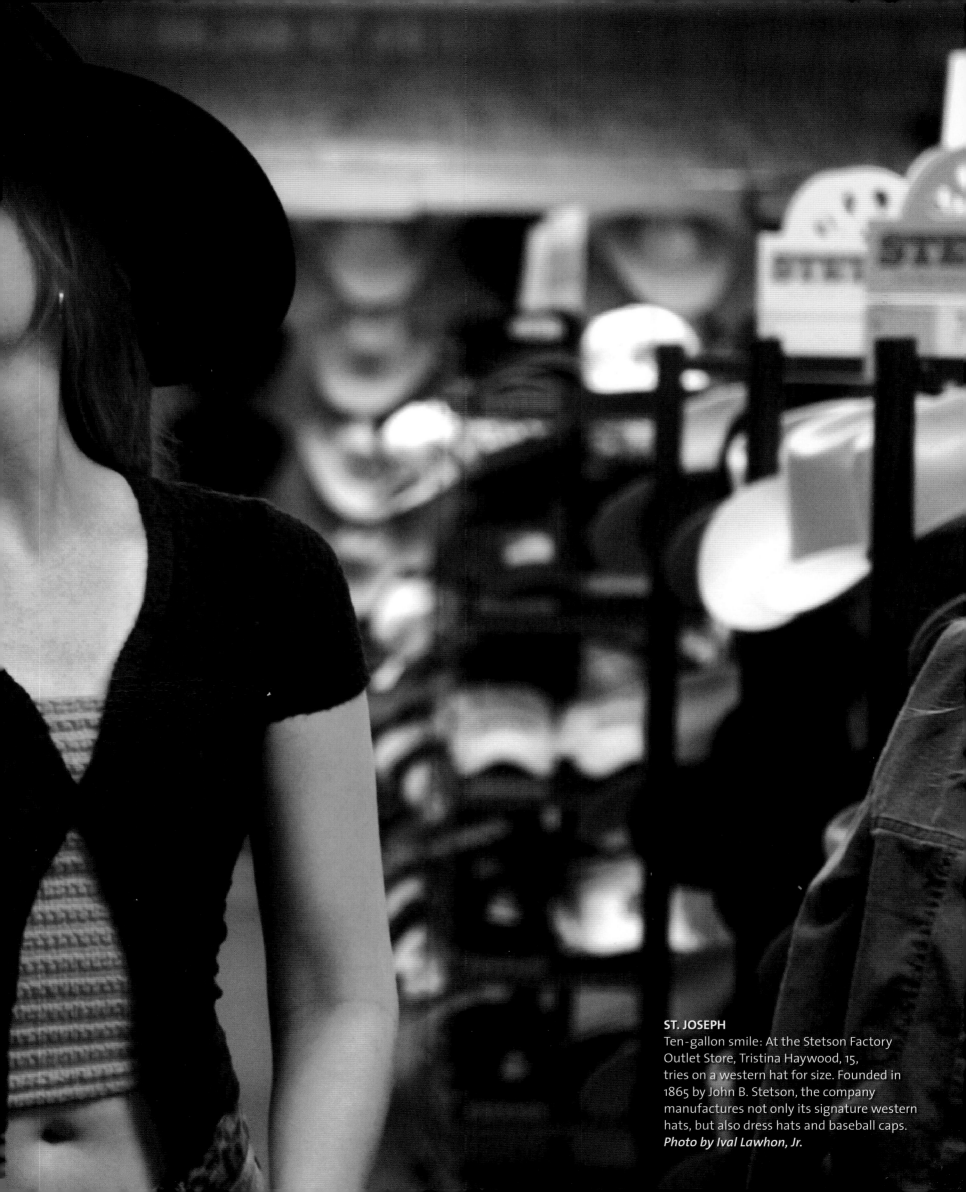

ST. JOSEPH
Ten-gallon smile: At the Stetson Factory Outlet Store, Tristina Haywood, 15, tries on a western hat for size. Founded in 1865 by John B. Stetson, the company manufactures not only its signature western hats, but also dress hats and baseball caps.
Photo by Ival Lawhon, Jr.

AUXVASSE

In 19th-century mourning garb, Hazel Davis of Virginia, a member of the Daughters of the Confederacy, walks among Civil War–era graves in the Old Auxvasse Church cemetery. Neither northern nor southern, Missouri was ripped apart by the Civil War, which set family against family and county against county.

Photos by Brian W. Kratzer, University of Missouri

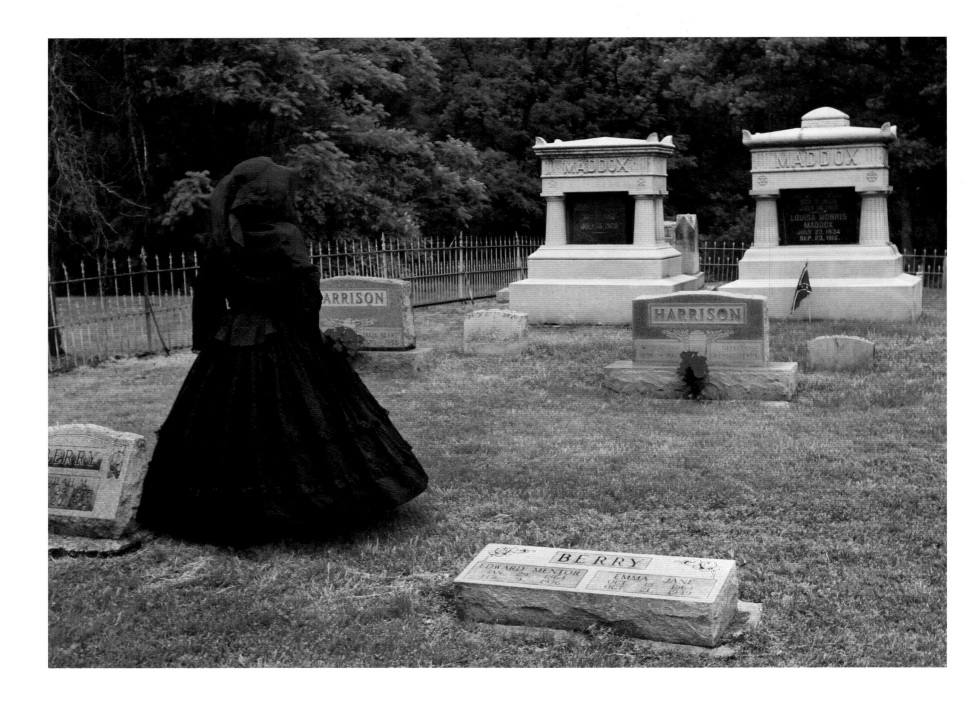

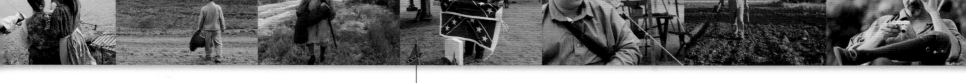

AUXVASSE

A member of the Sons of Confederate Veterans, Mark Douglas of Calloway County drapes a battle flag over the headstone of Civil War soldier Elijah Blankenship, a Virginian. The only southerner to survive "the ridge" during Pickett's Charge at the Battle of Gettysburg, Blankenship moved to Missouri after the war.

LEMAY

Cross dressing: These reenactors take advantage of the internal combustion engine on their way to a muzzleloader shooting competition. Pretending to be rough-and-ready frontiersmen from the 1770s, Steve Helfrich, Paul Bigham, Matt Olson, and Jack Leadbetter take a break from their real-life identities as technicians and engineers. "It's our excuse to wear tights," Leadbetter says.
Photo by Robert Cohen,
St. Louis Post-Dispatch

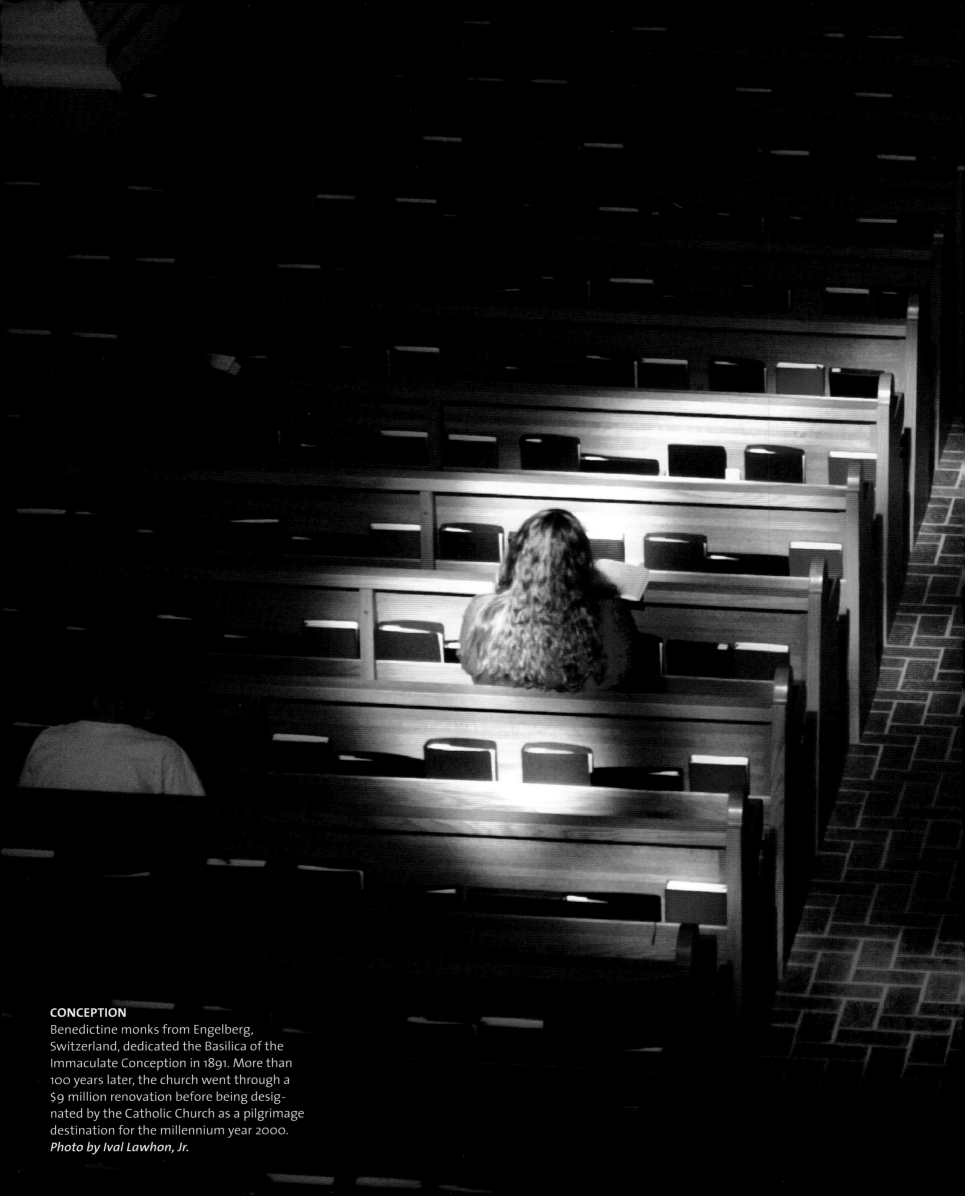

CONCEPTION
Benedictine monks from Engelberg, Switzerland, dedicated the Basilica of the Immaculate Conception in 1891. More than 100 years later, the church went through a $9 million renovation before being designated by the Catholic Church as a pilgrimage destination for the millennium year 2000.
Photo by Ival Lawhon, Jr.

Reason To Believe

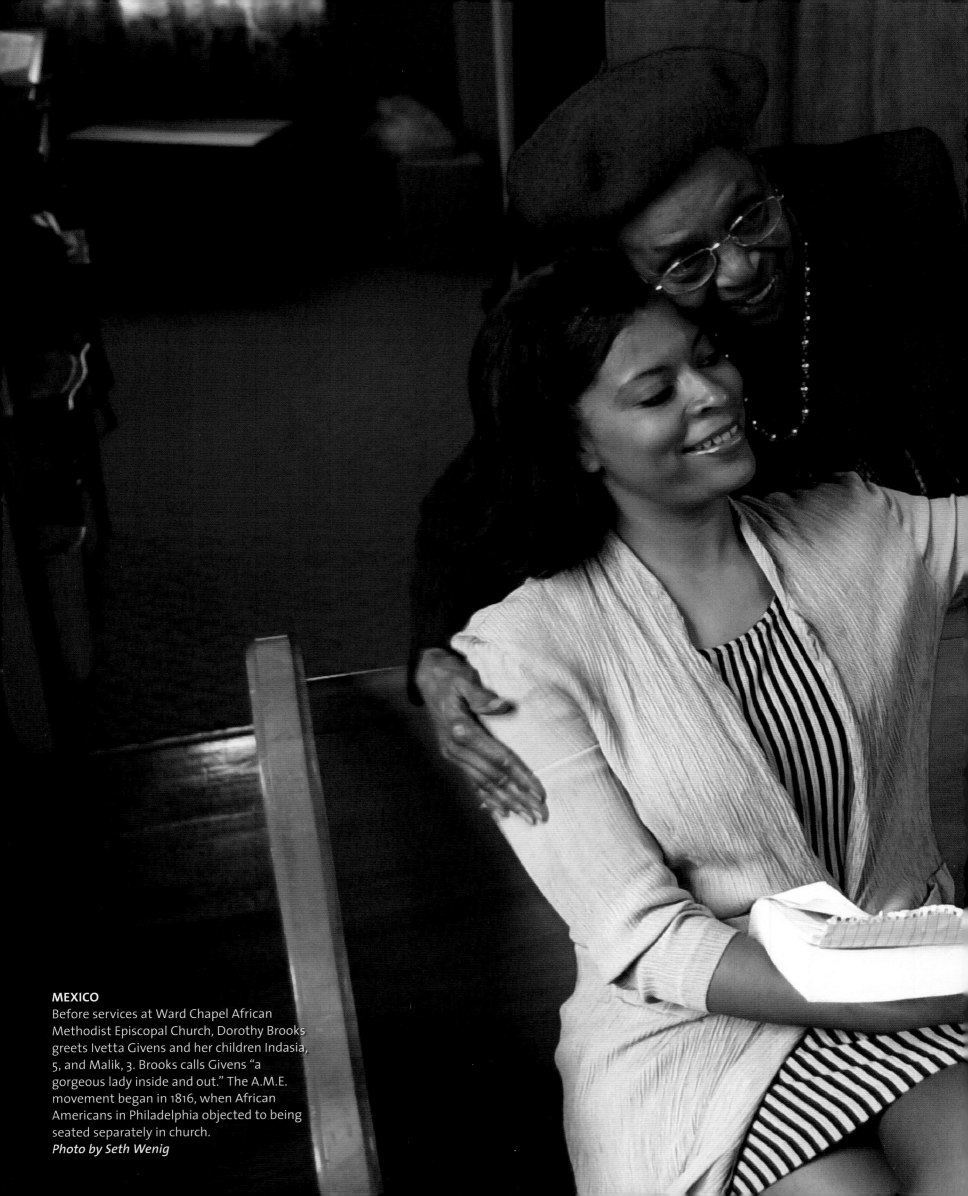

MEXICO
Before services at Ward Chapel African Methodist Episcopal Church, Dorothy Brooks greets Ivetta Givens and her children Indasia, 5, and Malik, 3. Brooks calls Givens "a gorgeous lady inside and out." The A.M.E. movement began in 1816, when African Americans in Philadelphia objected to being seated separately in church.
Photo by Seth Wenig

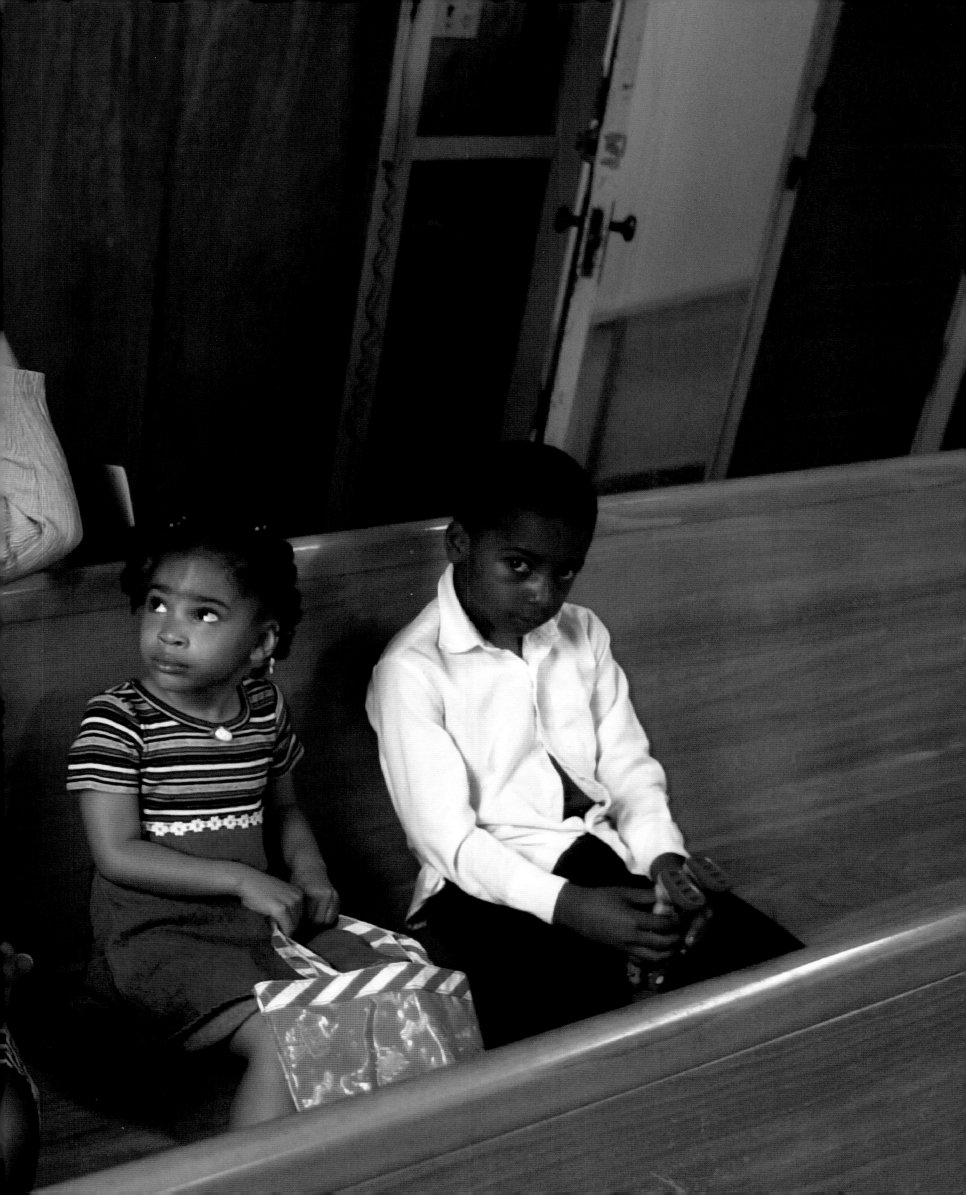

PATTONSBURG

The moon rises again over the new United Methodist Church. When the flood of 1993 destroyed the old one, its elderly 12-member congregation, soliciting funds from the federal government and the United Methodist Church, built a new church on higher ground. Pattonsburg has five churches—one for every 52 residents.

Photo by Eric Keith

WESTPHALIA

The town's patron saint, Joseph, is the inspiration for the 22 stained glass windows that illuminate the sanctuary of the town's famous church, which was built by German Catholic immigrants in 1848. Architectural fads influenced each of the church's four renovations. Its distinctive hodge-podge of baroque, Romanesque, and gothic styles earned it an entry on the National Register of Historic Places.

Photo by David M. Barreda, University of Missouri

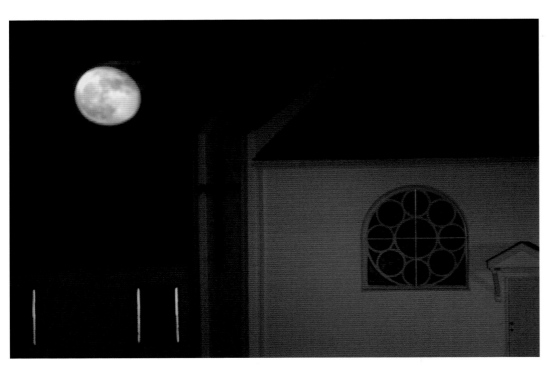

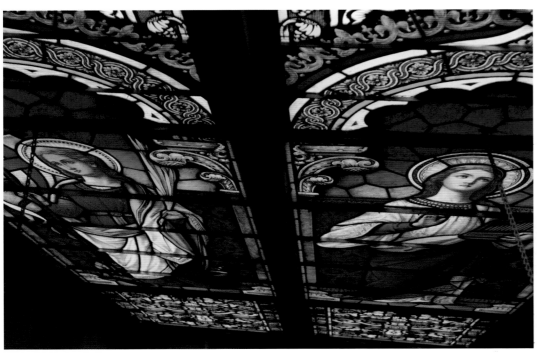

STARKENBURG

In the Sepulcher of Our Lady of Sorrows Shrine, volunteer Leo Bader places candles around the recumbent figure of Jesus. Bader is preparing for the church's spring pilgrimage, when the faithful walk the Stations of the Cross on the 40-acre wooded grounds.

Photo by Brian W. Kratzer, University of Missouri

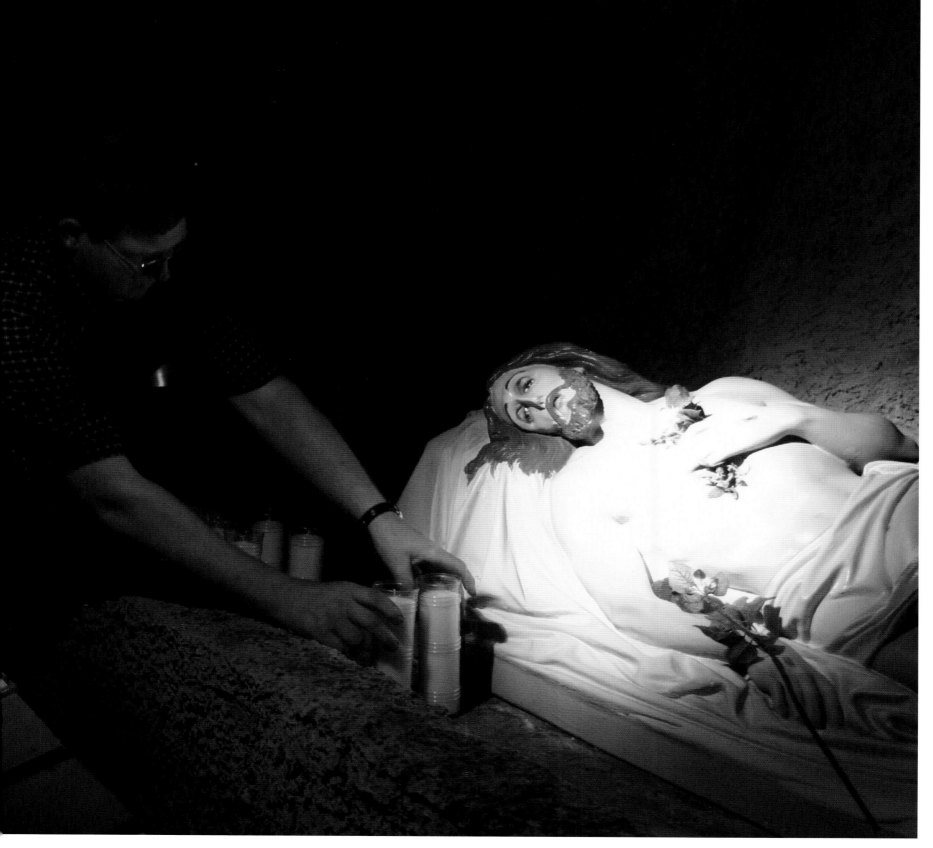

HIGHLANDVILLE
Bishop Karl Pruter, 83, celebrates mass every
morning in the tiny stone Cathedral of the Prince
of Peace, which seats 15. The building was a
washhouse until Pruter added the blue cupola in
1983 and began saying mass there in English and
Spanish. The 1984 *Guinness Book of World Records*
designated the Ozark church "the smallest
cathedral in the world."
Photos by Bob Linder

HIGHLANDVILLE
The Christ Catholic Church, although recognized
by Rome, refuses to bow to church hierarchy
over Jesus' authority. Following the teachings of
the ancient Catholic Church (before the Council
of Nicea), the denomination allows priests to
marry and regards all war as unacceptable. "We
believe the Ten Commandments are not sugges-
tions," says Bishop Karl Pruter.

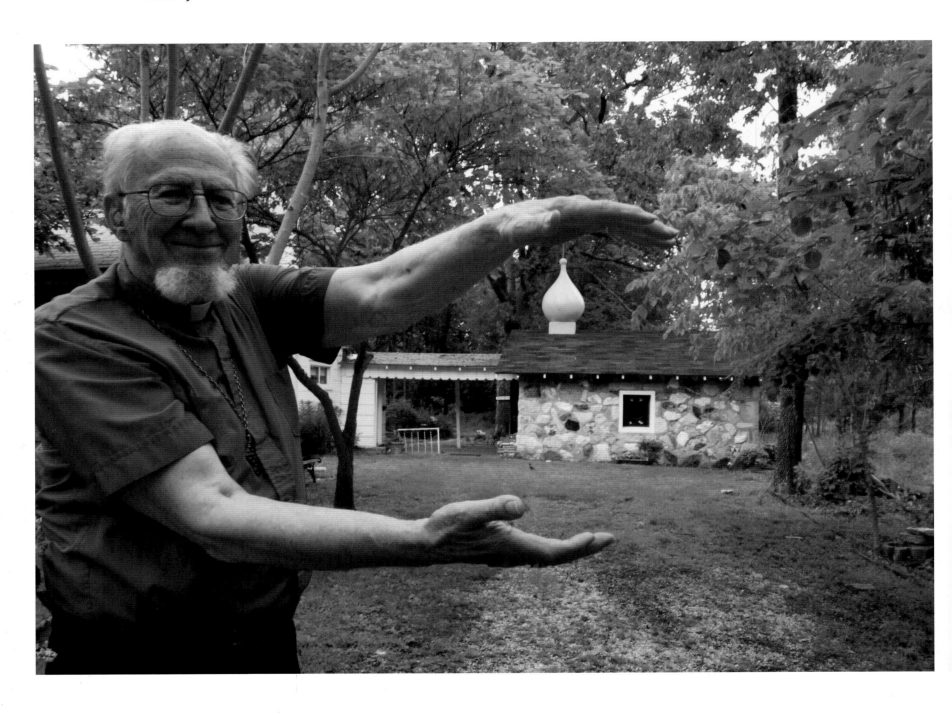

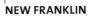

NEW FRANKLIN

The Sulphur Springs Baptist Church in rural central Missouri stands its ground between an oak and a walnut tree. The church, built in 1881, has 25 members.

Photos by Daniel Carapellotti

NEW FRANKLIN

The church has half of what it needs for piano music: a piano. What it lacks is somebody who can play it.

NEW FRANKLIN

Ralph Humphrey, foreground, has been a member of Sulphur Springs Baptist Church for a quarter of a century, but he's thinking of moving on. The retired tire salesman is hesitant to cast stones, but he wants to be "fed," he says, by a bible-preaching preacher, one who uses the King James version of the Bible.

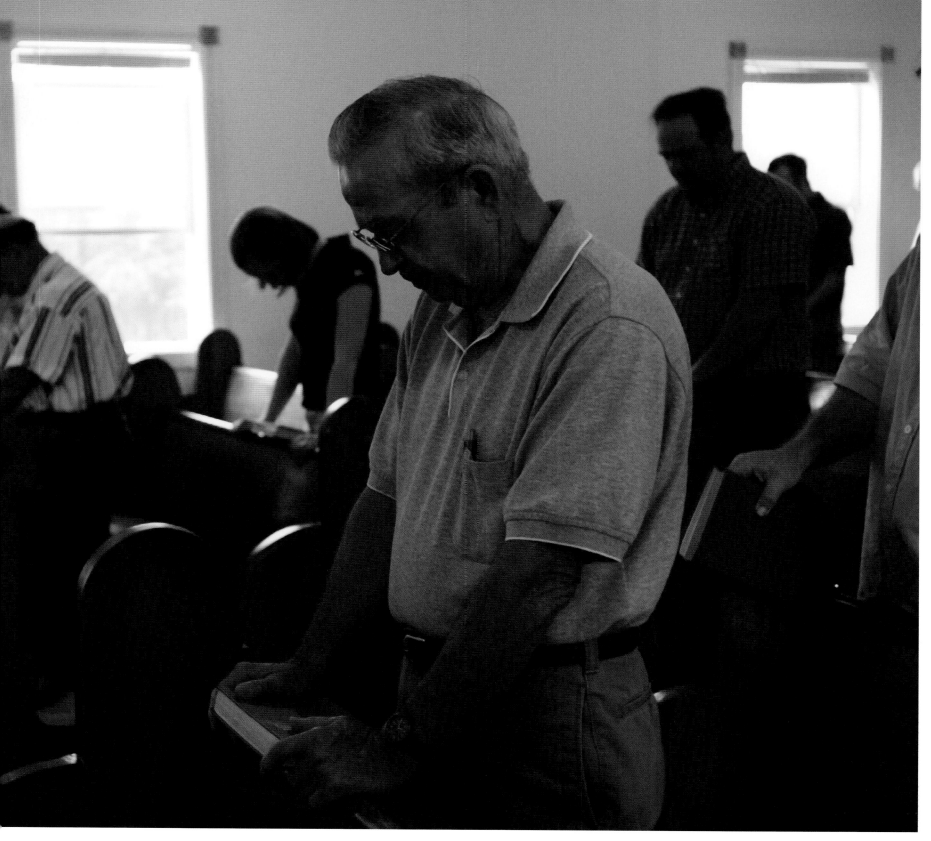

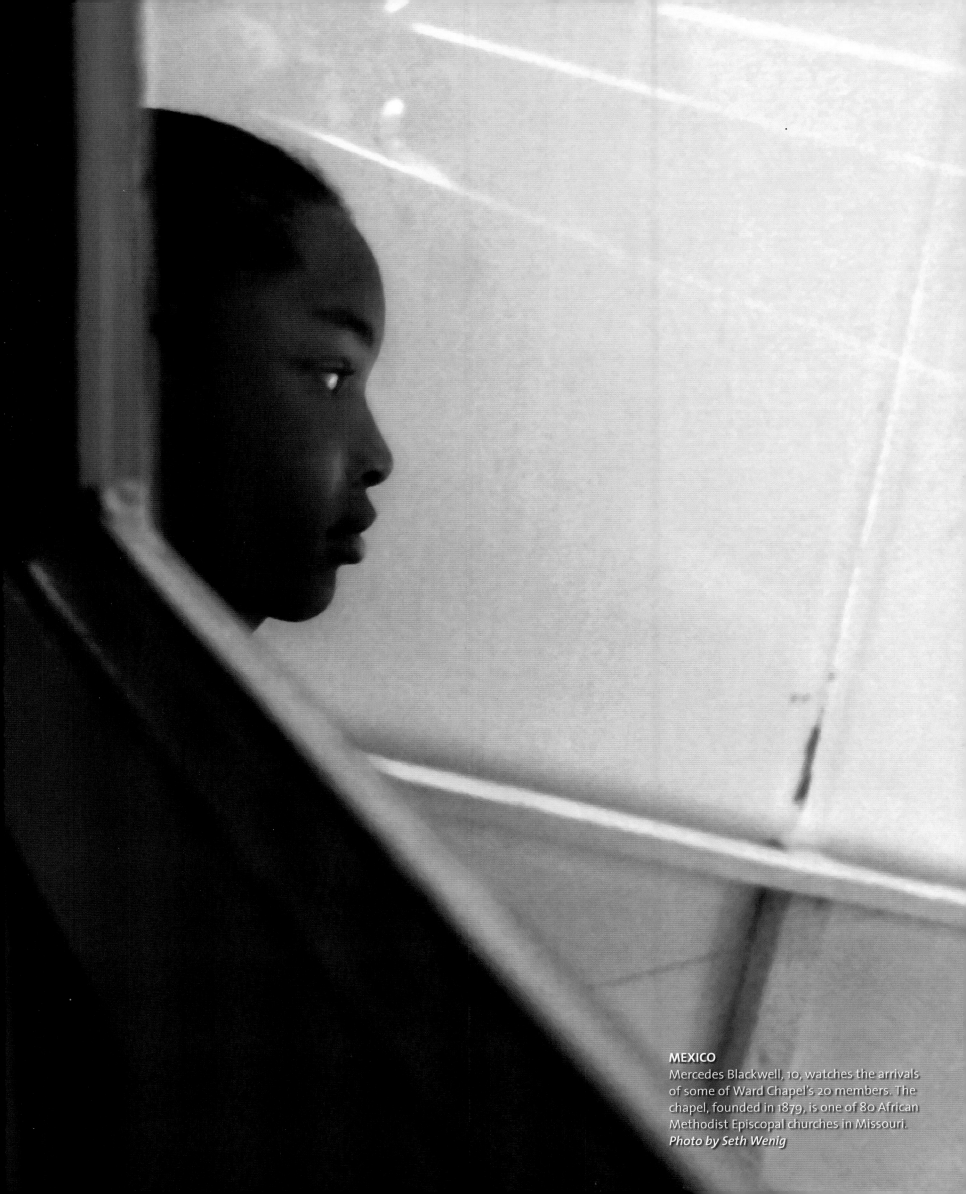

MEXICO
Mercedes Blackwell, 10, watches the arrivals of some of Ward Chapel's 20 members. The chapel, founded in 1879, is one of 80 African Methodist Episcopal churches in Missouri.
Photo by Seth Wenig

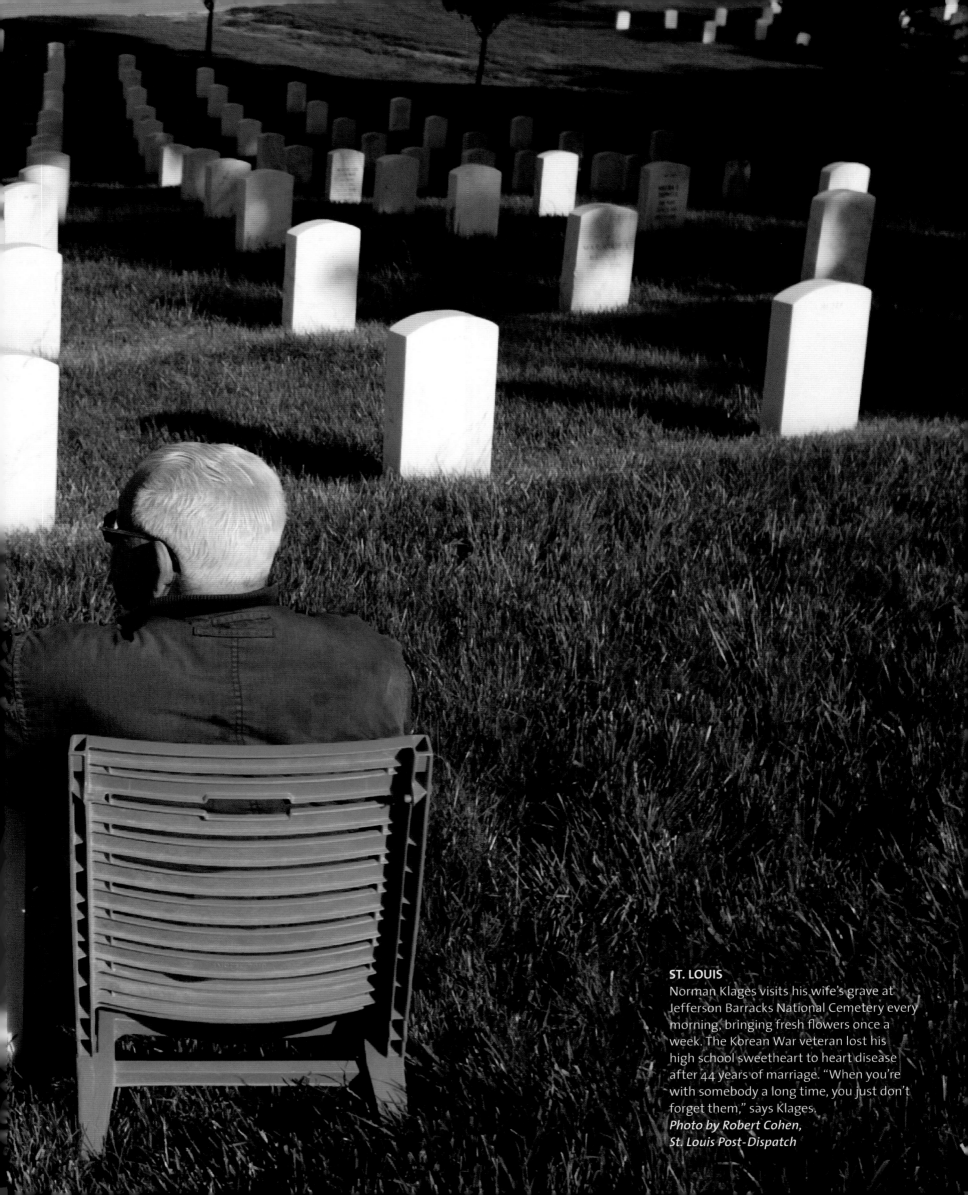

ST. LOUIS
Norman Klages visits his wife's grave at
Jefferson Barracks National Cemetery every
morning, bringing fresh flowers once a
week. The Korean War veteran lost his
high school sweetheart to heart disease
after 44 years of marriage. "When you're
with somebody a long time, you just don't
forget them," says Klages.
Photo by Robert Cohen,
St. Louis Post-Dispatch

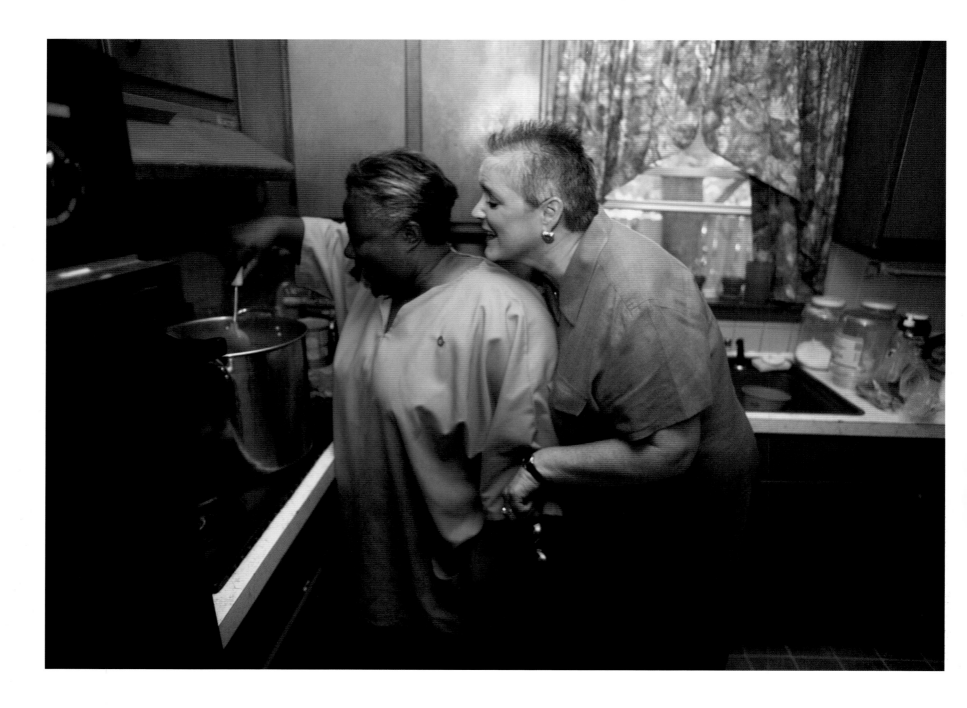

SIKESTON
Donna Morgan and Jane Pfefferkorn created
Mission Missouri, a faith-based social service
agency, in 1998 to address the racial tensions
that divided their town of 17,000. "Before we
started, we were a white community and a black
community and never the twain shall meet," says
Pfefferkorn. Now, volunteers from both provide
meals and drug treatment to Sikeston's poor.
Photo by Lisa Waddell Buser

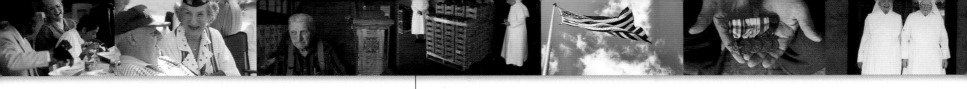

ST. LOUIS

Sisters Mary Helen and Irene Marie of
Little Sisters of the Poor Nursing Home
seek donations of fruits and vegetables
from vendors along Produce Row. Every
Wednesday, Sister Irene Marie is a welcomed
visitor and usually leaves with about 45 bushels
of produce. The home houses more than
100 elderly residents.
Photo by Justin Kase Conder

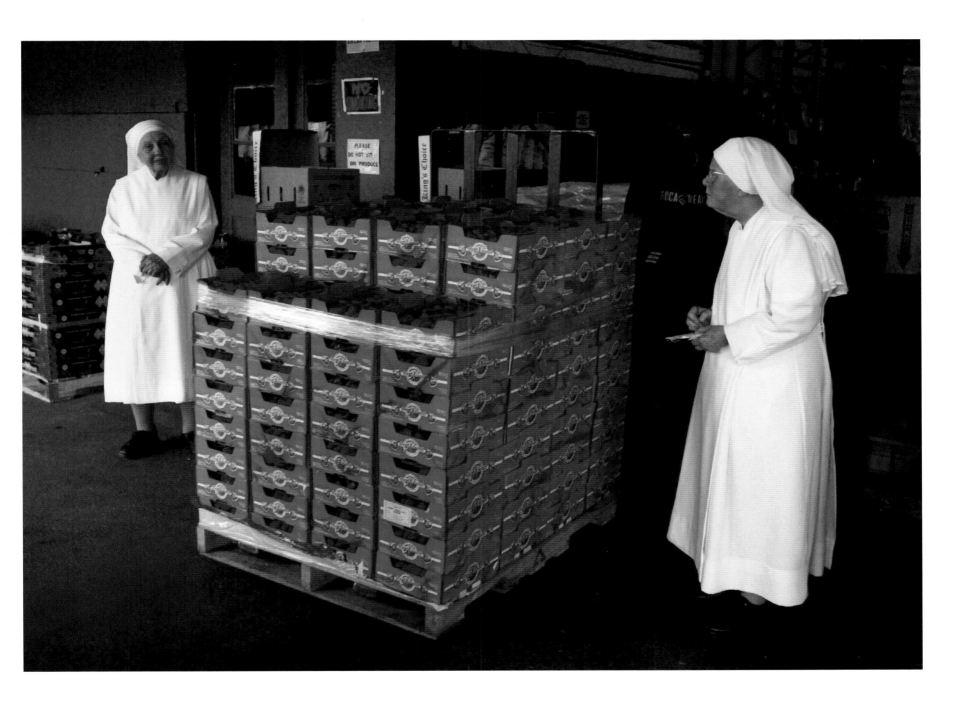

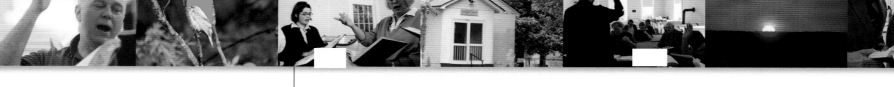

EOLIA

Maire Corcoran harmonizes to Becky Browne's melody during a shape-note singing session at St. John's Episcopal Church. Early English settlers brought the four-part, a cappella song style to America in the 1700s. Over the next century shape-note singing faded from the American cultural scene. Kept alive by churches in the Deep South, the form was rediscovered by folk musicians in the 1970s.

Photos by David M. Barreda, University of Missouri

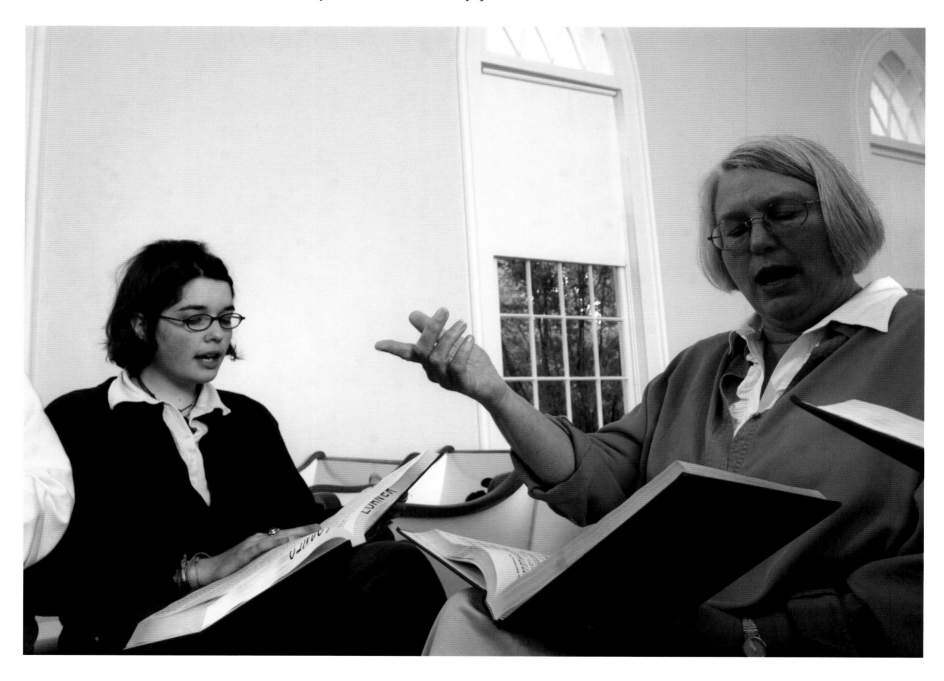

EOLIA

The Sacred Harp is the bible of shape-note singing. First published in 1844, the 573-page tome contains historic American hymns, odes, and anthems composed by colonial settlers, southern revival choirs, and a few contemporary composers.

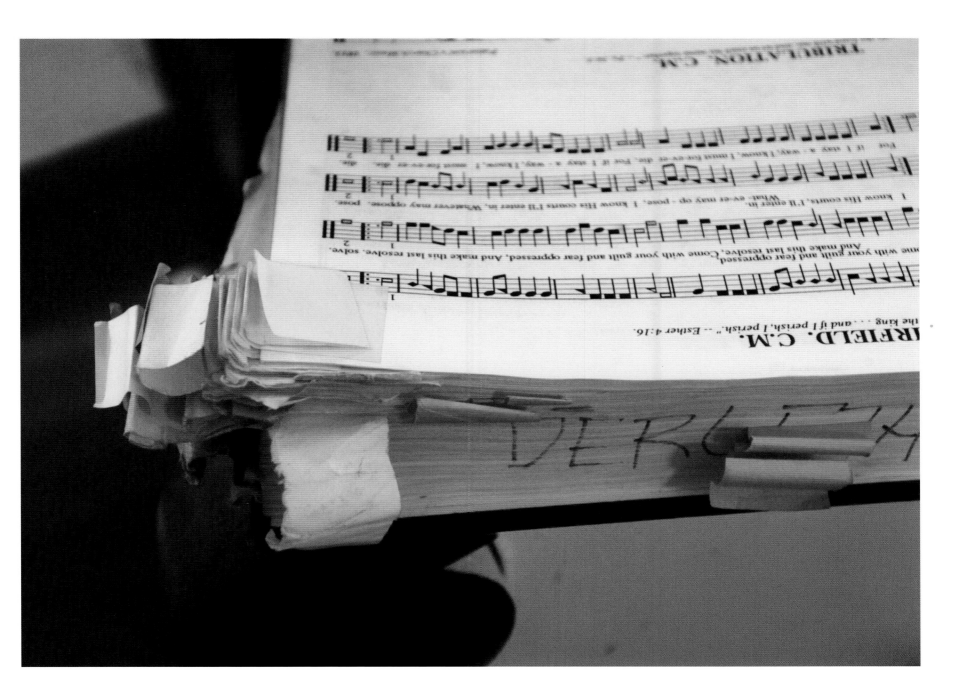

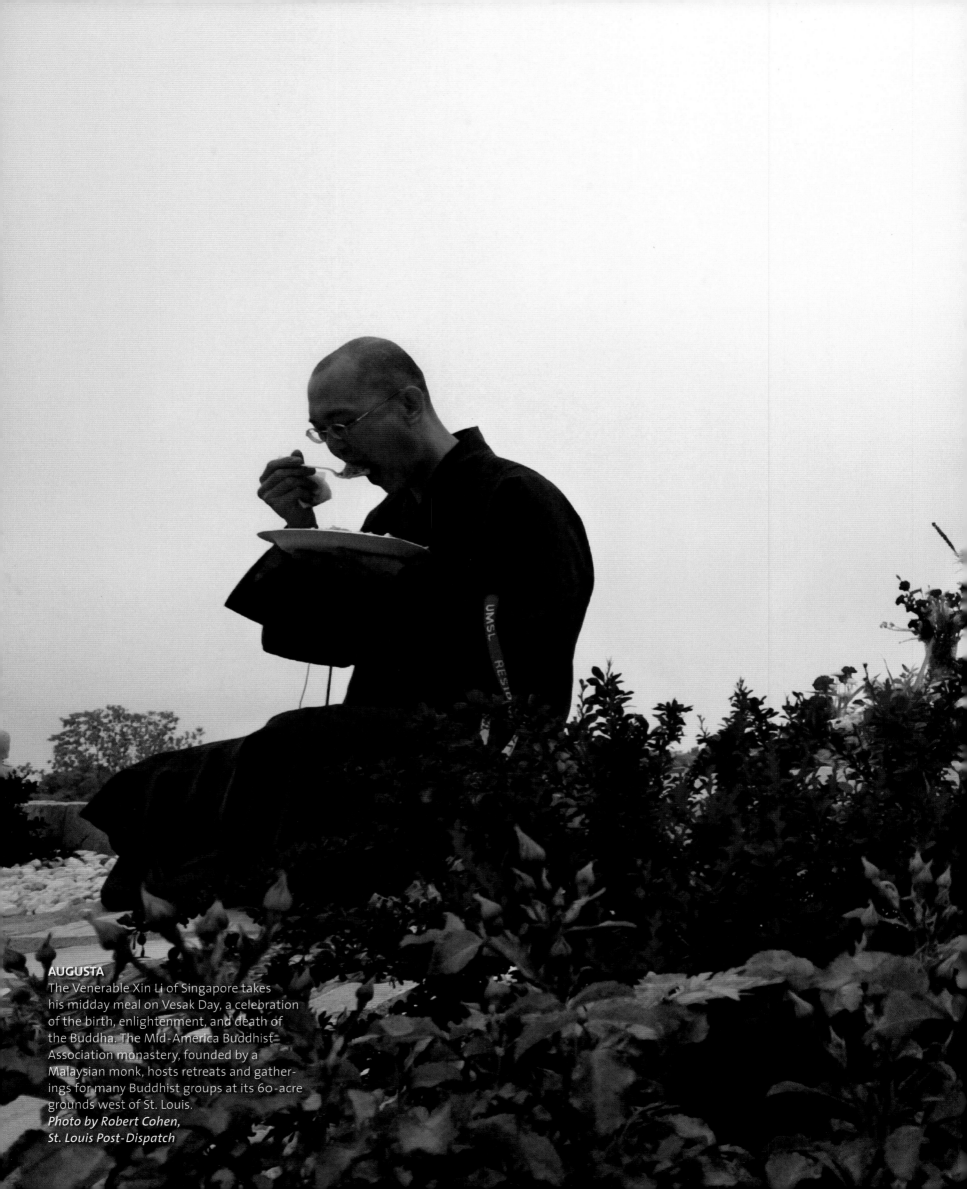

AUGUSTA
The Venerable Xin Li of Singapore takes his midday meal on Vesak Day, a celebration of the birth, enlightenment, and death of the Buddha. The Mid-America Buddhist Association monastery, founded by a Malaysian monk, hosts retreats and gatherings for many Buddhist groups at its 60-acre grounds west of St. Louis.
Photo by Robert Cohen,
St. Louis Post-Dispatch

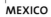

MEXICO
Acolytes Mercedes Blackwell and her brother T.J.
take it upon themselves to prepare the altar
before services at Ward Chapel A.M.E. Church.
Photo by Seth Wenig

CONCEPTION

After Lauds, Brother Blaise Bonderer waits for his wheat toast in the Conception Abbey dining hall. The 63-year-old monk entered the Benedictine monastery 43 years ago. As groundskeeper, his days consist of prayer and work, particularly tending to the abbey's apple orchard. Sixty-five monks live in the monastery, most of whom teach at Conception Seminary College.
Photo by Ival Lawhon, Jr.

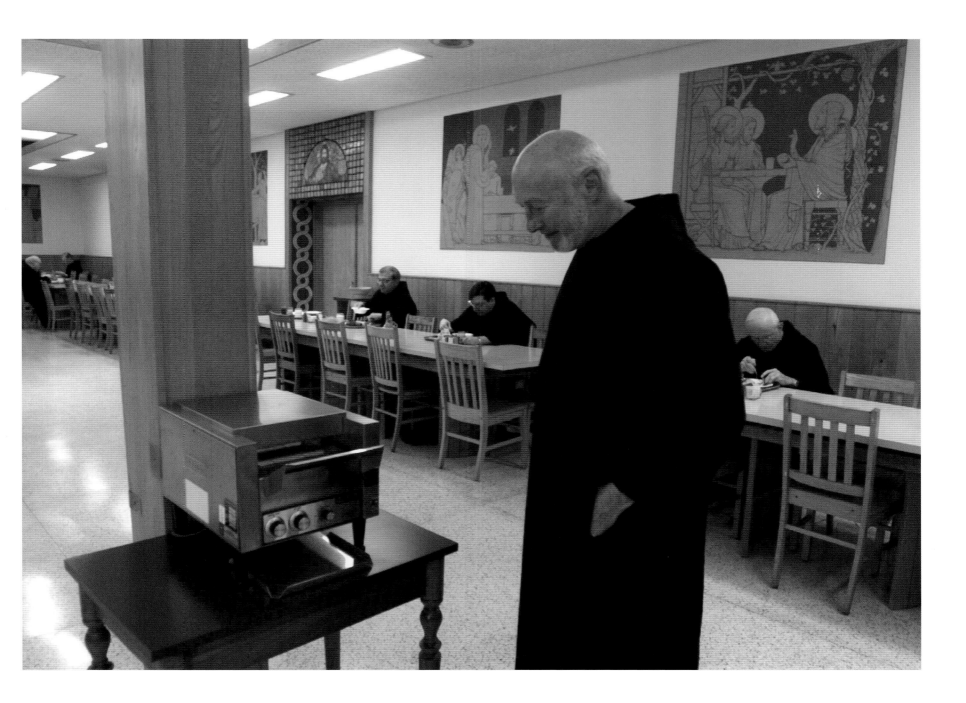

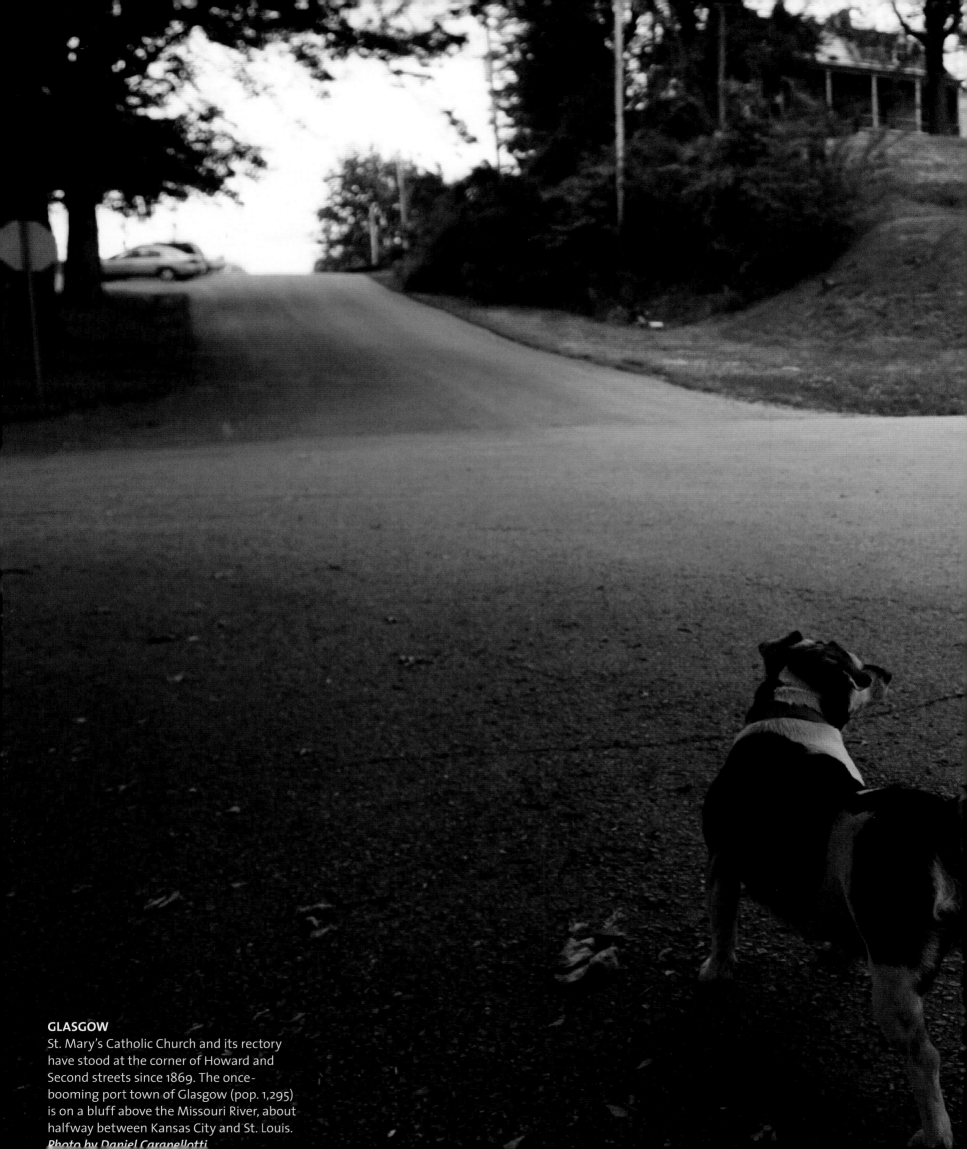

GLASGOW
St. Mary's Catholic Church and its rectory
have stood at the corner of Howard and
Second streets since 1869. The once-
booming port town of Glasgow (pop. 1,295)
is on a bluff above the Missouri River, about
halfway between Kansas City and St. Louis.
Photo by Daniel Caravellotti

Our Town

ST. LOUIS
On the last leg of their 12-day, 18-state road trip,
Joy and Randy Mardis of Boaz, Alabama, zoom
in on the Gateway Arch. "It's overwhelming,"
says Joy.
Photo by Laurie Skrivan, St. Louis Post-Dispatch

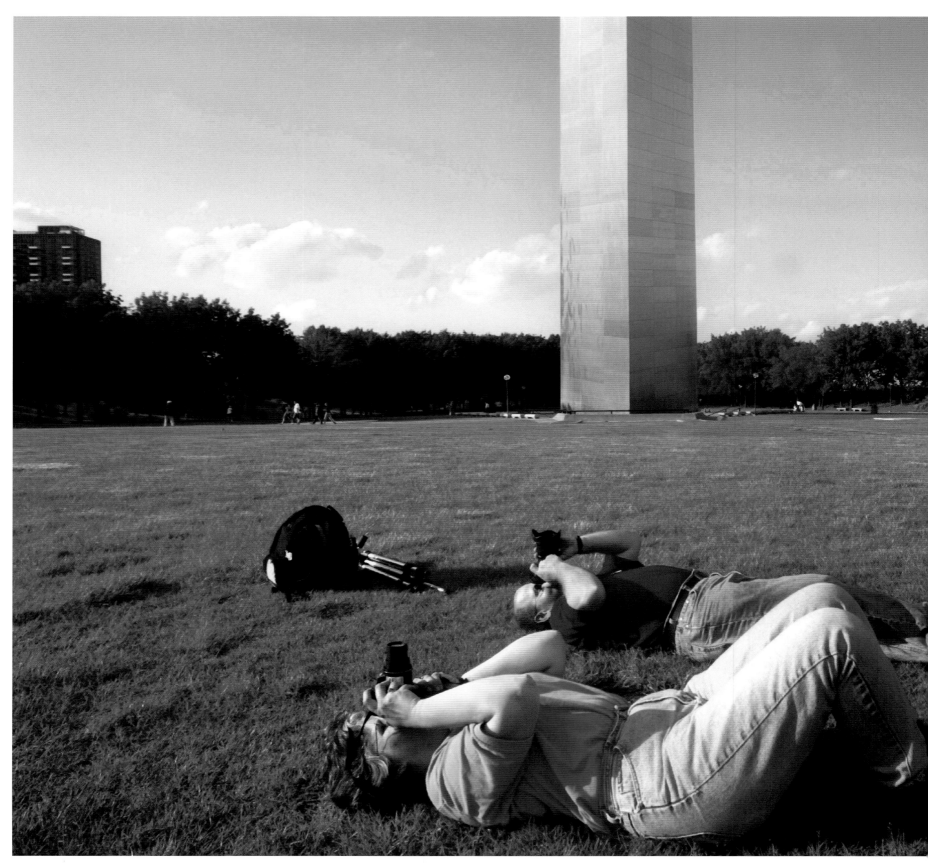

ST. LOUIS

The MacArthur Bridge (formerly the Municipal Free Bridge) opened to highway and railroad traffic in 1917. The bridge carried Route 66 across the Mississippi until the city of St. Louis halted car traffic on the bridge's crumbling upper deck in 1981.

Photo by Robert Cohen, St. Louis Post-Dispatch

ST. LOUIS

All the survey measurements for construction of the Gateway Arch were taken at night to avoid solar distortion. To ensure that the legs would meet at the top, the margin of error for all of the precomputer calculations was $\frac{1}{64}$th of an inch. Built of 142 stainless steel sections and weighing in at 17,246 tons, the arch can withstand hurricane winds of 150 mph.

Photo by Laurie Skrivan, St. Louis Post-Dispatch

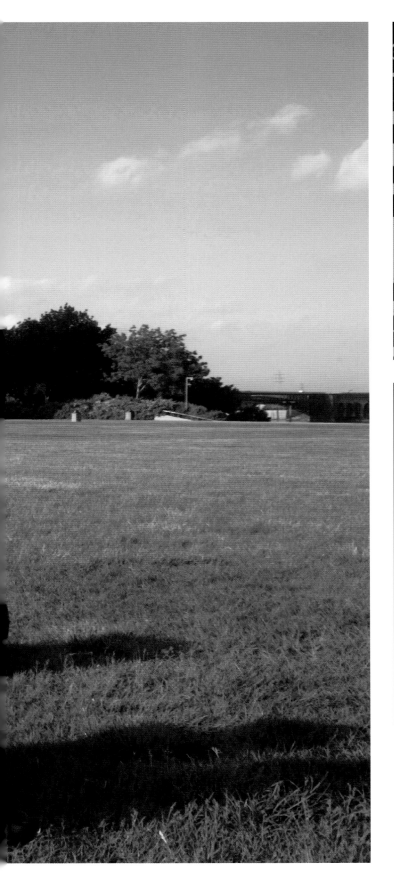

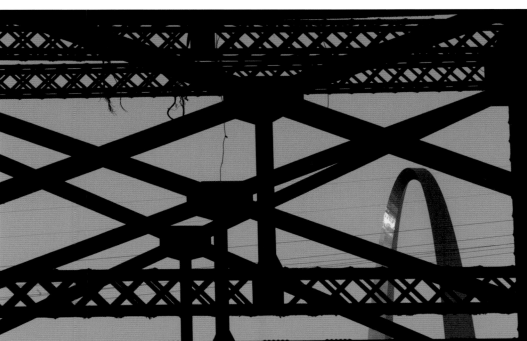

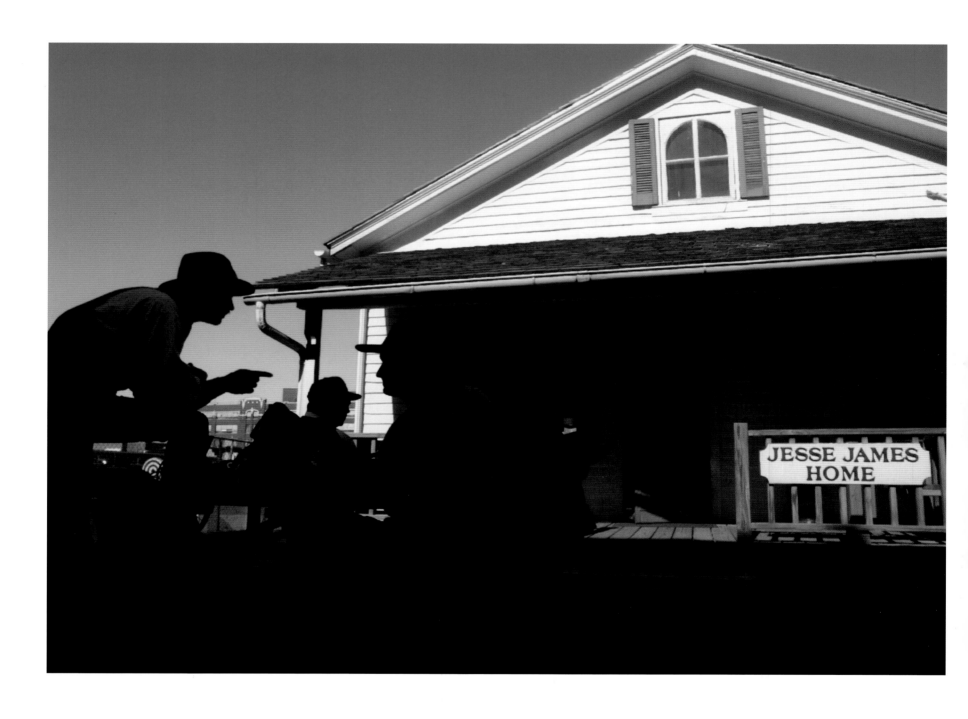

ST. JOSEPH
History Channel actors recreate a Wild West scene outside the home where outlaw Jesse James died in 1882. After 16 years of robbing banks, the 34-year-old fugitive changed his name and settled into a quiet life with his wife and two children on a hilltop looking out on St. Joseph.
Photos by Eric Keith

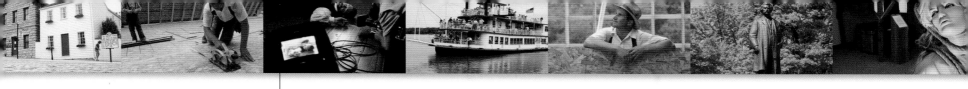

ST. JOSEPH
The outlaw returns—this time on cable television. Actor Chip Houser reenacts the final moments of the legendary bandit's death while cameraman Neil Rettis captures his dramatic denouement on film. Fellow gang member Bob Ford assassinated the reformed fugitive to collect on a $10,000 bounty from the state of Missouri.

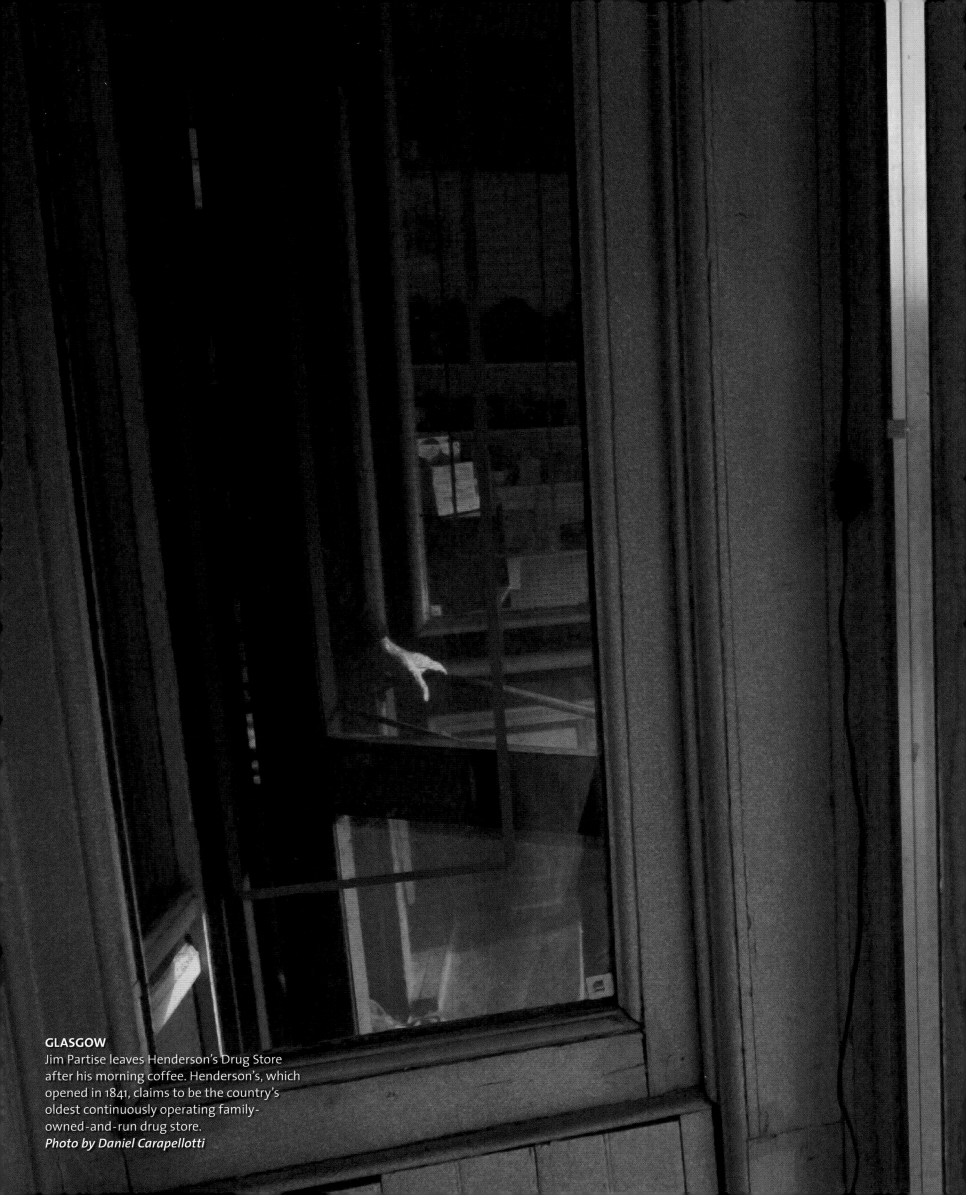

GLASGOW
Jim Partise leaves Henderson's Drug Store
after his morning coffee. Henderson's, which
opened in 1841, claims to be the country's
oldest continuously operating family-
owned-and-run drug store.
Photo by Daniel Carapellotti

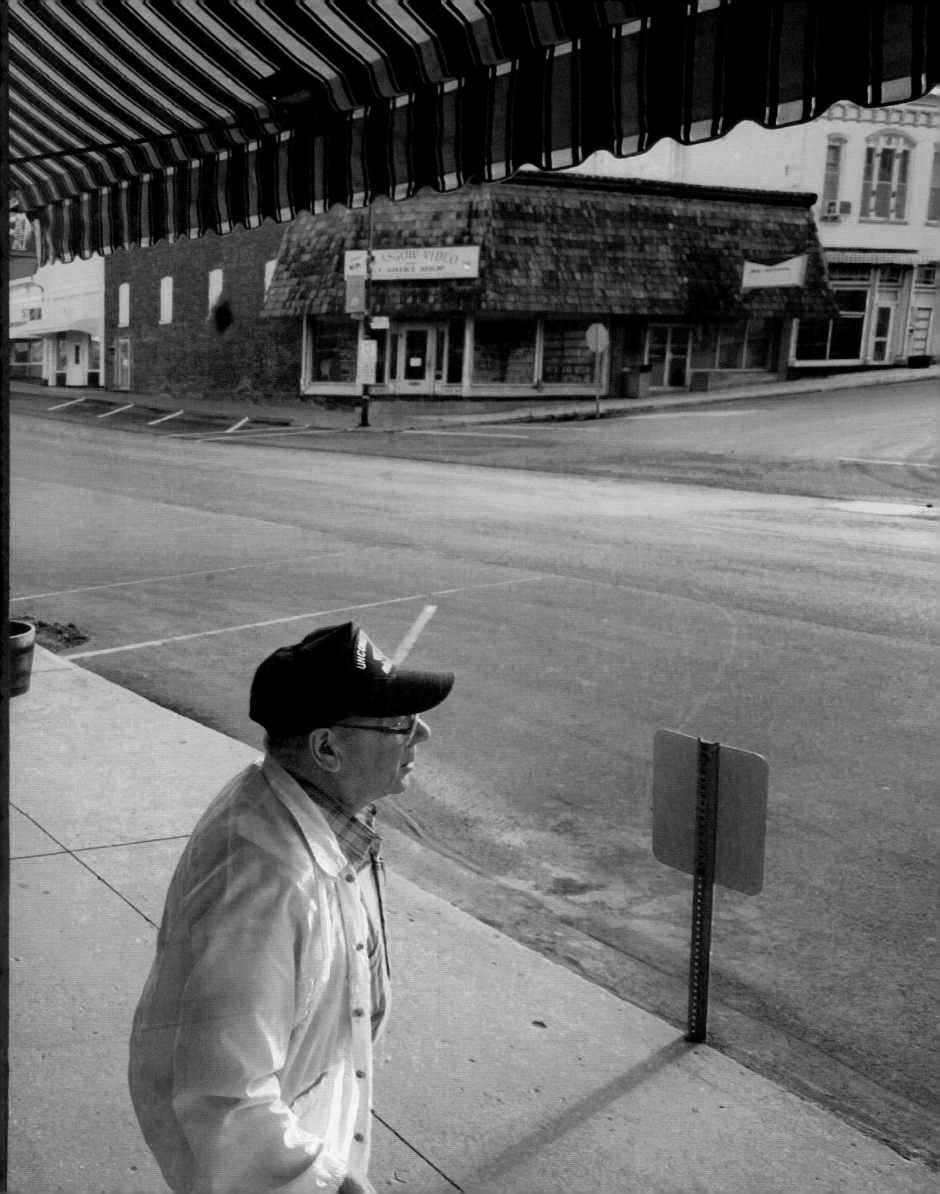

GLASGOW

For 12 years, Jim Partise has shown up at Henderson's at 7 every morning except Sunday to make coffee. Most of the coffee drinkers are fellow World War II veterans. They sit, sip, and tell war stories. Partise served in the Air Force at Iwo Jima. Is he a local hero? "I'm not a hero," he says, "but I'm local."
Photos by Daniel Carapellotti

GLASGOW

Henderson's allows Partise behind the counter to pour the morning coffee for his buddies. Partise pays for his own coffee—a cup of Folgers brew goes for 25 cents.

KANSAS CITY

The spectacular North Waiting Room at Union Station reminds visitors of days when Kansas City was a major railroad hub, and train travel seduced America with the promise of elegance and adventure. The station, the third largest in America, opened in 1914 and was restored in 1999.

Photos by Ival Lawhon, Jr.

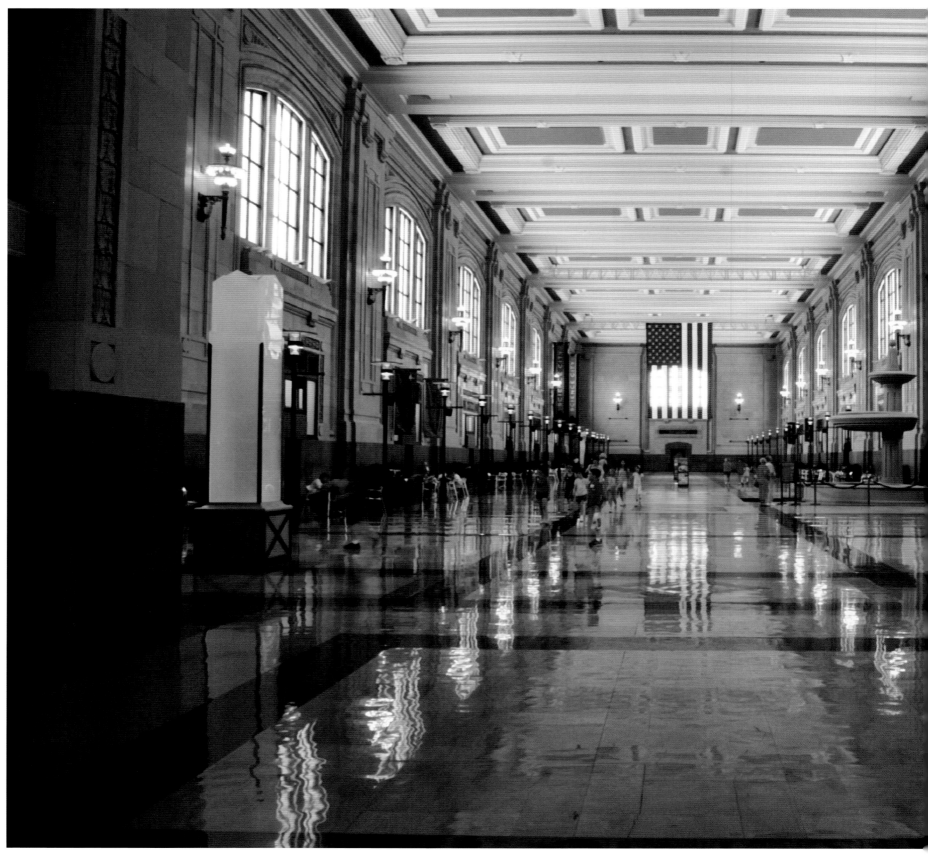

KANSAS CITY

On a day trip to Kansas City from Overland Park, Mary Dougherty, Sally Vandemark, and Charlotte Hamilton rendezvous in Union Station. The ladies got their hats at Fritz's Railroad Restaurant in the Crown Center nearby.

KANSAS CITY

Kansas City, Here I Come: In the fall of 2002, Union Station welcomed transcontinental rail passengers for the first time in 17 years. Major Amtrak spokes link the city to Chicago, St. Louis, Omaha, Tulsa, and Los Angeles.

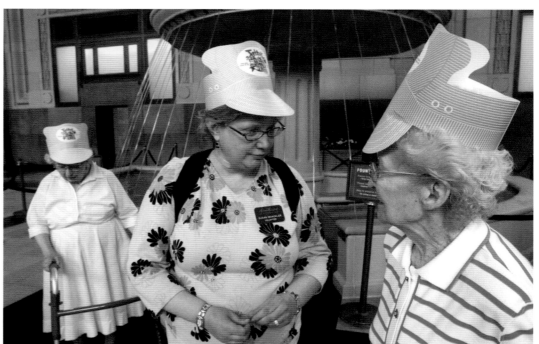

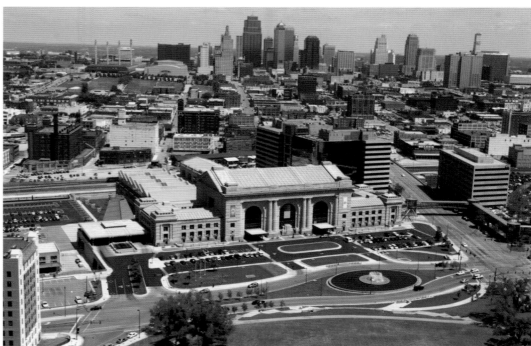

HERMANN
Overlooking the Missouri River, the K&S Bait Shop tries hard to attract fishermen and tourists. Owner Dallas Kropp bought the tiny store in 1995, after his recovery from a heart attack. Born and raised in Hermann, Kropp has never left. "I'll be here 'til I die," he says.
Photo by Chris Stanfield

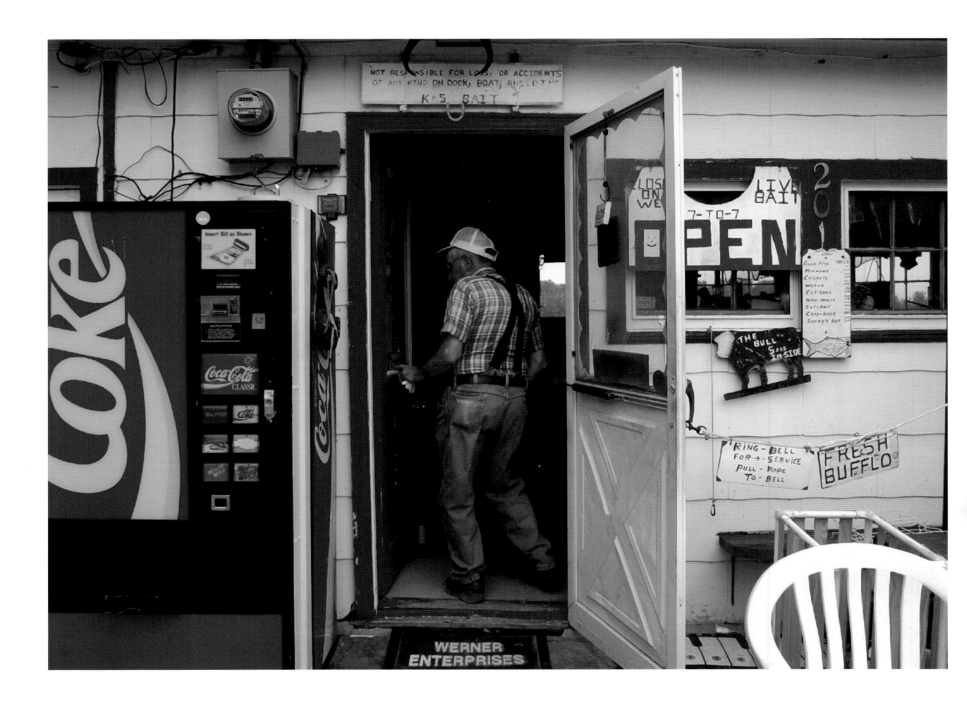

CANTON

Store manager Susie Wood was home when warning came of an F-2 tornado (winds up to 157 mph). Wood and her daughter drove to the store to evacuate customers and ducked under a desk as the twister hit the store. Although the back of the building blew off and a dumpster landed on the desk, the two emerged unhurt—unlike Wood's Beretta.

Photo by Sherry Skinner

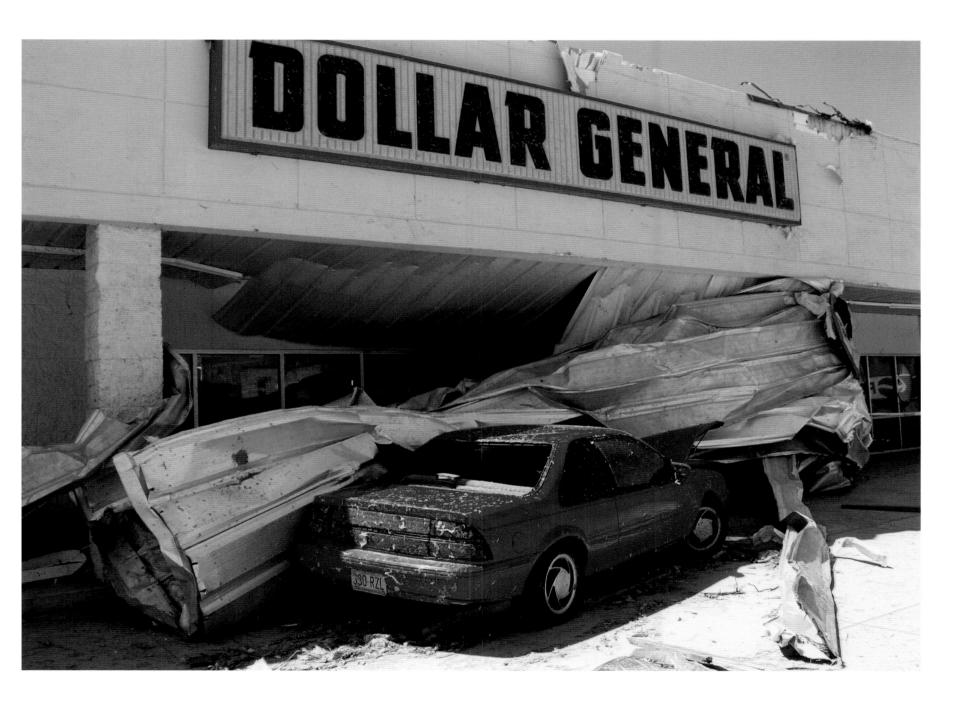

MEXICO
Attention! Cadets line up in three evenly spaced rows at 7:15 a.m. before marching in unison to the mess hall for breakfast.
Photos by David M. Barreda, University of Missouri

MEXICO
Cadet major Leonard Stephens's big pipes earned him the position of lead tuba player at the Missouri Military Academy's commencement exercises. Ninety-six percent of the academy's graduates go on to attend college including Stephens, who was the top-ranking cadet in his 2003 graduating class.

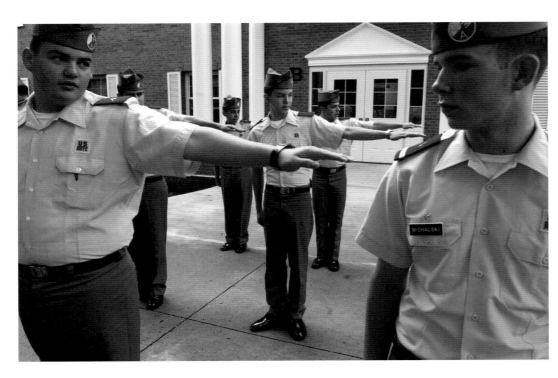

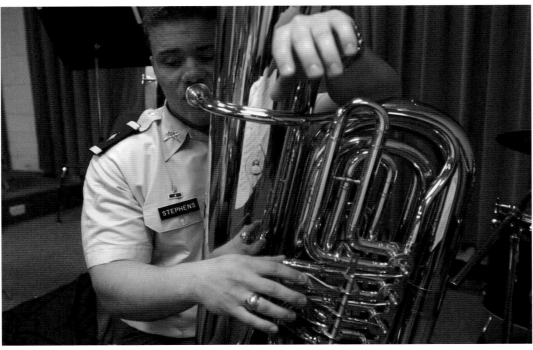

MEXICO
At the Missouri Military Academy, conduct code infractions are recorded on pink slips posted outside the campus's main building. Each morning, cadets scan the dreaded register to see who has been "pink-listed"—a designation that means extra chores.

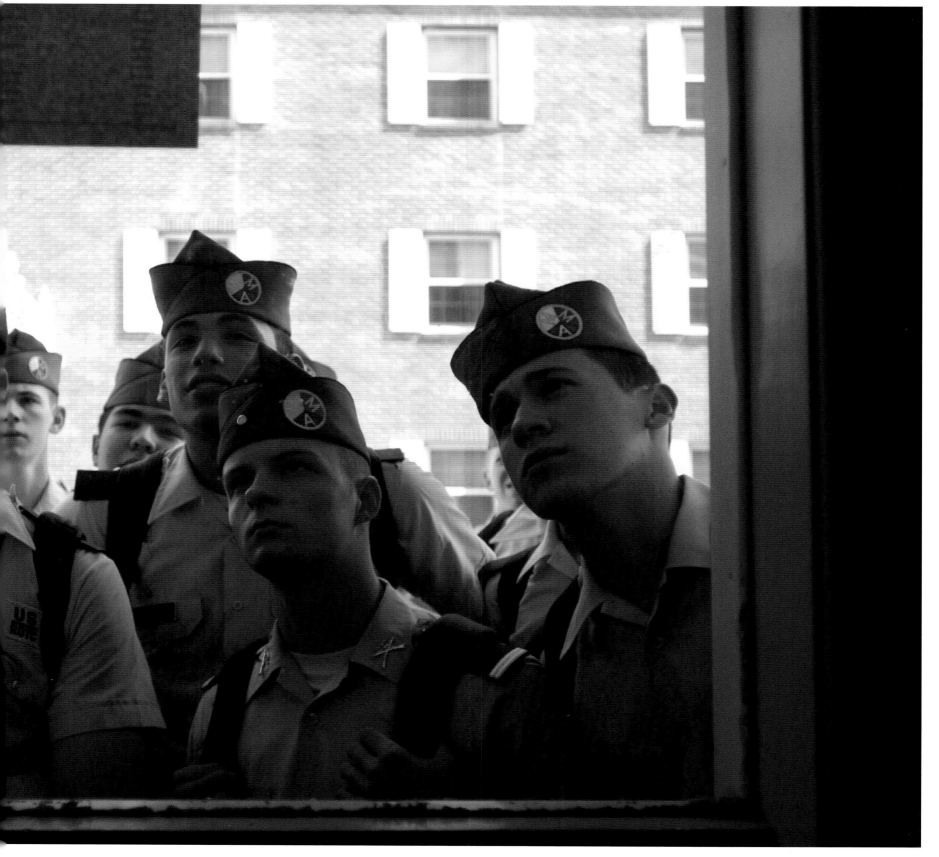

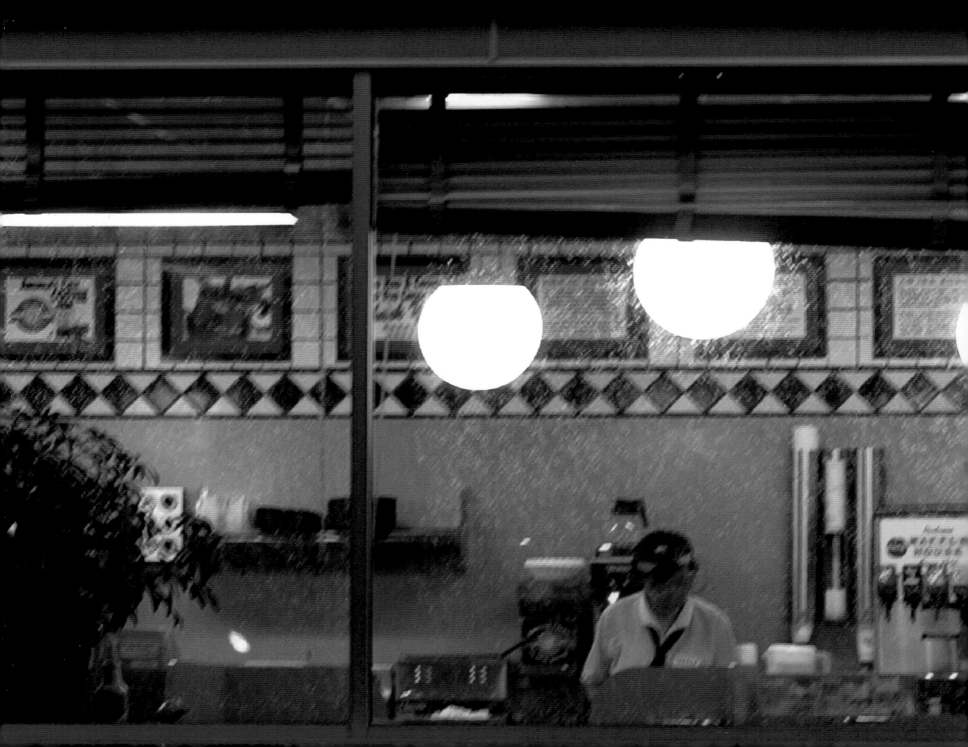

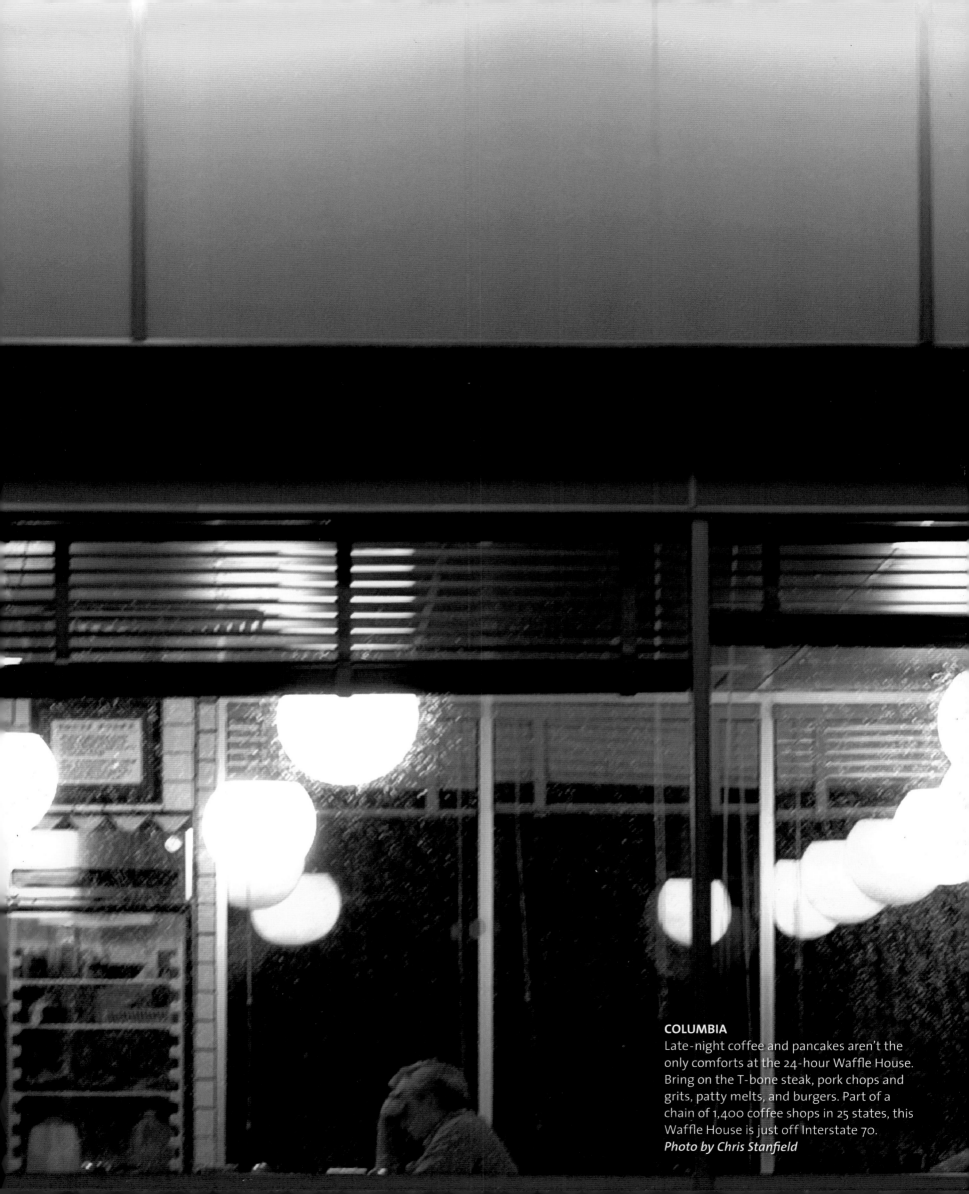

COLUMBIA
Late-night coffee and pancakes aren't the only comforts at the 24-hour Waffle House. Bring on the T-bone steak, pork chops and grits, patty melts, and burgers. Part of a chain of 1,400 coffee shops in 25 states, this Waffle House is just off Interstate 70.
Photo by Chris Stanfield

MARY'S HOME
The Corner Market sells food, clothes, and other necessities to folks who'd rather not make the 30-mile drive to Jefferson City. The town's folklore has it that statues of the Virgin Mary proliferated in the old, end-of-the-road settlement—thus the name.
Photo by Brian W. Kratzer, University of Missouri

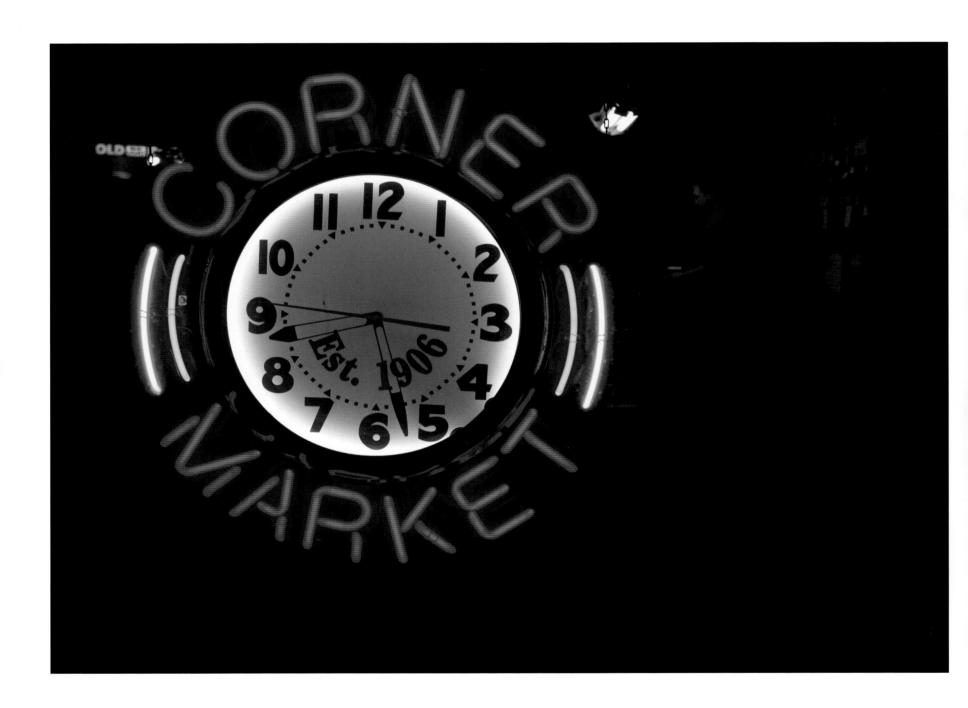

NEAR TAYLOR

Highway 6 runs 208 miles across northern Missouri, starting near the Illinois border at Taylor and stringing together small towns such as Ewing, Edina, Kirksville, and Gallatin before ending near St. Joseph.
Photo by Todd Weddle

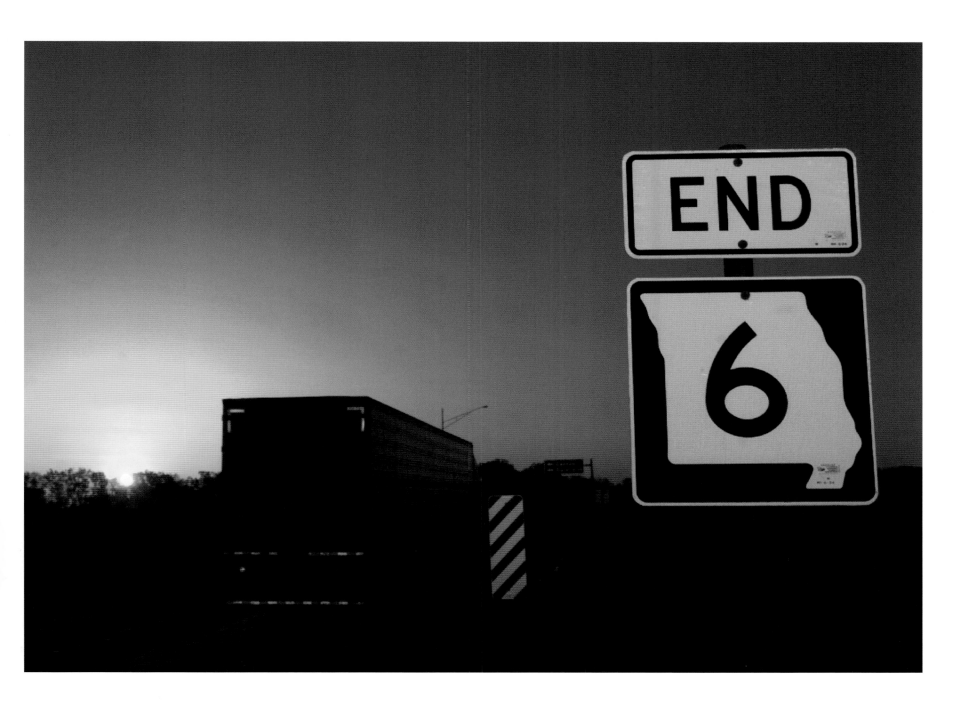

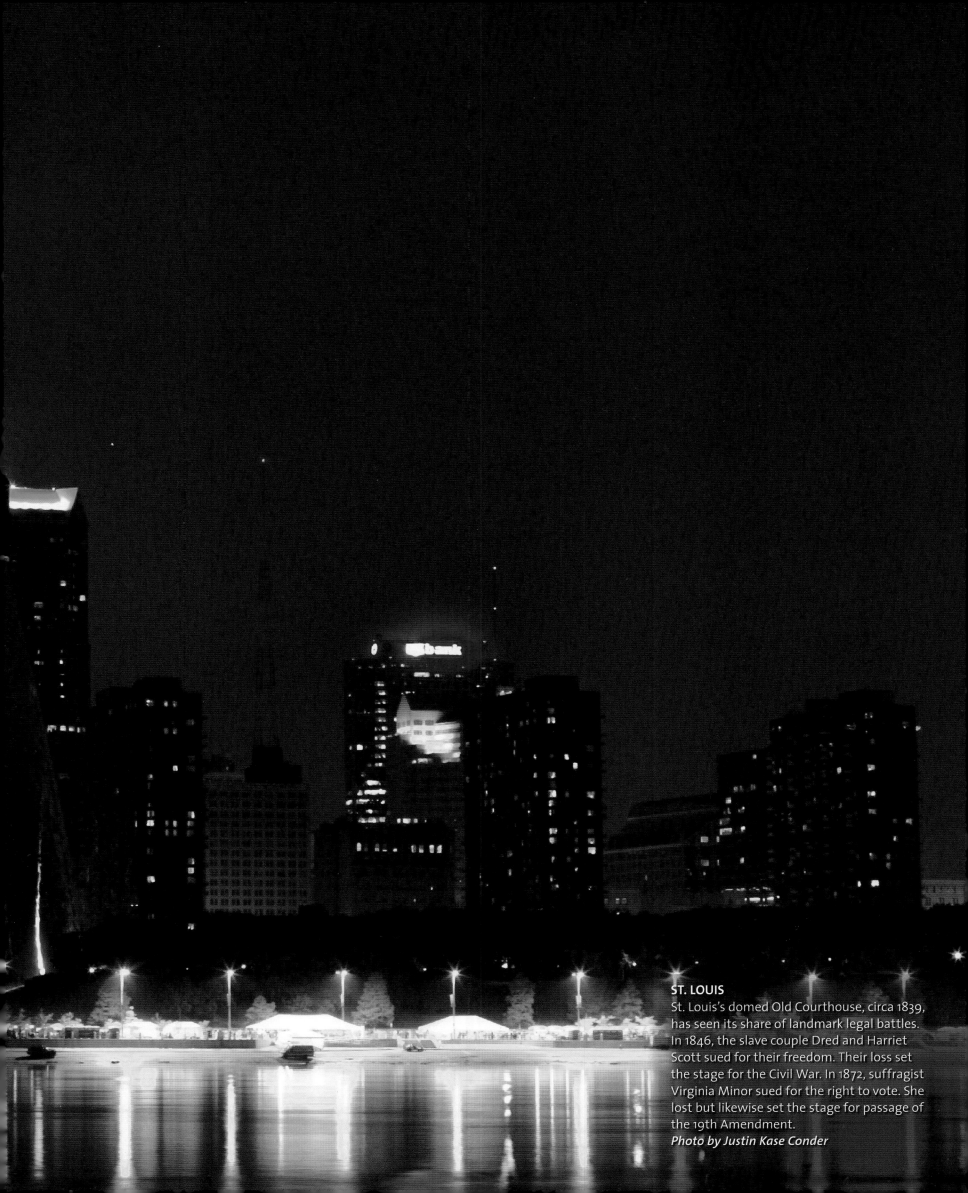

ST. LOUIS
St. Louis's domed Old Courthouse, circa 1839, has seen its share of landmark legal battles. In 1846, the slave couple Dred and Harriet Scott sued for their freedom. Their loss set the stage for the Civil War. In 1872, suffragist Virginia Minor sued for the right to vote. She lost but likewise set the stage for passage of the 19th Amendment.
Photo by Justin Kase Conder

How It Worked

T he week of May 12-18, 2003, more than 25,000 professional and amateur photographers spread out across the nation to shoot over a million digital photographs with the goal of capturing the essence of daily life in America.

The professional photographers were equipped with Adobe Photoshop and Adobe Album software, Olympus C-5050 digital cameras, and Lexar Media's high-speed compact flash cards.

The 1,000 professional contract photographers plus another 5,000 stringers and students sent their images via FTP (file transfer protocol) directly to the *America 24/7* website. Meanwhile, thousands of amateur photographers uploaded their images to Snapfish's servers.

At *America 24/7*'s Mission Control headquarters, located at CNET in San Francisco, dozens of picture editors from the nation's most prestigious publications culled the images down to 25,000 of the very best, using Photo Mechanic by Camera Bits. These photos were transferred into Webware's ActiveMedia Digital Asset Management (DAM) system, which served as a central image library and enabled the designers to track, search, distribute, and reformat the images for the creation of the 51 books, foreign language editions, web and magazine syndication, posters, and exhibitions.

Once in the DAM, images were optimized (and in some cases resampled to increase image resolution) using Adobe Photoshop. Adobe InDesign and Adobe InCopy were used to design and produce the 51 books, which were edited and reviewed in multiple locations around the world in the form of Adobe Acrobat PDFs. Epson Stylus printers were used for photo proofing and to produce large-format images for exhibitions. The companies providing support for the *America 24/7* project offer many of the essential components for anyone building a digital darkroom. We encourage you to read more on the following pages about their respective roles in making *America 24/7* possible.

SHOOT

7 images maximum uploaded to online Snapfish accounts → **Snapfish** servers

10s of 1,000s of amateurs

Photographers use **Adobe Photoshop** to convert RAW images to JPEG, and Photo Mechanic tagging software to add data

1,000 professionals with **Olympus** C-5050 cameras and **Lexar Media** compact flash cards

1,000s of stringers & students

Toolkit, registration info & password via email to photographers' laptops

Printer

InDesign layouts output via **Acrobat** to PDF format

5 graphic design and production teams

51 books: one national, 50 states

Produced by 24/7 Media, published by DK Publishing

50 state posters designed by 50 AIGA member firms

24/7

DESIGN & PUBLISH

SUBMIT

Amateur submission editors work on theme-of-day photos

Preclick processor adds caption data to pictures

America 24/7 website

FTP site

powered by Apple Xserve RAID

FTP accounts for all photographers created via registration

Adobe Acrobat PDF contracts with digital signature

Snapfish editing interface

All images

plus **Adobe InDesign** templates

Private LAN within CNET

Specific te images

MISSION CONTROL Database

WebWare Digital Asset Management

Worldwide picture syndication

Images to pson printers photo exhibit

Judging and selection by America's top picture editors flown in by JetBlue to Mission Control at CNET

documentary

SELECT

Diagram by Nigel Holmes

About Our Sponsors

America 24/7 gave digital photographers of all levels the opportunity to share their visions of what it means to live in the United States. This project was made possible by a digital photography revolution that is dramatically changing and improving picture-taking for professionals and amateurs alike. And an Adobe product, Photoshop®, has been at the center of this sea change.

Adobe's products reflect our customers' passion for the creative process, be it the photographer, graphic designer, layout artist, or printer. Adobe is the Publishing and Imaging Software Partner for *America 24/7* and products such as Adobe InDesign®, Photoshop, Acrobat®, and Illustrator® were used to produce this stunning book in a matter of weeks. We hope that our software has helped do justice to the mythic images, contributed by well-known photographers and the inspired hobbyist.

Adobe is proud to be a lead sponsor of *America 24/7*, a project that celebrates the vibrancy of the American spirit: the same spirit that helped found Adobe and inspires our employees and customers to deliver the very best.

Bruce Chizen
President and CEO
Adobe Systems Incorporated

Olympus, a global technology leader in designing precision healthcare solutions and innovative consumer electronics, is proud to be the official digital camera sponsor of *America 24/7*. The opportunity to introduce Americans from coast to coast to the thrill, excitement, and possibility of digital photography makes the vision behind this book a perfect fit for Olympus, a leader in digital cameras since 1996.

For most people, the essence of digital photography is best grasped through firsthand experience with the technology, which is precisely what *America 24/7* is about. We understand that direct experience is the pathway to inspiration, and welcome opportunities like this sponsorship to bring the power of the digital experience into the lives of people everywhere. To Olympus, *America 24/7* offers a platform to help realize a core mission: to deliver and make accessible the power of the digital experience to millions of American photographers, amateurs, and professionals alike.

The 1,000 professional photographers contracted to shoot on the America 24/7 project were all equipped with Olympus C-5050 digital cameras. Like all Olympus products, the C-5050 is offered by a company well known for designing, manufacturing, and servicing products used by professionals to perform their work, every day. Olympus is a customer-centric company committed to working one-

to-one with a diverse group of professionals. From biomedical researchers who use our clinical microscopes, to doctors who perform life-saving procedures with our endoscopes, to professional photographers who use cameras in their daily work, Olympus is a trusted brand.

The digital imaging technology involved with *America 24/7* has enabled the soul of America to be visually conveyed, not just by professional observers, but by the American public who participated in this project—the very people who collectively breath life into this country's existence each day.

We are proud to be enabling so many photographers to capture the pictures on these pages that tell the story of who we are as a nation. From sea to shining sea, digital imagery allows us to connect to one another in ways we never dreamed possible.

At Olympus, our ideas have proliferated as rapidly as technology has evolved. We have channeled these visions into breakthrough products and solutions to meet the demands of our changing world-products like microscopes, endoscopes, and digital voice recorders, supported by the highly regarded training, educational, and consulting services we offer our customers.

Today, 83 years after we introduced our first microscope, we remain as young, as curious, and as committed as ever.

Lexar Media has grown from the digital photography revolution, which is why we are proud to have supplied the digital memory cards used in the America 24/7 project. Lexar Media's high-performance memory cards utilize our unique and patented controller coupled with high-speed flash memory from Samsung, the world's largest flash memory supplier. This powerful combination brings out the ultimate performance of any digital camera.

Photographers who demand the most from their equipment choose our products for their advanced features like write speeds up to 40X, Write Acceleration technology for enabled cameras, and Image Rescue, which recovers previously deleted or lost images. Leading camera manufacturers bundle Lexar Media digital memory cards with their cameras because they value its performance and reliability.

Lexar Media is at the forefront of digital photography as it transforms picture-taking worldwide, and we will continue to be a leader with new and innovative solutions for professionals and amateurs alike.

Snapfish, which developed the technology behind the *America 24/7* amateur photo event, is a leading online photo service, with more than 5 million members and 100 million photos posted online. Snapfish enables both film and digital camera owners to share, print, and store their most important photo memories, at prices that cannot be equaled. Digital camera users upload photos into a password-protected online album for free. Users can also order film-quality prints on professional photographic paper for as low as 25¢. Film camera users get a full set of prints, plus online sharing and storage, for just $2.99 per roll.

Founded in 1995, eBay created a powerful platform for the sale of goods and services by a passionate community of individuals and businesses. On any given day, there are millions of items across thousands of categories for sale on eBay. eBay enables trade on a local, national and international basis with customized sites in markets around the world.

Through an array of services, such as its payment solution provider PayPal, eBay is enabling global e-commerce for an ever-growing online community.

JetBlue Airways is proud to be *America 24/7's* preferred carrier, flying photographers, photo editors, and organizers across the United States.

Winner of Condé Nast Traveler's Readers' Choice Awards for Best Domestic Airline 2002, JetBlue provides friendly service and low fares for travelers in 22 cities in nine states across America.

On behalf of JetBlue's 5,000 crew members, we're excited to be involved in this remarkable project, and for the opportunity to serve American travelers each and every day, coast to coast, 24/7.

Digital Pond has been a leading creator of large graphic displays for museums, corporations, trade shows, retail environments and fine art since 1992.

We were proud to bring together our creative, print and display capabilities to produce signage and displays for mission control, critical retouching for numerous key images for the book, and art galleries for the New York Public Library and Bryant Park.

The Pond's team and SplashPic® Online service enabled us to nimbly design, produce and install over 200 large graphic panels in two NYC locations within the truly "24/7" production schedule of less than ten days.

WebWare Corporation is pleased to be a major sponsor of the America 24/7 project. We take pride in being part of a groundbreaking adventure that is stretching the boundaries—and the imagination—in digital photography, digital asset management, publishing, news, and global events.

Our ActiveMedia Enterprise™ digital asset management software is the "nerve center" of *America 24/7*, the central repository for managing, sharing, and collaborating on the project's photographs. From photo editors and book publishers to 24/7's media relations and marketing personnel, ActiveMedia provides the application support that links all facets of the project team to the content worldwide.

WebWare helps Global 2000 firms securely manage, reuse, and distribute media assets locally or globally. Its suite of ActiveMedia software products provide powerful media services platforms for integrating rich media into content management systems marketing and communication portals; web publishing systems; and e-commerce portals.

Google's mission is to organize the world's information and make it universally accessible and useful.

With our focus on plucking just the right answer from an ocean of data, we were naturally drawn to the America 24/7 project. The book you hold is a compendium of images of American life distilled from thousands of photographs and infinite possibilities. Are you looking for emotion? Narrative? Shadows? Light? It's all here, thanks to a multitude of photographers and writers creating links between you, the reader, and a sea of wonderful stories. We celebrate the connections that constitute the human experience and are pleased to help engender them. And we're pleased to have been a small part of this project, which captures the results of that interaction so vividly, so dynamically, and so dramatically.

Special thanks to additional contributors: FileMaker, Apple, Camera Bits, LaCie, Now Software, Preclick, Outpost Digital, Xerox, Microsoft, WoodWing Software, net-linx Publishing Solutions, and Radical Media. The Savoy Hotel, San Francisco; The Pan Pacific, San Francisco; Four Seasons Hotel, San Francisco; and The Queen Anne Hotel. Photography editing facilities were generously hosted by CNET Networks, Inc.

Participating Photographers

Coordinator: Larry Coyne, Director of Photography, *St. Louis Post-Dispatch*

David M. Barreda, University of Missouri
Bud Kani
Lisa Waddell Buser
Daniel Carapellotti
Robert Cohen, *St. Louis Post-Dispatch*
Justin Kase Conder
Dean Curtis
Alex Duenwald
Sara Andrea Fajardo
Tyson Hofsommer
Eric Keith
Brian W. Kratzer, University of Missouri
Randall Kriewall
Ival Lawhon, Jr.
Bob Linder
Tammy Ljungblad
Dawn Majors, *St. Louis Post-Dispatch*

Don Parsons
L.G. Patterson
Richard Petty Photography
Teak Phillips
Jimmie Presley, University of Missouri
Earl Richardson
Andrea Haley Scott, *St. Louis Post-Dispatch*
Sherry Skinner
Laurie Skrivan, *St. Louis Post-Dispatch*
Chris Stanfield
Jessica A. Stewart
Rich Sugg
Todd Weddle
Seth Wenig
Catherine Williamson
Randall Wood

Thumbnail Picture Credits

Credits for thumbnail photographs are listed by the page number and are in order from left to right.

22 Brian W. Kratzer, University of Missouri
Brian W. Kratzer, University of Missouri
Brian W. Kratzer, University of Missouri
Brian W. Kratzer, University of Missouri
Sherry Skinner
Brian W. Kratzer, University of Missouri
Brian W. Kratzer, University of Missouri

23 Corey Eli Haynes
Sherry Skinner
Sara Andrea Fajardo
Sara Andrea Fajardo
Sara Andrea Fajardo
Corey Eli Haynes
Sara Andrea Fajardo

24 Brian W. Kratzer, University of Missouri
Lisa Waddell Buser
Laurie Skrivan, *St. Louis Post-Dispatch*
Justin Kase Conder
Corey Eli Haynes
Justin Kase Conder
Sherry Skinner

25 Lisa Waddell Buser
Sherry Skinner
Lisa Waddell Buser
Sherry Skinner
Sherry Skinner
Chris Stanfield
Sherry Skinner

26 Justin Kase Conder
Brian W. Kratzer, University of Missouri
Patrick Menihan
Ival Lawhon, Jr.
Michael R. Merit
Laurie Skrivan, *St. Louis Post-Dispatch*
Brian W. Kratzer, University of Missouri

27 Michael R. Merit
Brud Jones
Seth Wenig
Seth Wenig
Seth Wenig
Todd Weddle
Ellen E. Thompson

30 Jessica Slack
Eric Keith
Jessica Slack
Ival Lawhon, Jr.
L.G. Patterson
Jessica Slack
Laurie Skrivan, *St. Louis Post-Dispatch*

31 L.G. Patterson
Jessica Slack
L.G. Patterson
Bill Pappas, University of Arkansas
Bill Pappas, University of Arkansas
Lisa Waddell Buser
Laurie Skrivan, *St. Louis Post-Dispatch*

32 Dean Curtis
Dean Curtis
Dean Curtis
Dean Curtis
Dean Curtis
Dean Curtis
Sherry Skinner

33 Chris Stanfield
Dean Curtis
Corey Eli Haynes
Dean Curtis
Dean Curtis
Dean Curtis
Dean Curtis

36 Seth Wenig
Chris Stanfield
Seth Wenig
Eric Keith
Seth Wenig
Eric Keith
Seth Wenig

37 Sherry Skinner
Sherry Skinner
Seth Wenig
Ellen E. Thompson
Seth Wenig
Bill Pappas, University of Arkansas
Sherry Skinner

38 David M. Barreda, University of Missouri
Andrea Haley Scott, *St. Louis Post-Dispatch*

Corey Eli Haynes
Andrea Haley Scott, *St. Louis Post-Dispatch*
Corey Eli Haynes
Eric Keith
Andrea Haley Scott, *St. Louis Post-Dispatch*

39 Lisa Waddell Buser
David M. Barreda, University of Missouri
Bob Linder
Andrea Haley Scott, *St. Louis Post-Dispatch*
Todd Weddle
Todd Weddle
Andrea Haley Scott, *St. Louis Post-Dispatch*

42 Sherry Skinner
Eric Keith
Justin Kase Conder
Brian W. Kratzer, University of Missouri
Brian W. Kratzer, University of Missouri
Eric Keith
Corey Eli Haynes

43 Justin Kase Conder
Brian W. Kratzer, University of Missouri
Sherry Skinner
Eric Keith
Sherry Skinner
Sherry Skinner
Sherry Skinner

46 Brian W. Kratzer, University of Missouri
Robert Cohen, *St. Louis Post-Dispatch*
Dean Curtis
Robert Cohen, *St. Louis Post-Dispatch*
Robert Cohen, *St. Louis Post-Dispatch*
Justin Kase Conder
Robert Cohen, *St. Louis Post-Dispatch*

47 Robert Cohen, *St. Louis Post-Dispatch*
Robert Cohen, *St. Louis Post-Dispatch*
Robert Cohen, *St. Louis Post-Dispatch*
Robert Cohen, *St. Louis Post-Dispatch*
Corey Eli Haynes
Dean Curtis
Sherry Skinner

48 Michael R. Merit
Corey Eli Haynes
Seth Wenig
Robert Cohen, *St. Louis Post-Dispatch*
Laurie Skrivan, *St. Louis Post-Dispatch*
Seth Wenig
Robert Cohen, *St. Louis Post-Dispatch*

49 Sherry Skinner
Laurie Skrivan, *St. Louis Post-Dispatch*
Robert Cohen, *St. Louis Post-Dispatch*
Seth Wenig
Sherry Skinner
Robert Cohen, *St. Louis Post-Dispatch*
Michael R. Merit

58 Sherry Skinner
Teak Phillips
Seth Wenig
Sherry Skinner
Teak Phillips
Jessica Slack
Sherry Skinner

59 Jessica Slack
Teak Phillips
Sherry Skinner
Sherry Skinner
Teak Phillips
Teak Phillips
Teak Phillips

60 Brian W. Kratzer, University of Missouri
Brian W. Kratzer, University of Missouri
Brian W. Kratzer, University of Missouri

Lisa Waddell Buser
Ival Lawhon, Jr.
Sherry Skinner
Eric Keith

61 Chris Stanfield
Chris Stanfield
Chris Stanfield
Rena Cohen
Chris Stanfield
Lisa Waddell Buser
Chris Stanfield

62 Chris Stanfield
Jessica Slack
Eric Keith
Eric Keith
Seth Wenig
Earl Richardson
Sherry Skinner

63 Eric Keith
Todd Weddle
Earl Richardson
Sherry Skinner
Jessica Slack
Earl Richardson
Earl Richardson

68 Sherry Skinner
Justin Kase Conder
Rich Sugg
L.G. Patterson
Sherry Skinner
L.G. Patterson
Sherry Skinner

69 Justin Kase Conder
Sherry Skinner
L.G. Patterson
Sherry Skinner
Rich Sugg
Seth Wenig
L.G. Patterson

72 Chris Stanfield
Ival Lawhon, Jr.
Chris Stanfield
Eric Keith
Laurie Skrivan, *St. Louis Post-Dispatch*
Eric Keith
Ival Lawhon, Jr.

73 Eric Keith
Chris Stanfield
Laurie Skrivan, *St. Louis Post-Dispatch*
Ival Lawhon, Jr.
Laurie Skrivan, *St. Louis Post-Dispatch*
Eric Keith
Laurie Skrivan, *St. Louis Post-Dispatch*

74 Bob Linder
Eric Keith
Bob Linder
Bob Linder
Eric Keith
Bob Linder
Eric Keith

78 Dean Curtis
Dean Curtis
Dean Curtis
Chris Stanfield
Dean Curtis
Dean Curtis
Daniel Carapellotti

79 Sara Andrea Fajardo
Dean Curtis
Daniel Carapellotti
Daniel Carapellotti
Sara Andrea Fajardo
Sherry Skinner
Sherry Skinner

86 Sherry Skinner
Daniel Carapellotti
Laurie Skrivan, *St. Louis Post-Dispatch*
Allan E. Detrich
Laurie Skrivan, *St. Louis Post-Dispatch*
Richard Petty Photography
Daniel Carapellotti

87 Sherry Skinner
Todd Weddle
Jessica Slack
Sherry Skinner
Sherry Skinner
Todd Weddle
Allan E. Detrich

88 Jimmie Presley, University of Missouri
Jessica Slack
Allan E. Detrich
Jimmie Presley, University of Missouri
Richard Petty Photography
Eric Keith
Sherry Skinner

92 Sara Andrea Fajardo
Sara Andrea Fajardo
Sara Andrea Fajardo
Sherry Skinner
Brian W. Kratzer, University of Missouri
Sherry Skinner
Robert Cohen, *St. Louis Post-Dispatch*

93 Sherry Skinner
Brian W. Kratzer, University of Missouri
Brian W. Kratzer, University of Missouri
Sara Andrea Fajardo
Brian W. Kratzer, University of Missouri
Sherry Skinner
Brian W. Kratzer, University of Missouri

94 Sherry Skinner
Chris Stanfield
L.G. Patterson
Lisa Waddell Buser
Brud Jones
L.G. Patterson
L.G. Patterson

95 Justin Kase Conder
L.G. Patterson
Justin Kase Conder
L.G. Patterson
Sara Andrea Fajardo
L.G. Patterson
Sherry Skinner

98 Justin Kase Conder
L.G. Patterson
Chris Stanfield
Laurie Skrivan, *St. Louis Post-Dispatch*
Justin Kase Conder
Justin Kase Conder
Justin Kase Conder

99 Rich Sugg
Justin Kase Conder
Dean Curtis
Robert Cohen, *St. Louis Post-Dispatch*
Laurie Skrivan, *St. Louis Post-Dispatch*
Justin Kase Conder
Chris Stanfield

100 Sherry Skinner
Richard Petty Photography
Sara Andrea Fajardo
Sara Andrea Fajardo
Sara Andrea Fajardo
Sara Andrea Fajardo
Seth Wenig

101 Sherry Skinner
Sara Andrea Fajardo
Richard Petty Photography
Sara Andrea Fajardo

Sherry Skinner
Sherry Skinner
Sherry Skinner

102 Dean Curtis
David M. Barreda, University of Missouri
Chris Stanfield
Dean Curtis
David M. Barreda, University of Missouri
David M. Barreda, University of Missouri
David M. Barreda, University of Missouri

103 Jimmie Presley, University of Missouri
David M. Barreda, University of Missouri
Dean Curtis
David M. Barreda, University of Missouri
Dean Curtis
David M. Barreda, University of Missouri
Jimmie Presley, University of Missouri

106 Brian W. Kratzer,
University of Missouri
Eric Keith
Brian W. Kratzer, University of Missouri
Robert Cohen, *St. Louis Post-Dispatch*
Robert Cohen, *St. Louis Post-Dispatch*
Brian W. Kratzer, University of Missouri
Brian W. Kratzer, University of Missouri

107 Robert Cohen, *St. Louis Post-Dispatch*
Brian W. Kratzer, University of Missouri
Todd Weddle
Brian W. Kratzer, University of Missouri
Brian W. Kratzer, University of Missouri
Eric Keith
Robert Cohen, *St. Louis Post-Dispatch*

114 Bob Linder
Eric Keith
Brian W. Kratzer, University of Missouri
David M. Barreda, University of Missouri
David M. Barreda, University of Missouri
Brian W. Kratzer, University of Missouri
Bob Linder

115 David M. Barreda, University of
Missouri
Bob Linder
David M. Barreda, University of Missouri
Sara Andrea Fajardo
Brian W. Kratzer, University of Missouri
Bob Linder
Bob Linder

116 Robert Cohen, *St. Louis Post-Dispatch*
Bob Linder
Robert Cohen, *St. Louis Post-Dispatch*
Bob Linder
Bob Linder
Bob Linder
Bob Linder

118 Eduardo A. Molina
Daniel Carapellotti
Corey Eli Haynes
Corey Eli Haynes
Daniel Carapellotti
Daniel Carapellotti
Ival Lawhon, Jr.

119 Jake Steele
Daniel Carapellotti
Jimmie Presley, University of Missouri
Jimmie Presley, University of Missouri
Jimmie Presley, University of Missouri
Todd Weddle
Sherry Skinner

124 Ival Lawhon, Jr.
Rich Sugg
Lisa Waddell Buser

Jake Steele
Lisa Waddell Buser
Jake Steele
Andrea Haley Scott, *St. Louis Post-Dispatch*

125 Lisa Waddell Buser
Ival Lawhon, Jr.
Todd Weddle
Justin Kase Conder
Sherry Skinner
Todd Weddle
Justin Kase Conder

126 David M. Barreda,
University of Missouri
Corey Eli Haynes
David M. Barreda, University of Missouri
Corey Eli Haynes
David M. Barreda, University of Missouri
Jessica Slack
David M. Barreda, University of Missouri

127 Bob Linder
David M. Barreda, University of Missouri
Jimmie Presley, University of Missouri
Bob Linder
David M. Barreda, University of Missouri
Teak Phillips
David M. Barreda, University of Missouri

130 Ival Lawhon, Jr.
Chris Stanfield
Seth Wenig
Ival Lawhon, Jr.
Seth Wenig
Ival Lawhon, Jr.
Seth Wenig

131 Seth Wenig
Ival Lawhon, Jr.
Jimmie Presley, University of Missouri
Ival Lawhon, Jr.
Ival Lawhon, Jr.
Ival Lawhon, Jr.
Seth Wenig

134 Corey Eli Haynes
Justin Kase Conder
Laurie Skrivan, *St. Louis Post-Dispatch*
Corey Eli Haynes
Laurie Skrivan, *St. Louis Post-Dispatch*
Laurie Skrivan, *St. Louis Post-Dispatch*
Daniel Carapellotti

135 Laurie Skrivan, *St. Louis Post-Dispatch*
Robert Cohen, *St. Louis Post-Dispatch*
Eduardo A. Molina
Bill Pappas, University of Arkansas
Laurie Skrivan, *St. Louis Post-Dispatch*
Laurie Skrivan, *St. Louis Post-Dispatch*
Sherry Skinner

136 Ival Lawhon, Jr.
David M. Barreda, University of Missouri
Eric Keith
David M. Barreda, University of Missouri
Eric Keith
David M. Barreda, University of Missouri
Eric Keith

137 Sherry Skinner
David M. Barreda, University of Missouri
Eric Keith
Sherry Skinner
David M. Barreda, University of Missouri
Sherry Skinner
Eric Keith

140 Daniel Carapellotti
Daniel Carapellotti
Eric Keith
Daniel Carapellotti

Brud Jones
Daniel Carapellotti
Brud Jones

141 L.G. Patterson
Seth Wenig
Lisa Waddell Buser
Daniel Carapellotti
Bill Pappas, University of Arkansas
Seth Wenig
Seth Wenig

142 Ival Lawhon, Jr.
Ival Lawhon, Jr.
Sara Andrea Fajardo
Corey Eli Haynes
Ival Lawhon, Jr.
Sherry Skinner
Ival Lawhon, Jr.

143 Ival Lawhon, Jr.
Ival Lawhon, Jr.
Sherry Skinner
Sherry Skinner
Ival Lawhon, Jr.
Sherry Skinner
Ival Lawhon, Jr.

144 Sherry Skinner
Eric Keith
Chris Stanfield
Corey Eli Haynes
Chris Stanfield
Rena Cohen
Sherry Skinner

145 Eric Keith
Robert Cohen, *St. Louis Post-Dispatch*
Seth Wenig
Sara Andrea Fajardo
Sherry Skinner
Bob Linder
David M. Barreda, University of Missouri

146 Sherry Skinner
David M. Barreda, University of Missouri
Jimmie Presley, University of Missouri
David M. Barreda, University of Missouri
David M. Barreda, University of Missouri
Bob Linder
David M. Barreda, University of Missouri

147 David M. Barreda,
University of Missouri
Sara Andrea Fajardo
David M. Barreda, University of Missouri
Jimmie Presley, University of Missouri
David M. Barreda, University of Missouri
Sherry Skinner
Sherry Skinner

150 Brian W. Kratzer,
University of Missouri
Brian W. Kratzer, University of Missouri
Brian W. Kratzer, University of Missouri
Corey Eli Haynes
Brian W. Kratzer, University of Missouri
Daniel Carapellotti
Chris Stanfield

151 Daniel Carapellotti
Justin Kase Conder
Todd Weddle
Daniel Carapellotti
Justin Kase Conder
Corey Eli Haynes
Laurie Skrivan, *St. Louis Post-Dispatch*

Staff

The *America 24/7* series was imagined years ago by our friend Oscar Dystel, a publishing legend whose vision and enthusiasm have been a source of great inspiration.

We also wish to express our gratitude to our truly visionary publisher, DK.

Rick Smolan, Project Director
David Elliot Cohen, Project Director

Administrative
Katya Able, Operations Director
Gina Privitere, Communications Director
Chuck Gathard, Technology Director
Kim Shannon, Photographer Relations Director
Erin O'Connor, Photographer Relations Intern
Leslie Hunter, Partnership Director
Annie Polk, Publicity Manager
John McAlester, Website Manager
Alex Notides, Office Manager
C. Thomas Hardin, State Photography Coordinator

Design
Brad Zucroff, Creative Director
Karen Mullarkey, Photography Director
Judy Zimola, Production Manager
David Simoni, Production Designer
Mary Dias, Production Designer
Heidi Madison, Associate Picture Editor
Don McCartney, Production Designer
Diane Dempsey Murray, Production Designer
Jan Rogers, Associate Picture Editor
Bill Shore, Production Designer and Image Artist
Larry Nighswander, Senior Picture Editor
Bill Marr, Sarah Leen, Senior Picture Editors
Peter Truskier, Workflow Consultant
Jim Birkenseer, Workflow Consultant

Editorial
Maggie Canon, Managing Editor
Curt Sanburn, Senior Editor
Teresa L. Trego, Production Editor
Lea Aschkenas, Writer
Olivia Boler, Writer
Korey Capozza, Writer
Beverly Hanly, Writer
Bridgett Novak, Writer
Alison Owings, Writer
Fred Raker, Writer
Joe Wolff, Writer
Elise O'Keefe, Copy Chief
Daisy Hernández, Copy Editor
Jennifer Wolfe, Copy Editor

Infographic Design
Nigel Holmes

Literary Agent
Carol Mann, The Carol Mann Agency

Legal Counsel
Barry Reder, Coblentz, Patch, Duffy & Bass, LLP
Phil Feldman, Coblentz, Patch, Duffy & Bass, LLP
Gabe Perle, Ohlandt, Greeley, Ruggiero & Perle, LLP
Jon Hart, Dow, Lohnes & Albertson, PLLC
Mike Hays, Dow, Lohnes & Albertson, PLLC
Stephen Pollen, Warshaw Burstein, Cohen, Schlesinger & Kuh, LLP
Rick Pappas

Accounting and Finance
Rita Dulebohn, Accountant
Robert Powers, Calegari, Morris & Co. Accountants
Eugene Blumberg, Blumberg & Associates
Arthur Langhaus, KLS Professional Advisors Group, Inc.

Picture Editors
J. David Ake, Associated Press
Caren Alpert, formerly *Health* magazine
Simon Barnett, *Newsweek*
Caroline Couig, *San Jose Mercury News*
Mike Davis, formerly *National Geographic*
Michel duCille, *Washington Post*
Deborah Dragon, *Rolling Stone*
Victor Fisher, formerly Associated Press
Frank Folwell, *USA Today*
MaryAnne Golon, *Time*
Liz Grady, formerly *National Geographic*
Randall Greenwell, *San Francisco Chronicle*
C. Thomas Hardin, formerly *Louisville Courier-Journal*
Kathleen Hennessy, *San Francisco Chronicle*
Scot Jahn, *U.S. News & World Report*
Steve Jessmore, *Flint Journal*
John Kaplan, University of Florida
Kim Komenich, *San Francisco Chronicle*
Eliane Laffont, *Hachette Filipacchi Media*
Jean-Pierre Laffont, *Hachette Filipacchi Media*
Andrew Locke, MSNBC
Jose Lopez, *The New York Times*
Maria Mann, formerly AFP
Bill Marr, formerly *National Geographic*
Michele McNally, *Fortune*
James Merithew, *San Francisco Chronicle*
Eric Meskauskas, *New York Daily News*
Maddy Miller, *People* magazine
Michelle Molloy, *Newsweek*
Dolores Morrison, *New York Daily News*
Karen Mullarkey, formerly *Newsweek, Rolling Stone, Sports Illustrated*
Larry Nighswander, Ohio University School of Visual Communication
Jim Preston, *Baltimore Sun*
Sarah Rozen, formerly *Entertainment Weekly*
Mike Smith, *The New York Times*
Neal Ulevich, formerly Associated Press

Website and Digital Systems
Jeff Burchell, Applications Engineer

Television Documentary
Sandy Smolan, Producer/Director
Rick King, Producer/Director
Bill Medsker, Producer

Video News Release
Mike Cerre, Producer/Director

Digital Pond
Peter Hogg
Kris Knight
Roger Graham
Philip Bond
Frank De Pace
Lisa Li

Senior Advisors
Jennifer Erwitt, Strategic Advisor
Tom Walker, Creative Advisor
Megan Smith, Technology Advisor
Jon Kamen, Media and Partnership Advisor
Mark Greenberg, Partnership Advisor
Patti Richards, Publicity Advisor
Cotton Coulson, Mission Control Advisor

Executive Advisors
Sonia Land
George Craig
Carole Bidnick

Advisors
Chris Anderson
Samir Arora
Russell Brown
Craig Cline
Gayle Cline
Harlan Felt
George Fisher
Phillip Moffitt
Clement Mok
Laureen Seeger
Richard Saul Wurman

DK Publishing
Bill Barry
Joanna Bull
Therese Burke
Sarah Coltman
Christopher Davis
Todd Fries
Dick Heffernan
Jay Henry
Stuart Jackman
Stephanie Jackson
Chuck Lang
Sharon Lucas
Cathy Melnicki
Nicola Munro
Eunice Paterson
Andrew Welham

Colourscan
Jimmy Tsao
Eddie Chia
Richard Law
Josephine Yam
Paul Koh
Chee Cheng Yeong
Dan Kang

Chief Morale Officer
Goose, the dog

ALABAMA 24/7

ALASKA 24/7

ARIZONA 24/7

ARKANSAS 24/7

CALIFORNIA 24/7

HAWAII 24/7

IDAHO 24/7

ILLINOIS 24/7

INDIANA 24/7

IOWA 24/7

MASSACHUSETTS 24/7

MICHIGAN 24/7

MINNESOTA 24/7

MISSISSIPPI 24/7

MISSOURI 24/7

NEW MEXICO 24/7

NEW YORK 24/7

NORTH CAROLINA 24/7

NORTH DAKOTA 24/7

OHIO 24/7

SOUTH DAKOTA 24/7

TENNESSEE 24/7

TEXAS 24/7

UTAH 24/7

VERMONT 24/7